THE COLLECTOR'S GUIDE
TO DOLLHOUSES AND
DOLLHOUSE MINIATURES

The Collector's Guide to Dollhouses and Dollhouse Miniatures

MARIAN MAEVE O'BRIEN

WITH PHOTOGRAPHS BY ELINOR COYLE

HAWTHORN BOOKS, INC.
Publishers/NEW YORK

THE COLLECTOR'S GUIDE TO DOLLHOUSES AND DOLLHOUSE MINIATURES

Copyright © 1974 by Marian Maeve O'Brien. Copyright under International and Pan-American Copyright Conventions. All rights reserved, including the right to reproduce this book or portions thereof in any form, except for the inclusion of brief quotations in a review. All inquiries should be addressed to Hawthorn Books, Inc., 260 Madison Avenue, New York, New York 10016. This book was manufactured in the United States of America and published simultaneously in Canada by Prentice-Hall of Canada, Limited, 1870 Birchmount Road, Scarborough, Ontario.

Library of Congress Catalog Card Number: 73–11742
ISBN: 0–8015–1405–3

5 6 7 8 9 10

To my grandchildren,
 Bobby,
 Carey,
 Cathleen,
 Colleen,
 David,
 Donna,
 and Jeffrey,
who taught me all about the world of Lilliput.

Contents

Part III

List of Color Illustrations

List of Black and White Illustrations

Preface

Microphile, a friend or devotee of small things, is a term that fits any reader of this book. In my experience, microphiles seem to be of three natures, often very faintly differentiated. There are the antique collectors, who love only small, old things and are willing to travel to distant lands and flatten their pocketbooks in order to acquire them. Then there are the collectors of miniatures to whom antiques are not all that sacrosanct; they love any sort of small thing, old or new, that is an illustration of life—as the furnishings of a doll's house must always be. And then there are, of course, the builders; the artists who love to create the houses and the miniatures within. They are the true givers and will long be remembered by the collectors who inherit their art.

Members of all three divisions, however, will find themselves among exalted company. Benevenuto Cellini, who made little wax miniatures of all his projected sculptures, has written, "Had these figures been first tried on a large scale, I should not have produced them with near such beauty as I accomplished with these." And A. C. Benson, an editor of *The Book of the Queen's Dolls' House*, which was published in 1924, remarked therein,

> There is great beauty in smallness. One gets all the charm of design and colour and effect, because you can see so much more in combination and juxtaposition. And then, too, the blemishes and small deformities which are so inseparable from seeing things life-size all disappear; the result is a closeness and fineness of texture which please both the eye and the mind. One realizes in reading of the travels of Gulliver how dainty and beautiful the folk and buildings of Lilliput were, and on the other hand, how coarse and hideous the magnifying effect of Brobdingnag was.

After one has spent time searching for small pieces to furnish a miniature house, one begins to realize that everything that has been made life-size for people has also been produced in miniature. Possessing these tiny works of art is satisfying in the extreme; one becomes infected with the thrill of planning miniature houses, shops and stores, and copies of great rooms.

And, since we are such a mobile people, we can travel to country auctions, antique shops, rummage sales and flea markets. Never overlook one of them, for it could be in that spot that you may find the tiny pieces discarded by some collector of long ago and offered now at a pittance. The experiences you encounter along the way, the friends you will make, will be unbelievable; almost all collectors are warm-hearted, friendly people. You will, in short, begin to enjoy life to the fullest. I hope that this volume will guide you along the way.

Acknowledgments

Someone has said that there is always one person, other than the author, without whom a book would never have been written. In the case of this book, there are so many whose help and kindness and cooperation contributed to the book's completion, that it would be impossible to single out all of them; I can only express my gratitude.

Special thanks, however, must be given those friends who stood ready all along the way: to Edith Margolis, my agent, who first conceived the idea; to Elizabeth Backman, my editor at Hawthorn Books, whose patience and understanding can never be measured in mere words; to Catherine MacLaren and Dee Snyder, who opened not only their collections to me, but made available the fantastic fund of knowledge about miniatures that they alone possess; and to Elinor Martineau Coyle, whose prowess with a camera brought most of the photographs contained herein to perfection.

Who can thank properly the collectors who labored to get the greatest possible photos of their special treasures? Who can properly acknowledge the work done by the girls of the St. Louis and Kirkwood Public Libraries as they toiled in the stacks to bring forth every single volume that might yield even a sentence of research value? Who can express the gratitude I felt as readers of my newspaper column sent me useful clippings of stories of collections from the four corners of the country?

The only answer is that no one can. But every collector and every miniaturist who studies this book will know that it was written with them in mind, and with the hope that it will help them to derive even greater pleasure from a hobby that has already delighted so many. I thank them all.

And last but certainly not least, I thank the husband who endured neglect, skimpy meals, and the loss of the second floor of his house while work on the book went on, to say nothing of the preoccupation of a wife who for nearly a year was so deep into this book that she often couldn't give a reasonable answer even to such queries as "Do you think it will rain today?"

The Doll House

After the children left it, after it stood
For a while in the attic,
·Along with the badminton set, and the skis too good
To be given away, and the Peerless Automatic
Popcorn Machine that used to fly into rages,
And the Dr. Doolittle books, and the hamsters' cages,
She brought it down once more
To a bedroom, empty now, on the second floor
And put the furniture in.
 There was nothing much
That couldn't be used again with a bit of repair.
It was all there,
Perfect and little and inviolate.
So, with the delicate touch
A jeweler learns, she mended the rocking chair,
Meticulously laundered
The gossamer parlor curtains, dusted the grate,
Glued the glazed turkey to the flowered plate,
And polished the Lilliput writing desk.
 She squandered
One bold October day and half the night
Binding the carpets round with a ribbon border;
Till, to her grave delight

(With the kettle upon the stove, the mirror's face
Scoured, the formal sofa set in its place)
She saw the dwelling decorous and in order.
It was a good house. It had been artfully built
By an idle carpenter once, when the times were duller.
The windows opened and closed. The knocker was gilt.
And every room was painted a suitable color
Or papered to scale
For the sake of the miniature Adam and Chippendale.
And there were proper hallways,
Closets, lights, and a staircase.
(What had always pleased her most
Was the tiny, exact, mahogany newel post.)
And always, too, wryly she thought to herself,
Absently pinning
A drapery's pleat, smoothing a cupboard shelf—
Always, from the beginning,
This outcome had been clear. Ah! She had known
Since the first clapboard was fitted, the first rafter hung
(Yet not till now had known that she had known),
This was no daughter's fortune but her own—
Something cautiously lent to the careless young
To dazzle their cronies with for a handful of years
Till the season came
When their toys diminished to programs and souvenirs,
To tousled orchids, diaries well in arrears,
Anonymous snapshots stuck around a mirror frame,
Or letters locked away.
 Now seed of the past
Had fearfully flowered. Wholly her gift at last,
Here was her private estate, a peculiar treasure
Cut to her fancy's measure.
Now there was none to trespass, no one to mock
The extravagance of her sewing or her spending
(The tablecloth stitched out of lace, the grandfather's clock,
Stately upon the landing, with its hands eternally pointing
 to ten past five).
Now all would thrive.
Over this house, most tranquil and complete,
Where no storm ever beat,
Whose innocent stair
No messenger ever climbed on quickened feet
With tidings of rapture or of despair,
She was sole mistress. Through the panes she was able
To peer at her world reduced to the size of dream
But pure and unaltering.

There stood the dinner table,
Invincibly agleam
With the undisheveled candles, the flowers that bloomed
Forever and forever,
The wine that never
Spilled on the cloth or sickened or was consumed.
The "Times" lay at the doorsill, but it told
Daily the same unstirring report. The fire
Painted upon the hearth would not turn cold,
Or the constant hour change, or the heart tire
Of what it must pursue,
Or the guest depart, or anything here be old.
 "Nor ever," she whispered, "bid the spring adieu."
And caught into this web of quietnesses
Where there was neither After nor Before,
She reached her hand to stroke the unwithering grasses
Beside the small and incorruptible door.

 Phyllis McGinley
 from *Times Three*

Collections

This madness of the milder kind
Assails the wise or simple mind;
From dogs who cherish buried bones
To scientists with labeled stones,
From those who seek old ivory fans,
To those who cherish pots and pans.
Our tasks of everyday neglecting,
We mount our hobby of collecting!

There is no eagerness like this—
The something that we must not miss
Because it fills a final niche,
Completes a group, or makes us rich
In something that took work and time
But is perhaps not worth a dime,
Except to us! What zest it brings—
This fervor of collecting things!

For samples, stamps or antique chair,
For candlesticks in one or pair,
For postmarks (which don't cost a sou) ,
For jewels of the dead queens (which do) ,
For first editions of old books,
For recipes of famous cooks,
For feathers dropped by moulting birds,
For volumes full of English words,

For etchings, clippings, handmade laces,
For garden seeds from famous places,
For wildlife photographs, for shells,
For mounted butterflies, for bells,
For sketches of our favorite trees,
For maps—for any one of these
Goes all our zeal to their possession—
Go get yourself a pet obsession!

Dorothy Brown Thompson

PART I

I

Introduction to Dollhouses

IT SEEMS TO ME THAT THERE IS NOT MUCH REASON, IN A BOOK specifically dedicated to collectors, for going into the history of dollhouses. That subject has been covered in a dozen volumes written by historians more accomplished than I. Every dollhouse of note has been documented and described until the aspiring collector is familiar with it down to the last tiny spoon on the last tiny table.

And even if this were not true, the collector, whether a neophyte or a dedicated devotee of his hobby, has already been infected with the fascination of what he is doing. What he really wants now are a few pointers on how he can recognize a worthwhile dollhouse or miniature, and what "worthwhile" means. A question about whether the price is right never occurs to him; once we've been bitten by the collecting bug, we simply must have the things that appeal to us. As far back as the doll-houses of Augsburg, we find tales of the extravagances of our fellows. Even then (c. 1558) collectors who really could not afford them couldn't resist them, and Flora Gill Jacobs writes in *A History of Dolls' Houses* of an Augsburg lady, one Frau Negges, who so overbalanced her doll house budget that "she did hurt to her estate."

I happen to have grown up in a family imbued with a love of the miniature—meaning, of course, miniature houses and all the things that go with them. My English grandfather, a fine cabinet maker, whiled away his spare hours building a dollhouse that brightened most of my childhood. Only four rooms, it was nevertheless most imposing: The roof sported handmade shingles; one could look through

movable glass windows into the attic's raftered space; and each room was lined in a different wood, lovingly polished to a high gloss. The stairs going up to the second floor were elegant with their railing of handturned spindles and imposing newel post; the bay windows in the downstairs rooms were patterned after the ones he remembered from England; and the double-hung sash raised and lowered smoothly. This house even had a back door (something one seldom finds in doll houses), electric lights, and bookcases stocked with all of our favorite books in miniature.

It delighted me, my three sisters, and a beloved cousin before it was stored away to await the arrival of our children. On the day I moved into a new house as a bride, I came home and found it in flames in the driveway. My husband, otherwise a most loving person, but one who had grown up in a family in which there was neither tradition nor sentiment, had decided that "there's no sense in moving all this old junk into a nice new house!"

I recovered, but the idea, the urge, was still there.

While our own girls were still babies, I decided that it was time to begin to build a dollhouse for them, and I promptly executed a replica of our house with blueprints on a scale of an inch to a foot (1/12 scale). This house, too, was unique, the sort you must look for when you are collecting dollhouses, in that neither time nor trouble was spared in executing the details that distinguished the life-size house it was meant to represent.

Tiny kitchen cabinets had handles exactly like those in my own kitchen. Electric chandeliers really lit up and were copies of those in our house. Water ran from the faucets in the bath, pumped from a little reservoir in the base of the house. A pond glistened in the back meadow, just as it does when I look out my kitchen window.

But there came a New Year's Day (this was almost thirty years ago) when tragedy struck again. In the midst of a houseful of people, one couple arrived with a little boy. We invited him to go upstairs and play, a little irked at the thought that people could be so insensitive as to bring a child to such a party, and when we went to get him this dollhouse was in ruins. He did it, he said, because he was angry that he couldn't come to the party.

Regardless, the idea, the urge, lived on. My next dollhouse, modeled after Tara, the plantation mansion in *Gone with the Wind*, was made for granddaughters, but they soon proved that they were too young for such a treasure. The delicate legs on the Queen Anne chairs were quickly splintered. The tiny dishes were lost and forgotten. The hand-embroidered bedspreads were too often used to wipe the grease from bicycle chains.

So I took it back.

And soon, just as in Phyllis McGinley's poem, the house became mine again. Now I could be extravagant. The little dining table gleamed with sterling silver napkin rings and real linen napkins. The carpets were handmade copies of exquisite Orientals that I saw in the shops. In the music room I could feast my eyes on handpainted mural wallpaper of the Federal period, and a little gold harp stood next to the square piano just as it did in Scarlett O'Hara's day.

And to justify my extravagance (and possibly because I felt guilt about all the joy it gave me) Tara began to make the rounds of dollhouse tours for charity: of the childrens' hospitals in our area to delight the little patients; of the bazaars for the Animal Protective Association. Thus, I rationalized, my joy wasn't just for my own pleasure; it did some good, too.

You will, of course, be looking for originals for your collection, such as the lovely pink creation with the fine balustrades shown in figure 1, from the Mannion collection. But don't disdain the con-

1

This charming Mediterranean villa, c. 1900, measures about 31 inches wide, 26 inches high, and 17 inches deep. The roof is bright red, probably repainted, and the house itself is a delicate pink with white balustrades, which are in themselves masterpieces. Collection of Adelaide Mannion.

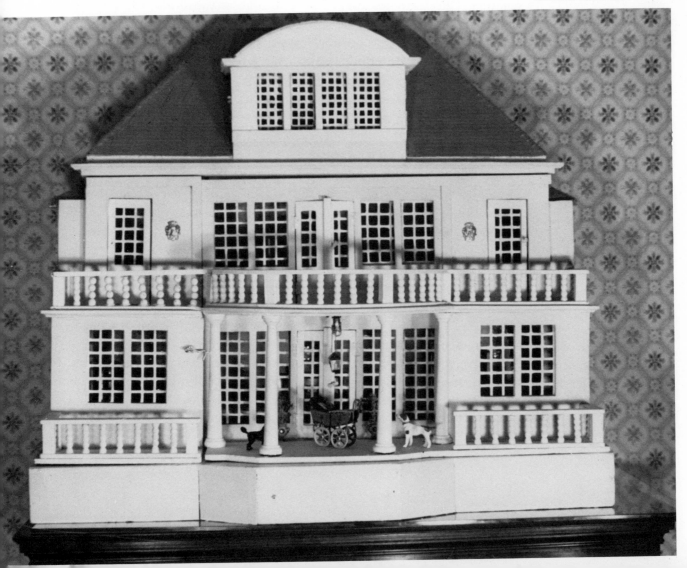

temporary houses, either. John Noble, curator of dolls and toys at the Museum of the City of New York and author of *A Treasury of Beautiful Dolls,* remarked in an interview for the *Nutshell News,* a paper devoted to the study of dollhouse collecting, that while it's true that there is a need and a place for the original, reproductions, too, merit our attention. The charm of the old is just that—an honest expression of its time and purpose, he went on.

Let us say we have discovered a fine old dollhouse in a barn—not very likely these days, when everyone is on the lookout for just that; the fine old 1/12-scale domicile that may have been hidden away fifty or a hundred years ago is becoming harder and harder to find. This is what the collector calls a "pure" house; to him it is one that has had only one owner and contains the original furniture. He should first spend a little time verifying the date, or at least the era, from which it came. The person from whom it was bought will probably have a fund of information, but all of this should be checked, for people have a habit of exaggerating the age of antiques. There are times when the closer one checks an old house, the younger it becomes!

This accomplished, a careful investigation into the finish on the walls and floors should be instituted. Scrape off a little paint in a corner to see whether many coats of paint have been added to the original. Check the wallpaper in a similar way, working at an inconspicuous corner until you can see underneath. In the small balustraded house in the Mannion collection, for example, someone with hideous taste had glued wallpaper over a very pretty pattern. All such additions must be scraped off, the walls sanded (the floors, too, if they've had too many coats of paint), and then the restoration begins. A purist will avoid any idea of "modernizing" his pure house, for this would destroy its charm. He will retain the lovely faded draperies, the delicate silk upholstering, the little carved pieces, no matter how crude, that were made by a loving father for a little daughter.

The restoration will take him down many streets as he searches for authentic replacements. Books on architecture of the period will be pored over. Those on interior decoration of the era will be found; even volumes on the living habits of the time of his house will be grist for his mill. Before he has finished, he will be so enthusiastic about all this learning that the pain of the price of the house will be forgotten.

Some collectors will never be satisfied with anything but a very old and rare house. They make a mistake when they refuse to consider the appealing structures that are newer. Consider, for example, the house from the Mannion collection shown in figure 77. This was built about fifteen years ago to Mrs. Mannion's specifications, to house her collection of miniatures gathered from all over the world.

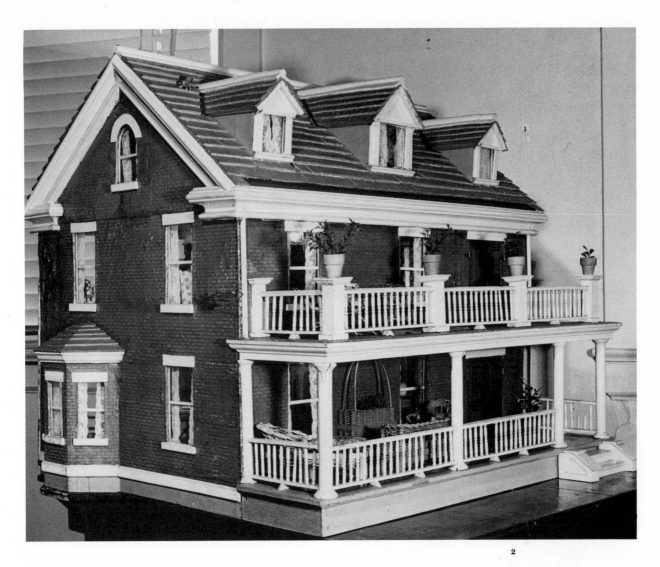

2

Good dollhouses are not cheap, as anyone who has shopped for one, new or old, can testify. Around $100 seems about average for a nice ¹⁄₁₂-scale house these days, with prices scaling downward to around $30 as design and workmanship are simplified, and upward in cases of the buyer wanting a particular house made by hand and conforming to a particular period. Joen Ellen Kanze of North White Plains, New York, has formed her own company called the Mini Contracting Company, and constructs such houses to order: They are priced on an average of $400 for the house complete but unpainted, or $500 for the house painted inside and out, depending upon the hours necessary for the work. That's quite a sum for a container of one's miniatures, but of course a dollhouse is never anything quite so sim-

ple. A proper dollhouse has a personality, an aura about it, that establishes a rapport the moment the right owner comes into view. You face it and—pow!—something happens, much the same as love at first sight. This is what happened to another collector, Phyllis Rembert, when she first began to hear tales of a Victorian dollhouse that has since become the core of her collection (figures 3 and 4). She traced it down (no one can analyze the reason that impels one to feel, sight unseen, that one simply *Must* have a certain thing, she says) and finally located it, after thirty long-distance calls to Chicago shops. Upon hearing its description, she made a deal in the middle of a conversation and had it air-shipped to her home on the West Coast. It's been a

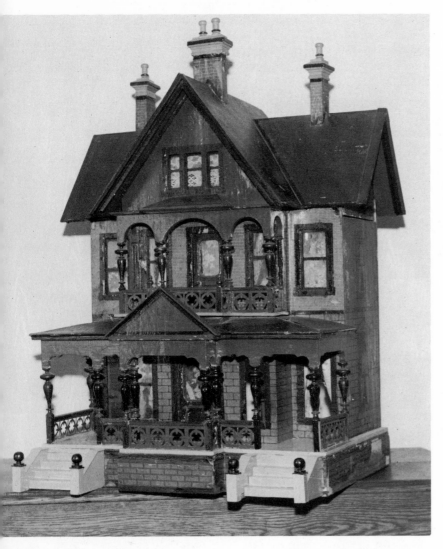

3 & 4

Two views of a dollhouse recently acquired in Chicago. This house is an excellent example of pure Victorian design; note the fretwork and frame decoration, characteristic of the era. Collection of Phyllis Rembert. (*Photos by Lorraine Berland*)

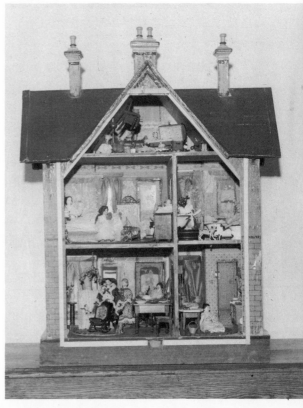

8

love affair that has flowered and brought her much happiness ever since.

Although we are calling this a "Victorian" dollhouse, because of the architectural details, and because it is of lithographed paper laminated on wood as are the Bliss houses and others of this genre, it is unmistakably German; it is stamped in several places with the words "Gesetzlich Geschutz," which is the German equivalent of "patent applied for." Appraisers have dated it c. 1900.

As the bonus that every collector dreams of, the house came complete with furniture; the chairs have backs and seats of woven mesh or cane, and certainly predate the house. The dining room table, matching the chairs, is particularly rare. The grandfather clock, lace-covered screen, and sewing basket of ormolu in figure 5a, also came with the house (the dresser second from right is unidentified), as did a most unusual marble-topped table, rectangular on the ends and oval in the center (figure 5b). A tiny piece of faded paper glued to the underside dates this as 1850.

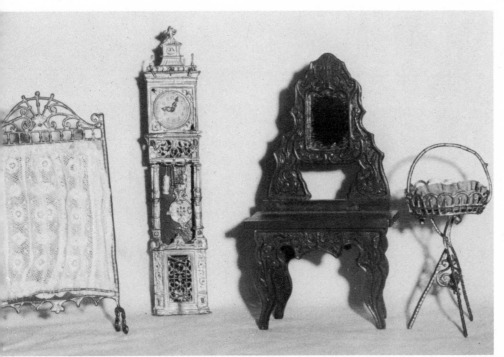

5a-b

These rare pieces, a lace-covered screen, metal grandfather clock with swinging pendulum, and ormolu sewing basket, came with the Rembert house when it was shipped from Chicago. The marble topped table, c. 1850, was also included. The dresser second from right has never been identified. (*Photos by Lorraine Berland*)

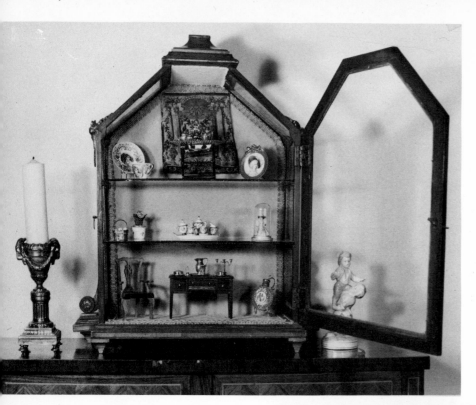

6

This French cabinet was probably made in the early nineteenth century. Notice that the French Sevres cup and saucer, top shelf, are a bit larger than scale, as is the French perfume bottle on the lower shelf. The miniature of Empress Eugenie is painted on ivory and the tea set is Limoges. The tapestry on the top shelf was cut from an old handbag. The cabinet lining is of a luscious deep pink velveteen. Collection of Adelaide Mannion.

7

This French cabinet, of the early nineteenth century, is finished in black. Particularly noteworthy is the heavy beading that decorates all four corners. The two chairs are also French, early nineteenth century, and the tiny piece of carved ivory on the center table is exactly an inch high. The base of this table is made from an old bottle top, gilded. The Battersea enameled tray on the table is English, of the mid-1900s and very rare. The dog and cat on the bottom shelf are made of French porcelain, about an inch high, and the man and woman, less than 3 inches high, are of Dresden. The cabinet is about 7 inches by 14 inches. Collection of Adelaide Mannion.

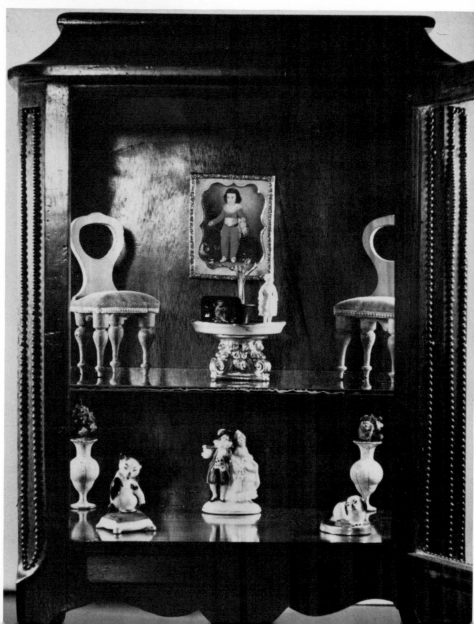

2

Box Rooms and Cabinets

THERE ARE INNUMERABLE COLLECTORS WHO SPECIALIZE IN cabinet or box collections. Exhibiting miniatures in cabinets was a favorite hobby of European royalty in the early seventeenth century. In 1675 the earliest miniature room of which we have record was made in France and presented to the Duc-de-Maine. By this time, the Dutch were also making cabinets for collections, and the English soon joined them.

In Amsterdam, London, and Paris, the cabinets boasted intricately carved legs and elaborate embellishments on the frames. They were not intended as playthings for children (their contents were far too valuable for that) nor were they models or miniatures of houses. They were designed as ornamentation for a room, and both the cabinets and their contents were arranged with that in mind. Some cabinets had legs tall enough so that they could stand alone as separate pieces of furniture; others were designed to stand upon tables or hang on the wall.

Examples of seventeenth- and eighteenth-century cabinets are still extant in the museums, although very few are available on the open antiques market. Occasionally one can be found at estate dispersals and art gallery auctions, if one hunts persistently. The two cabinets from the Mannion collection (pictured in figures 6 and 7) are French. Mrs. Mannion estimates their age at early nineteenth cen-

tury (appraisers have confirmed this) but there is no documentation, so their exact age is difficult to determine. Both cabinets were purchased in Paris, and the brass ornamentation and general shape all point to an accomplished craftsman. The miniatures in the cabinets are discussed below, but particular attention must be paid to the doll under the glass dome; she is quite old, as evidenced by the condition and style of her costume. An aspiring collector might begin with almost exact replicas of the doll featured in the catalog of the Peddler's Shop in San Francisco, which are contemporary in execution.

The first cabinet measures about 20 inches tall by 6 inches deep. In addition to the tiny doll under glass, the cabinet contains a miniature of the Empress Eugenie, painted on ivory, and a French cup and saucer of the same period. The tea set is French Limoges porcelain, and the Chippendale chair is handcarved by a local artisan, acquired from an antique shop.

In the second cabinet, which measures about 14 inches high by 7 inches wide, the two upholstered chairs are French, c. 1910–1920. There is a small bronze flower pot, probably of the same period, which contains a lovely enameled flower. The little ivory figure, so meticulously carved, is exactly 1 inch high, and may have come from the Jack Norworth collection. The Battersea enameled tray is of a later date, perhaps the mid 1900s, but is extremely rare.

Notice the border beading on the sides of the cabinet, as well as the metalwork on the feet. The former is made of fruitwood, while the latter has a very attractive black finish; it has been suggested that this fine wood and metalwork was originally made as salesmen's samples.

The collector might have better luck searching for a late Victorian cabinet such as the one pictured in figure 8. Here, although the finish is very fine, the work is not so detailed as in the French examples. There is no brasswork or beading. It almost gives one the impression that it was made by a country craftsman, but there are some touches that belie this: The sides and top are lined with fine black velvet, and the mirror back certainly did not come from a country shop. Notice, too, the fact that the top corners are slanted off to give a more pleasing frame for the contents, in the manner of the French cabinets. The small size of this, 13½ × 9 × 3 inches, indicates that it was meant to hang on the wall, and when it was purchased, the two screw eyes in the top were already in place.

Another difference between the French and Victorian cabinets is one of interior decorating. The miniatures within the French cabinets were chosen for their airy elegance. In the Victorian cabinet, the min-

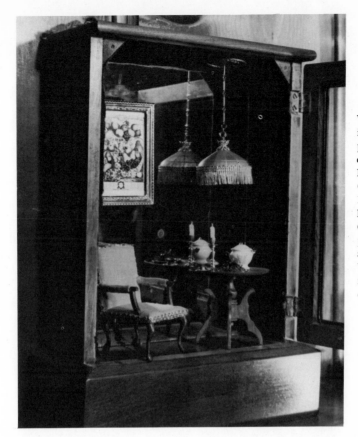

8

Victorian cabinet, c. 1840,
is furnished with a color
print from the Williamsburg
catalog, a chair by B. Leo
Fallert, a side table in the
Queen Anne style by Mel
Prescott, and a leaded glass
lamp by Pickwick Miniatures.
On the table are a plum
pudding by Ruth Janecke,
a silver candlestick from
Williamsburg, and a tureen
from Suzanne Ash. Author's
collection.

iatures are heavier and more sturdy. The chair is handmade by B. Leo
Fallert. The picture is a clipping from the catalog, "Williamsburg
Restorations," one of a group of four depicting the fruits of the sea-
son. (This book, by the way, will be a source of great ideas for the
collector; the color printing is very fine and it contains a number of
fine prints in 1/12 size.) The hanging chandelier from Pickwick Minia-
tures is a reproduction of a leaded glass lamp, so popular in Victorian
times. The tea set is of English china, and the side table upon which it
stands is Queen Anne, made by Mel Prescott.

Another example of fine modern craftsmanship in the most
lauded eighteenth-century style are the Lanthorn houses, six-sided,
that are made and marketed by Mr. and Mrs. Wes Faurot, proprietors
of Willoughby's 18th Century. The name of their firm was inspired by
the nineteenth-century painting of "Miss Willoughby" by George
Romney. The Faurots research every piece they make most thor-
oughly, and all of their pieces are signed, thus making them most
valuable to collectors. These little cabinets, about 16 inches high and
8 inches deep, are called "lanthorns" after the early lanterns that were
made of horn transparencies. They are roofed in the tea-caddy man-

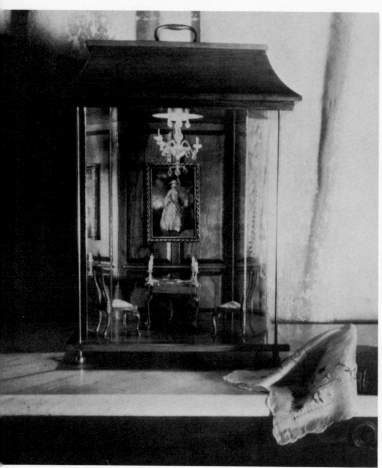
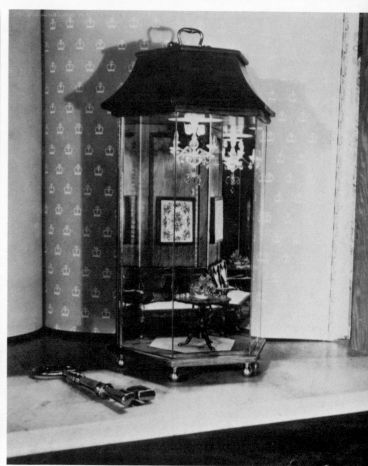

9 a&b

Lanthorn houses, exquisite reproductions of eighteenth-century lanterns, are the work of the craftsmen at Willoughby's 18th Century shop. "Lanthorn" is an early spelling stemming from the use of translucent horn where glass would now be used.

ner, braced and footed in solid brass, and are made of furniture-finish cherry. Each features discreetly placed mirrors that increase the size of the lanthorn and produce three or four images of each miniature. The cabinets can be carried, hung, or simply placed upon a table.

The charming little cabinet in figure 10 was made by the Faurots from a clock case. Here, the works were removed, paneling was placed in the back of the cabinet, and glass was installed in the other three walls. The Queen Anne hoopback settee with fiddle-shaped splat, the card table, side chair, and tea kettle (sterling) on a kettle stand were all made by the Faurots. The painting on the back wall is the Williamsburg color print that the author has also used in the Victorian cabinet in figure 8. Note that the Faurots have carried their fancy a bit further: The portrait of the little girl hanging beside the cabinet is the "Miss Willoughby" for which their endeavor is named. On the table beneath is a tiny Queen Anne screen which they made, as well as a miniature book and a modish eighteenth-century garden hat on a stand. The roses are real, however; they are a miniature bloom. The table is made of an antique cheese box.

14

10

Cabinet made from an eighteenth-century clock case without the works, by the Faurots, illustrates the possibilities of using such old pieces in home decorating. The furniture is from Willoughby's. Notice the tiny pair of shoes beside the settee.

The box rooms in figures 11, 12, and 13 are a series of shadow boxes conceived and executed by Mrs. Louise Bradley of St. Joseph, Missouri, many of which are displayed in the Doll Museum at St. Joseph. Mrs. Bradley's boxes seem doubly astounding, not only because of their beauty but also because of their scope. Her collection includes the silver parlor illustrated here, an American Empire dining room, a room from Paul Revere's house complete with corn shuck dolls, a Slavic country festival scene with figures from Poland, a Pilgrim setting, also shown, a Dresden music room, and an American Gothic parlor.

11

The Gothic Parlor shadow box, 15½ inches high × 18 inches wide and 12 inches deep, displays furniture handmade for a child years ago. The wallpaper is in a tiny pattern of soft green, the carpet is of velvet in the same color, and the drapery and large floor puff (at left of photo) are of old red taffeta. The bowl on the lamp is also red. The doll is antique bisque. Notice also, the little pug dog. Collection of Louise Bradley.

12

The Silver Parlor shadow box, 9 × 9½ × 14½ inches long, reflects the elegance of eighteenth-century Austrian silvered furniture. Chandelier and cornices are gold-plated, the walls are pale pink, the wall panel paper and velvet carpet are violet, and the upholstery is pink slipper satin. Collection of Louise Bradley.

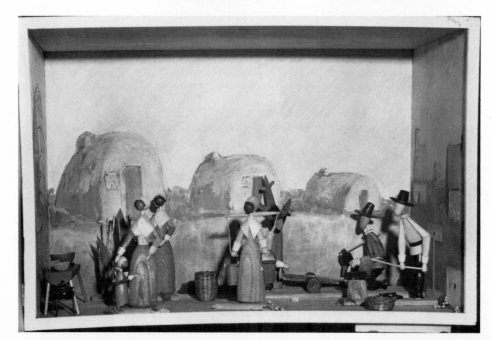

13

The Pilgrim shadow box, 18½ × 12 × 9 inches deep, boasts handpainted (oil) backgrounds. Here, a few small pieces accentuate the mood. Collection of Louise Bradley.

Mrs. Bradley belongs to our third class of collectors—the dedicated artists who do their own building. She seems to have a talent for getting along well with people, since innumerable friends and neighbors have contributed their treasures to her shadow boxes. The Gothic parlor in figure 11 is furnished with pieces made years ago by the father of one of her friends. The little "Silver Parlor," which is distinguished by its Austrian silvered furniture and gold-plated chandelier, was built entirely by Mrs. Bradley, including the pale pink walls and violet panels; the curtains, draperies, and other accessories came from shops searched on her travels.

The Pilgrim case is especially interesting because it demonstrates the amount of historical research that is necessary in order to give a box a feeling of authenticity. The wooden figures are carved by hand, and the background, painted in oil by Mrs. Bradley, illustrates the type of "haystack" houses that were among the first dwellings built by the Pilgrims.

A cabinet consisting of two rooms has been made from a case that was originally used to encase wine bottles (figure 14). It is from the

14

A box made in France for shipping wine, the wood of a lovely warm honey color, makes an interesting dollhouse cabinet when upended to make two rooms. The partition between the rooms is the original partition in the wine box. Collection of H. W. Pirie.

collection of H. W. Pirie and was executed by Mrs. Gene Trammel, who used the box upended and thus took advantage of the division in it to provide two rooms. The furniture within, with the exception of the little table in front of the settee, is made by a commercial firm and stocked in the Peasant Bazaar, which the Piries operate for the benefit of the Animal Protective Association. The base of the table consists of an elaborate bottle top, which has been gilded, while the top was made from a circle of tin (probably taken from a can) decorated with perforations and crimped edges.

The pleasing little cabinet room shown in figure 15 is a fine idea. Originally it was marketed by UNICEF for the Christmas 1972 holiday trade, and it is one of a series of five depicting the life of people in foreign countries. The little doors of this Japanese house slide to close. Although the accessories are few, they are all exceedingly well made. A collector might care to make his own additions. Each of the "foreign houses" was sold in department and specialty stores throughout the Midwest and was originally priced at $6.50. They make a colorful addition to any collection, and will undoubtedly increase in value.

The use of sectional bookcases as dollhouses seems to date from about 1904–10. These bookcases were built to stack one upon the other as high as the collector wished to go; they are about 12 inches

15

This charming little Japanese box house retailed by UNICEF is a delightful illustration of early cabinet dollhouses that were constructed in carrying cases with a handle on the top. This set contains sliding doors, a two-fold Japanese screen, three nice soft little Japanese people, a garden, a pet, a bridge, and a rickshaw. A most pleasing modern adaptation of an early nineteenth-century toy, made completely in plastic. Author's collection.

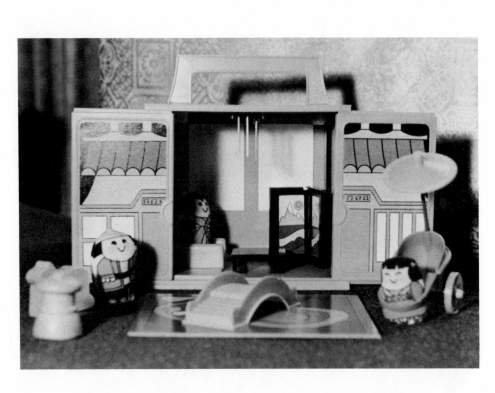

deep and 14 inches tall. The cases had sliding doors that amply protected the contents from dust. Each bookcase was large enough to house two rooms, and we have seen a few that were carefully wallpapered and carpeted inside. They make most attractive *poppenhuizen* (dollhouses) for the beginning collector.

Other possibilities for the collector who is looking for a dust-and-cat-proof cabinet in which to display his miniatures while he continues his search for a dollhouse are discarded television cabinets, so often found in used furniture stores and in Goodwill emporiums. Depending upon the size of the original screen, television cabinets will accommodate two, three, or even four rooms if partitions are inserted carefully.

Box rooms were used to display valuable miniatures by such masters as Fabergé and his peers. Many artists—Dutch, French, and English—executed box rooms according to their own ideas, and the small pieces soon grew popular as table ornamentations and wall decorations.

Box rooms are thought to have appeared first in the collection of the Princess Augusta Dorothea in Schwarzburg-Arnstadt. The first one, a village of over 100 rooms, was put together between 1715 and 1750. Each room showed all the details of daily court life of the period. We could have learned a great deal about the life and habits of the people of the time, but in 1819 the rooms were given to an orphanage, and seem to have disappeared. A pity!

Throughout the nineteenth and well into the twentieth century, another version of the box house was used as a toy in London. It was also popular in this country at the turn of the century. These were the so-called poppy shows that were made in a shoe box. A child had only to obtain a suitable box with a lid and then work out his own ideas as to what a house should contain. Usually a picture, a card, or a cutting from a magazine or old book was pasted in the far end of the box to serve as a background. Then the walls were colored or covered with cuttings from catalog or magazines. Pictures of families dining, playing cards, or engaged in other activities were pasted at intervals lengthwise of the box, usually braced with a bit of folded cardboard so they stood at right angles to the floor. Since celluloid in sheets or Plexiglas were not known, the windows (rectangles cut in the sides) were covered with bits of colored tissue paper or, in a few cases, actual fabric curtains. A candle was set in some sort of small container in the exact center of the box, directly beneath a hole cut in the lid. This hole formed a draft and drew flame and smoke directly upward. A string for pulling was run through the front wall directly beneath the viewing aperture, and the child then lighted the candle and pulled his

"poppy show" through the dusky streets (most couldn't wait until it was really dark, after having worked on their house all day) crying a chant that began, "Come and see my poppy show! It's really very nice, you know! A pin, a pin, and I'll let you look in! Just come and see my poppy show!" One paid one's pin by sticking it into a circle around the roof aperture and peeking through the front opening at the scene inside. Some nostalgic correspondents mention that children strung together four or five boxes, thus achieving a whole house. Some report that youngsters charged a penny for a peek; others report a pin. Probably there were some neighborhoods in which a penny was worth more than a pin, or vice versa, and this governed the asking price. It was a springtime diversion, and a charming one as the little lighted rooms shone against the sidewalk.

The name "poppy show" seems to have derived from the English "peep show," but wherever the word originated, it's a delightful idea for the miniaturist, and one universally beloved by youngsters.

Poppy-show boxes don't offer much of a field for collectors, since they apparently were too fragile to have survived through the years. We found only one in the attic of a correspondent—a scene at Valley Forge made by a ten-year-old boy that is complete with snow, snow-covered rocks, lead soldiers marching, and cannon. Here the backdrop was a large photo of General Washington superimposed upon an American flag.

Cigar boxes are another possibility for box rooms. A cigar box is large enough to make possible the execution of an elaborate design, but small enough to make the completion a pleasant task. The one pictured in figure 16 was completed in less than a day. The room was planned on the horizontal measure of the box, which was about 9½ by 7½ inches. The box stood on its long side, the other long side being the ceiling of the room. In this case, both were painted white. The gold cornice is the gold border paper carefully removed from a box of candy. In the center of this wall stands one of the Petite Princess grandfather clocks. In the right corner is one of the Chinese screens described in Chapter 12; the use of the screen here makes a more pleasing joint at the two walls, and sort of ties the whole thing together. Glued to the floor exactly as were the inhabitants of the poppy shows, are the various adjuncts of a Christmas celebration. The outside back and sides of this box were covered with a gold and white marbleized preglued paper (Con-Tac) so that it is pretty enough to stand upon a table. The frame is a ¾-inch picture frame molding in

16

Cigar box cabinet that celebrates Christmas is an example of the pleasing effects that can be managed if the collector has little space in which to display his prizes. Author's collection.

white speckled with gold. The glass (in this case, ⅛-inch Plexiglas) is carefully glued to the cigar box frame (most are 3/16-inch thick; some are closer to ¼-inch) and the picture frame is then glued over the glass. A collector might want to plan an entire series covering the various seasons or holidays. The collector may find a poppy show box occasionally in an antique shop or in dispersals of private collections.

One of the most noteworthy makers of box rooms is David W. Dugger of Edmonds, Washington. His box rooms are considered to be the smallest group of miniatures in the world, yet perfect in every detail. Four of these are shown in actual size in figures 17 and 18. Composed on a scale of 1 inch to 7 feet, they are one-of-a-kind, signed and dated, and therefore expensive. Dugger estimates that 400 hours of work went into the tiny hallway titled "Entry to Elegance," and more than 900 pieces went into another room.

17a, b, & c.

These three shadow boxes are without equal in the miniature world. At left, in actual size, is David Dugger's "Prelude to Serenity," with a rosewood piano actually containing eighty-eight keys individually carved. At center is his "Harmonious Strings"; both the harp and viola are strung with human hair. At right, slightly less than actual size, is his "Repast in Splendor," which is one unit from an eight-room house constructed on the same scale. Collection of David Dugger.

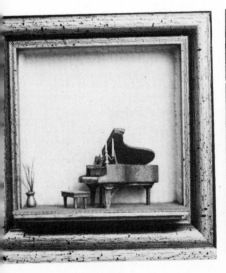
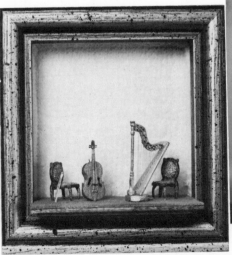
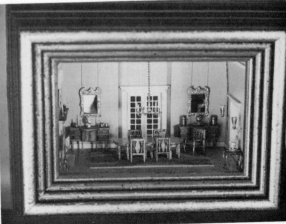

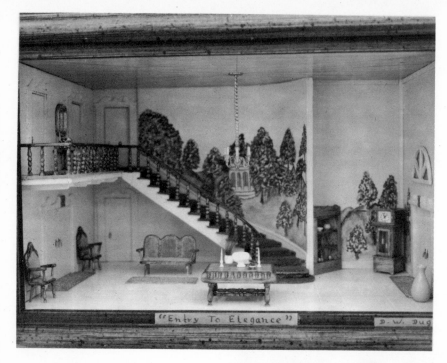

"Entry to Elegance" is also constructed in the exact size shown here, has a marble floor and a railing with thirty-five handcarved balusters. The grandfather clock has a glass face with time-telling hands and weights in the pendulum, and the minuscule chandelier raises and lowers. On the table is a bowl of fudge placed between the two candles. Even the wall mural was executed by the artist-builder. Collection of David Dugger.

19

This three-walled wood grocery store, c. late nineteenth century, was brought from Germany in 1972 by a dealer. The counter, drawers, faded red wallpaper, and the simulated tile wallpaper flooring are original; other accessories have been added. Mrs. Ackerman believes that a sign, "Grocery Store," is missing from the back wall. Collection of Evelyn Ackerman. (*Photo by Evelyn Ackerman*)

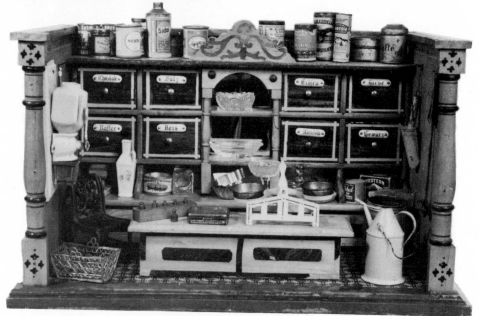

20

Although few American tin kitchens have survived, there is always the possibility of a collector finding one. This one was found at a local auction. It is made of stamped and painted tin, late nineteenth century, and is distinguished by the pump that appears on the right. Collection of Evelyn Ackerman. (*Photo by Evelyn Ackerman*)

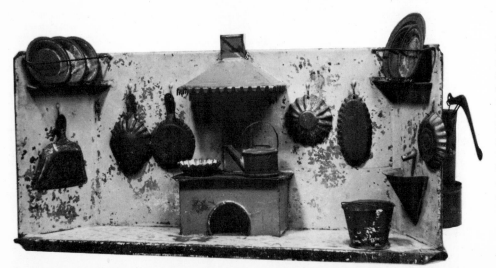

Mr. Dugger has two projects in progress, according to an interview with him in *Hobbies Magazine* for July 1972. He is completing his construction of a seven-room house, which he is making frame by frame and then mounting on a wedge inside a glass case. One room has windows that open and close, and contains a piano—complete with 88 individually carved keys, strings, and a hinged top—within the boundaries of a 2½-inch square frame. At the same time, he is designing and framing single settings.

Three-sided rooms were great favorites not only with German and French collectors, but also with builders of dollhouses in Victorian America. These little rooms had no ceilings, but often were furnished in astonishing detail. The German grocery store in figure 19, of wood and about 19 inches wide by 11¼ inches high and 10 inches deep, has an undeniable charm that is seldom found in modern toys. The handpainted front posts make the German store doubly interesting. This store, like the two kitchens that follow, are from the collection of Mrs. Evelyn Ackerman of Culver City, California.

The American tin kitchen is Mrs. Ackerman's favorite, because it is all original. It deserves the careful study of any would-be collector because it was found at a local general auction. It measures about 16 inches wide, including the outside pump, by 7 inches high and 4 inches deep, and dates from the last quarter of the nineteenth century. It is made of stamped and painted tin and the crimping on the pans and the design of the fire hood show a great deal of expertise.

The little kitchen that Mrs. Ackerman dubs the German wood kitchen was bought at auction, like the grocery store, and without equipment; the original paint and patterned papers were all that remained. Its small size (10½ inches wide, 7½ inches high, and 6½ inches deep) appealed to Mrs. Ackerman because it gave her an opportunity to search for appropriate furnishings. She voices the feeling of all collectors when she says,

> One challenge of having only the room itself is the need to find miniatures with which to fill it—no easy task. Thank goodness, items are found piece by piece over long periods of time, for otherwise I might not feel I could afford to buy them. Their overall cost can really mount up, but one at a time, it doesn't seem to hurt.

A box room as small as this one (see figure 22) will even fit on a bookshelf.

Every single room or house which the Motts display in Buena Park, California, shows an incredible attention to detail. In the general store pictured in figure 23, one notices not only the old cash register on the counter at left, but the rack with mail in it at right—

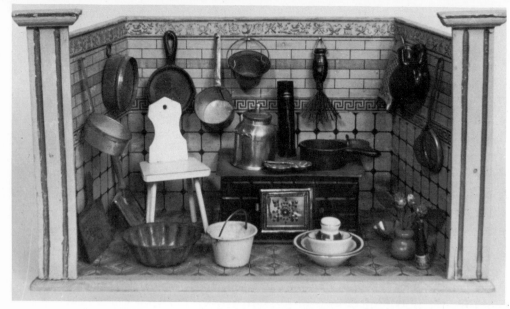

21

This German wood kitchen was a bare three walls when discovered at an auction. All of the accessories are authentic and were added later. It is thought to be late nineteenth century. Collection of Evelyn Ackerman. (*Photo by Evelyn Ackerman*)

22

This rare wooden kitchen, c. 1930, was made in Nuremberg. It is 36 inches wide at the back and 16½ inches deep. In almost mint condition, the thick lithographed wallpaper resembles blue and white tiles, the floor a different tile paper. All the basic furniture and all the accessories, except a few added pieces, came with it. The rare milliner's doll standing by the stove is c. 1820–50. Collection of Phyllis Rembert. (*Photo by Lorraine Berland*)

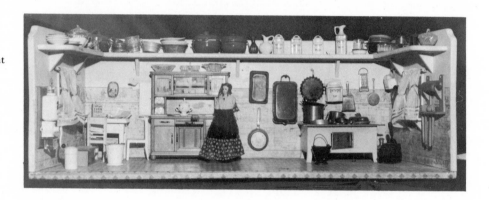

23

This country store was made by the Mott family at Buena Park, California. Notice the butcher's block table and the advertising posters, a few of which are over 100 years old. Collection of the Mott family.

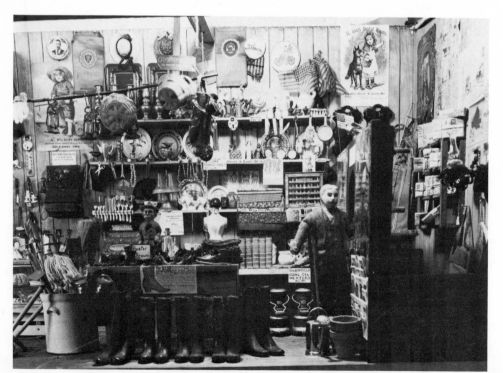

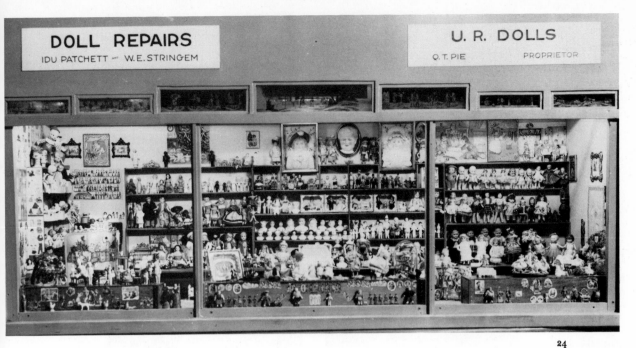

The almost incredible
detail in this doll repair
shop from the Mott
collection is ample testimony
to the lifetime of collecting
engaged in by the Mott
family. Some of the dolls
are very old, some are
contemporary—our guess is
that no one could count
them. Collection of the
Mott family.

indispensable adjuncts of any general store. Silver and china are displayed on the same shelf with yard goods and thread, while a corseted mannikin stands next an offering of Bibles. There is even a tiny pair of overalls in the right corner.

In the Mott's doll repair store, figure 24, dressed dolls, undressed dolls, doll dress patterns (left), and minuscule doll photos decorate the store. The Motts estimate that there are 300 dolls in this exhibit (some of them valuable and very old), but our guess is that they long ago lost count.

The ball scene (figure 25) demonstrates Allegra Mott's endless imagination and beautiful work. Note the exquisite work on the side walls and cornice. The forty-six pairs of dolls were all dressed by the late Mrs. Mott. In addition, she laid the parquetry floors and made the chandelier.

Diane V. Sayres is another of the exceptional creators of box rooms or, rather, room settings, and the collector might be on the outlook for any of her creations that, depending upon the amount of architectural detail, range between $300 and $500. Her rooms are all in the $\frac{1}{12}$ scale, the average size being 8 × 15 inches. Woodwork and fireplaces are constructed either of balsa or basswood or a combination of both, and the floors are made of individually laid boards. Bricks are actually made of wood; stones are separately glued in place. All of the rooms have their own picture-frame cases and are electrically lighted. Unlike most box settings, Ms. Sayres constructs realistic scenes to back up the windows and doors. Some of her rooms have three-dimensional

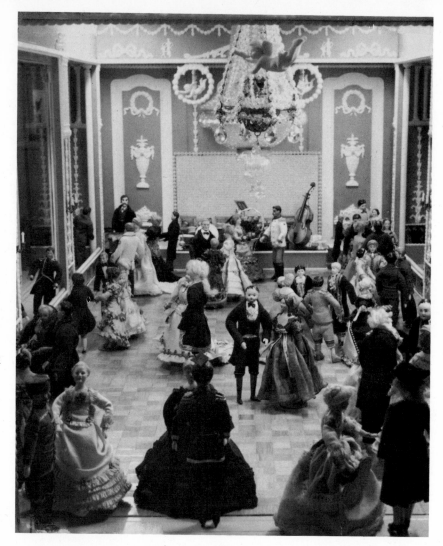

landscapes with rocks, dried moss, dried flowers, fences, whatever is
necessary for perfect illusion. They, too, are fine works of art.

Chestnut Hill Studio has created a series of shadow box minia-
tures, that can be placed at eye level on a mantel, in a bookcase, or
recessed into the wall—particularly if the box room is a larger model.

Designed on the $\frac{1}{12}$ scale, the same size as the Chestnut Hill
miniatures, these are better than a three-dimensional picture, for the
collector can create a charming little room and develop his decorator
talents to his heart's content in changing and improving. The large
rooms are 11⅛ inches high by 24 inches wide by 18 inches deep; the
smaller rooms are 23 inches wide by 10½ inches high by 10 inches deep.
We show here in figure 26 a completely outfittd store; in figure 27 a
contemporary room is shown in a box frame; and in figure 28 an 1812
hallway that features an assortment of extraordinarily elegant furni-
ture of various styles (notice the doorway with ten side-lights on ei-
ther side and recessed panels below). The landscape mural wallpaper

Box rooms are becoming more and more popular, because they are so easy to display and take up so little space. This country store, made by Chestnut Hill Studios, presents a most attractive, comparatively uncluttered scene.

27

Box room made by Chestnut Hill Studios is actually a shadow box designed to display a collector's finest pieces. It may be placed at eye level on a mantel, mounted in a bookcase, or recessed into the wall.

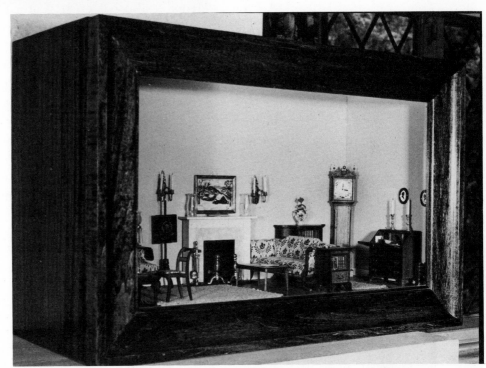

28

Chestnut Hill Studios' famous 1812 hallway is another box room that will become an heirloom piece as time goes by.

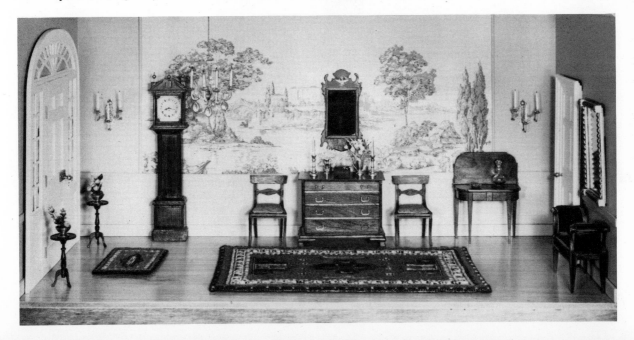

is handpainted for Chestnut Hill. Shown in figure 29 is the Chestnut Hill 1848 music room.

Susan Hendrix of Gardena, California, is a "collector's collector." She has been acquiring valuable small pieces for a number of years and, in addition, she can make practically anything she wishes (her husband builds the shells of the shops). Figure 30 pictures a glass and china shop, with the glass shop on the main floor and the china shop on the balcony. Notice the staircase at the right of the photo, placed exactly as though a customer would be climbing up to the balcony to look at a piece of china. Note, too, the step ladder outside the door on the left, provided in case a proprietor has to reach something on a high shelf.

Susan Hendrix also has created an Oriental shop, which is a particular favorite of mine. Mrs. Hendrix has been collecting ivory and jade miniatures for some years, and this charming shop, shown in Figure 31, was designed to display them. Notice the central panels, both above stairs and below, which serve to break up the feeling of clutter that might result from the display of so many small pieces. Note, too, the mosque that furnishes a focal point, and the two pagoda-like structures that serve as display cases. The viewer yearns to enter the shop and handle all of these minuscule masterpieces. The "stock" in both shops is composed of one-of-a-kind treasures; one can only guess how much traveling and how much time went into finding them.

29

The shadow box displaying the 1848 music room is especially fine. The piano is a copy of one of the Cowles', bearing a tuner's date of 1848. Made by Chestnut Hill Studios.

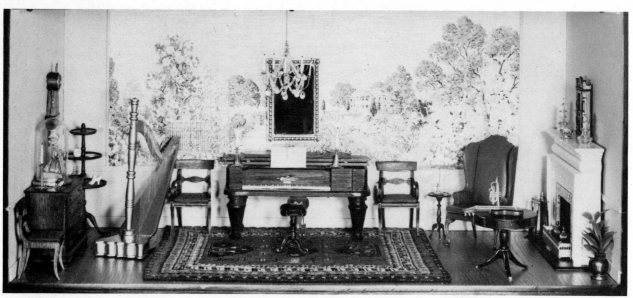

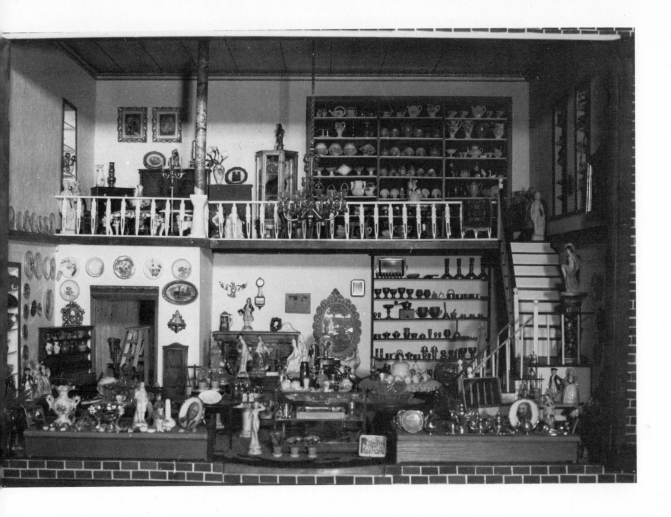

30 & 31

Two box room shops made by Mrs. Susan Hendrix exemplify the effect that every collector would like to achieve. Notice that both are quite tall, and the balconies are used to break the line from floor to ceiling.

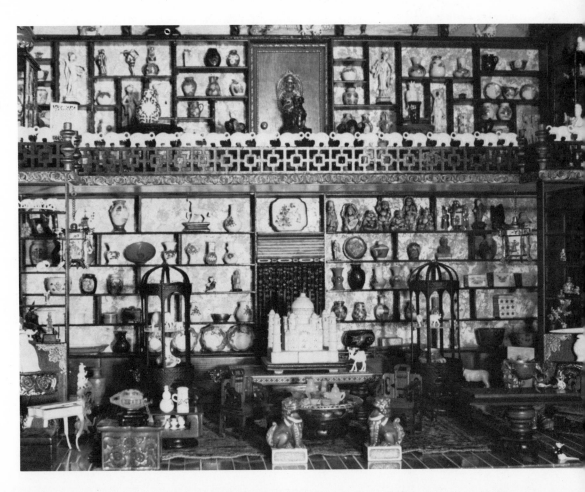

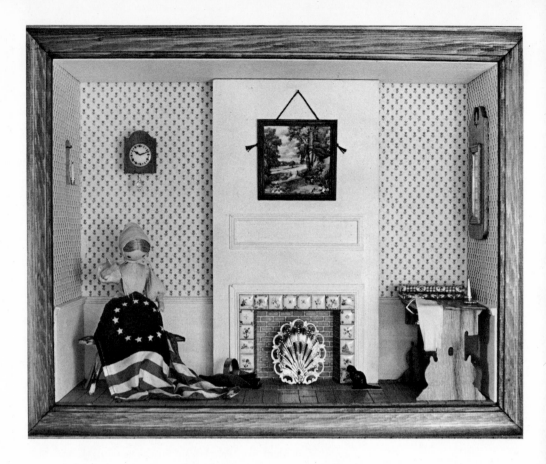

"Americana in Miniature"
shadowbox rooms are
11" × 14" × 5" deep, and
are handfinished in maple,
walnut, or mahogany. The
glass front may be removed
for adding your own
accessories, if you wish.
From the Lilliput Shop.

The Betsy Ross Bi-Centennial Commemorative Shadow box is shown in figure 32. It is one of a series of shadow boxes entitled "Americana in Miniature," and is made by Marjorie Geddes of the Lilliput Shop in Beaverton, Oregon. It is a numbered piece limited to not more than fifty. "Betsy," a handmade cornhusk doll from Czechoslovakia, was chosen for her starring role in this production because Mrs. Geddes feels that the cornhusk dolls are more truly American than other varieties. Every piece in the room was chosen after much researching of Betsy Ross's own home. The tiles around the fireplace are handpainted and kiln-fired. The hardwood flooring is pegged as it was in Revolutionary times. Each box is glass enclosed, dated, numbered, and signed by the artist.

An example of the ingenuity of dollhouse collectors is shown in Mrs. Marjorie Walrond's three-room house made in a tiny galleried corner shelf (figure 33). The kitchen displays very old iron furniture; the drawing room, an old iron sofa and chair; the third shelf is the bedroom, furnished in stenciled rosewood. Notice the simulated windows, the leaded glass chandelier, and the tables.

A collector with a great deal of space at his disposal might construct a whole street of shops, as H. W. Pirie did, spending his time and money on acquisitions for a post office, an antique shop, a ware-

house (an accumulation of things that can't be used elsewhere makes, oddly enough, a most interesting display), a barber shop, a tonsorial parlor, a bakery, a dress shop, and a flower shop. John Blauer of San Francisco has concentrated his efforts on just one or two box rooms, most prominently his tonsorial parlor, which is a most elegant demonstration of the luxury of the gay nineties. "Entrance to Carter's Grove", (see color plate 6) a replica of the impressive entrance to the famous Virginia mansion, is a 1/12 re-creation by John Blauer and his wife, Ellen, who is a famed miniaturist in her own right. Taking almost a year to complete, the room was created in black walnut paneling with careful attention being paid to finding wood with the correct scale grain. Mrs. Blauer reproduced the Carter's Grove chandelier and clocks, and also the lustres in the original mansion. The furniture represents the skill of several of the artists employed by the Blauers in creating miniature shops and settings. Eugene Kupjack, another great miniaturist, is creating a series to be titled "Famous Bedrooms in Miniature."

A shadow box or one-room house with the Winbon hallmark on it is a considerable acquisition. All of Winbon's creations are one-of-a-

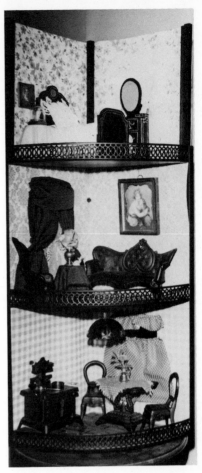

33

An example of the ingenuity of dollhouse collectors is shown in this three-room house made in a tiny galleried corner shelf. The kitchen displays very old iron furniture; the drawing room, an old iron sofa and chair; the third shelf is the bedroom, furnished in stenciled rosewood. Notice the simulated windows, the leaded-glass chandelier, and the tables. Collection of Marjorie G. Walrond.

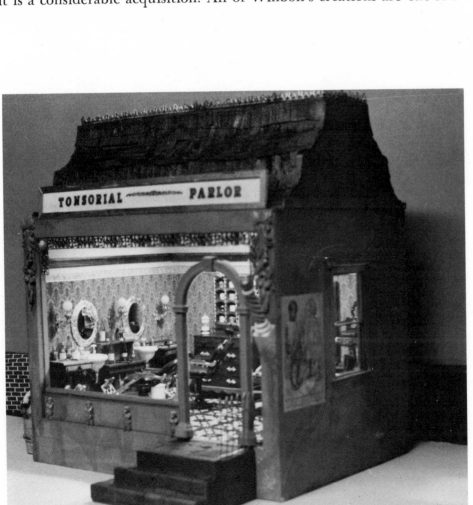

34

One of the most elegant examples of a room-in-a-box is John Blauer's replica of an 1890 Tonsorial Parlor. The attention paid to detail within the room, the carving on the outside walls, and the mansard-shaped roof all help to create the feeling of authenticity.

kind and, consequently, expensive. Their value will appreciate as time passes. One of their creations consists of a five-room house, designed and executed by Mrs. James Ward Thorne. For this dollhouse, a price was never set; they merely ask for offers. Their "Becky's Toyshop," a shadow box of tremendous depth and vitality, seems to sell out as fast as it is produced. A two-story shadow box, which is the home of Mr. and Mrs. Mouse, shows a great deal of action. Mrs. Mouse is preparing a pie for dessert, and a turkey roasts in the oven of the corner stove. In another Mouse house, a country one-story version, Mr. Mouse has just come in, rabbit and gun in hand, and all the clutter of supper preparations is apparent on the kitchen sink. Both box houses have hinged glass fronts and are ready to hang on the wall or be displayed on a shelf. In addition, their price is not prohibitive. Winbon makes a variety of fireplaces, too, if you are building your own dollhouse; their baker's oven shows an oven above the fire opening, complete with a little wood door.

From the collection of Mrs. Vincent Mastrovito of Alexandria, Virginia, whose home is a veritable museum of fine miniatures, both contemporary and antique, the following rooms were selected because they offer the collector a splendid opportunity to see what might be found in the market today. The bedroom shown in figure 35 is notable for its chandelier, the brocaded draperies that hang so beautifully,

35

Bedroom from the Charlotte Mastrovito collection holds furniture well worth studying. Made by an old craftsman who has since passed away, John Blauer believes that his work is becoming valuable. (*Photo by Mrs. Mastrovito*)

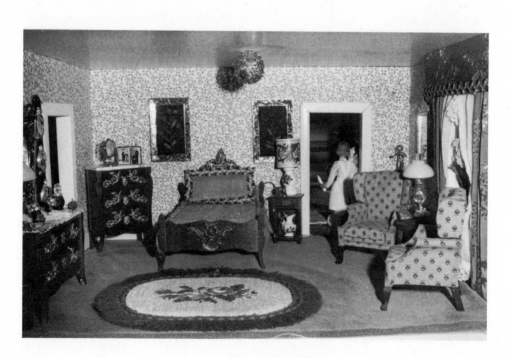

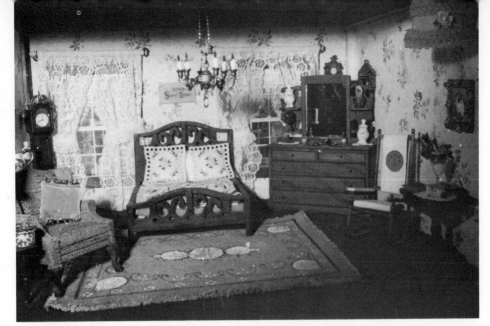

36

Another bedroom from the Mastrovito collection with furniture made entirely by Marty White. The furniture pieces, c. 1920, are made of oak. The dresser, with its "what not shelf" mirror, is particularly noteworthy. (*Photo by Mrs. Mastrovito*)

37

The bachelor's bedroom is particularly notable for its shirred Austrian curtains and the beautiful "mini-print" draperies, spread, and cornice. All the furnishings were made by Mrs. Mastrovito. (*Photo by Mrs. Mastrovito*)

and the furniture with magnificent brasses. Since its creator has passed away, it has become a true collector's item. The chairs are Linfield wings. Mrs. Mastrovito reports that she bought the first in 1968 for $3, found a matching one in 1970 for $5, came across a third in 1971, for which she paid $10, and just recently paid $25 for a fourth.

The bedroom furniture in figure 36 is also worthy of study, particularly the Victorian dresser in the corner. The bed and dresser, c. 1920, are made of oak. The pillows are sachet bags.

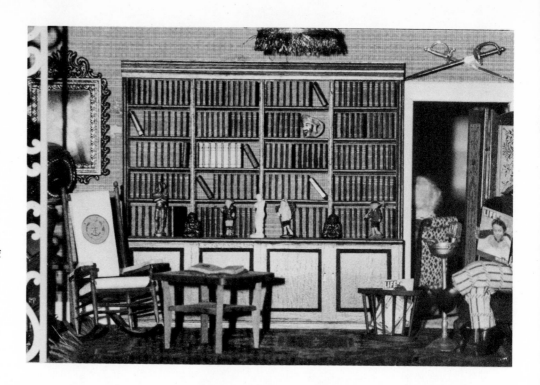

38

The Mastrovito library
houses an impressive
collection of miniature
books. The doll in the
doorway is simply a device
to convey the impression of
another room. The Toby
mug on the shelf is by
Frieda Leininger.

Mrs. Mastrovito's bachelor bedroom, figure 37, is one of our favorites. Although the miniatures are not particularly rare, their use shows great ingenuity. Most of the furniture is from Shackman except for the dresser, which is a Petite Princess piece. The pewter chandelier was a modest piece that came from Shackman, but the collector has turned it upside down, sprayed it gold, and added glass "globes" (beads).

Mrs. Mastrovito's library room (figure 38) is distinguished by a one-of-a-kind copy of the Kennedy Rocker that was made by a Washington craftsman. The Toby mug on the shelf was made by Freida Leininger.

3

Foldout and Paper Houses

FOLDOUT HOUSES IN THE FORMS OF BOOKS OR BOXES OFTEN CAN be found at auctions, old book shops, flea markets, and in book fairs. They are usually in good condition; they seem to have been cherished by their small owners. Foldout houses recently have been revived by the Hallmark company, who makes various versions that sell at about a dollar. The foldout house pictured in figure 39 features a living room with a standing fireplace and settee. In addition, the dining room folds out, and has dining chairs and a rocker to cut out. The kitchen has more foldouts and more cutouts, including father, mother, and a cradle. In the bedroom, a door opens to show the hallway beyond.

In addition to the Hallmark modern version, we picture two other dollhouse books published by the Merrimack Publishing Corporation that are extraordinarily successful copies of antique books. Here the yellowed effect of age on the cover is beautifully reproduced, as is the printing on the inside. Dolly's Mansion, of which the author has one of the originals in her collection, is particularly interesting. The dining room and pantry, unlike the remainder of the house, were produced in sepia tones. Figure 41 shows the kitchen with the cat watching the broiling pan. Another foldout house pictures a linen room, with boiling water in the cauldron, one maid handling the irons, and one little maid sweeping the floors. These foldouts are all

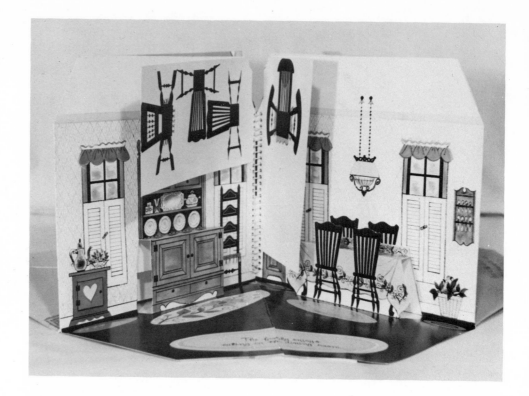

available in reproduction from the Federal Smallwares Corporation in New York.

Another collectible that was in high esteem in grandmother's time, and seems to be coming into its own again, is the paper house that is put together from a flat piece. Actually, these are not dollhouses; the doors don't open, the windows aren't movable, no family ever treads the stairs or enjoys the pleasant rooms that come to mind as one views the outside of the house. There are no rooms. Paper houses are not children's toys; they take concentration and large reservoirs of patience and dexterity before they're brought to completion. However, they will afford may afternoons of pleasure to collectors who will no doubt start out with one building but go on to a streetful of the tiny houses.

A great many paper houses come from Germany; the castle photographed in figure 42 is one of these. A line has recently been launched by 101 Productions of San Francisco that includes such favorites as the Dickey House in Tiburon, California, the John Muir House in San Francisco (also shown in figure 42), the Captain Penniman House in New England, and St. Paul's Trinity Chapel in New York. St. Paul's is on a 1/16-inch scale, as is the castle from Germany; smaller structures are on a 1/4-inch scale. Like the dollhouse books, these for some reason don't seem to have been generally popular, and

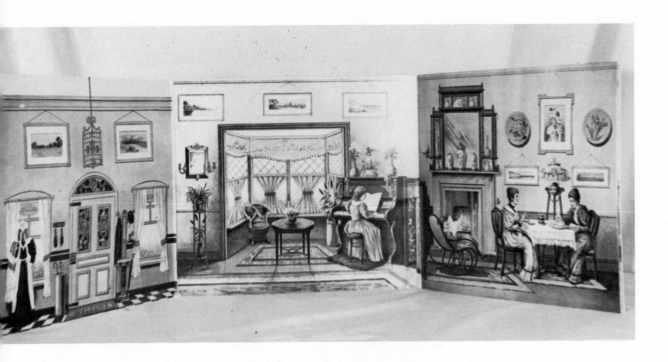

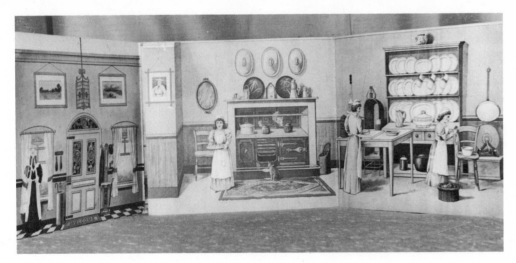

40 & 41

Fold-up cardboard dollhouses were a favorite toy in the days of Queen Victoria. They are printed today in Germany and exported to American companies. The one shown, an original in the author's collection, is also offered by Federal Smallwares in a contemporary edition. Opened on a table, the first view shows the dining and living room, then another opened page shows the kitchen.

the collector will have to search for them through book stores and craft shops. Williamsburg structures, however, are readily available and may be ordered direct from the Craft House at Williamsburg. They are extraordinarily beautiful (see figure 42). The lithographed cardboard seems more sturdy in the Williamsburg structure than in other paper houses, and one has the impression of more permanence.

Paper houses produce a great deal of satisfaction and pleasure when finished. Because of their perishability, however, collectors should take especial care of them. We know of three separate instances

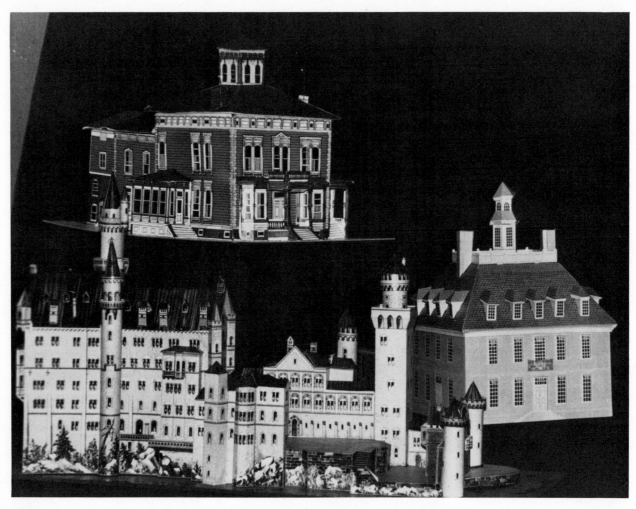

42

Examples of three
cardboard houses available
for the collector: top, a
model of the John Muir
House by 101 Productions
of San Francisco; bottom
left, Castle Schloss
Neuschwanstein from a
German firm; and right, the
Governor's Palace at
Williamsburg. They make
an enchanting hobby and
could form the nucleus of
a fine collection.

where European castles, intact and uncut, have been found at dispersal sales; two of them were dated 1899 and one 1904, and they are valuable today.

In 1925 a folding dollhouse was produced by the Dowst Brothers Company of Chicago that surpassed them all—the Tootsietoy Doll House. These were made expressly for children of what was then called container board; today it is called corrugated. "Very substantial," the 1925 catalog reads, "and no breakage."

Unlike the castles and mansions described earlier, Tootsietoy houses had everything. To quote the catalog again, they were "painted in seven colors, with oil paint; all are washable. Inside is fully decorated with curtains, rugs, pictures, tile in the bathroom, linoleum in the kitchen." The complete house folded into a sturdy carton only ½-inch high, and the house could be set up in minutes by merely pressing on the ends and inserting a few metal fasteners.

The house shown in figures 43a and b, front and back elevations, is from the collection of Mrs. Evelyn Ackerman; considering the fragility of this cardboard building it is in a remarkable state of preservation. Figure 44 shows the imprint that was on every authentic Tootsietoy house. Mrs. Ackerman's version is without doubt the one described in the 1925 catalog: "A reproduction of a fine brick Colonial home, the most complete ever shown at a popular price." In its 1930 catalog, the Dowst company presented a new Spanish Tootsietoy mansion,

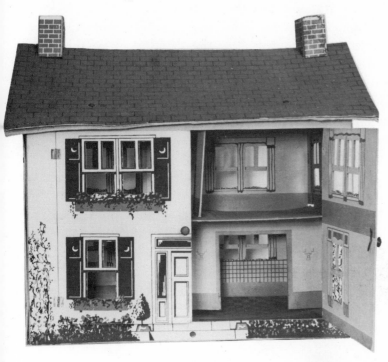

43a & b

An original Tootsietoy house, c. 1925. This version is 17 inches wide by 17 inches high by 11 inches deep, with the height measured to the top of the chimneys. Collection of Mrs. Evelyn Ackerman.

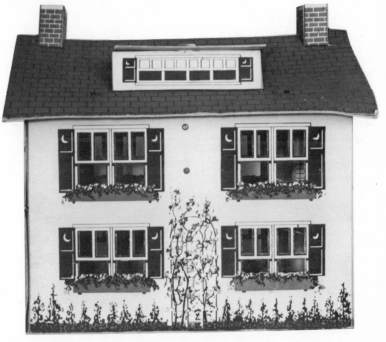

designed by one of America's greatest architects who specialized in the Spanish type of architecture. True to type and with every detail carefully worked out to make it not only strong but easy of assembly; we consider this the finest house five dollars can buy.

It was at this time that Tootsietoy began to offer metal furniture, and they offered it with a vengeance; there was nothing that the chatelaine of a Tootsietoy house could wish for that couldn't be found in a Tootsietoy box (see figures 45, 46, and 47). There were "large sets" and smaller sets, although the word "smaller" was never used. The bedroom suite in the large set was offered in gilt, oak, mahogany, pink enamel, or blue enamel. Kitchens and bathrooms were offered in the beginning only in white enamel, but as the demand grew, these were offered in red, rose, gilt, purple, blue, and green. Cars, trucks, trains, and train stations came upon the scene, and it is plain to see that the average Tootsietoy family lived in style. The sedan came in an assortment of bright-colored enamel finishes, and the Ford touring car was available also in the bright enamel, plus a bronzed windshield and disc wheels. An assortment of candelabras was also offered, as well as a 2¼-inch Statue of Liberty that, oddly enough, is still encountered fairly frequently when a collection is dispersed.

Mrs. William Henderson, who is the founder of the Doll House Museum at Big Bear Lake, California, has collected the Tootsietoy furniture since 1936. She reports that in that year she purchased a collection of 1932 Tootsietoys at auction, including dining room, living room (complete with baby grand piano), bedroom with twin beds, and a complete kitchen for $5.95. The kitchen alone was recently listed at $39.50—not including the ice box! The baby grand piano was recently sold for $32.50. At a recent dispersal of a collec-

44

This is the Tootsietoy trademark, which a collector should insist upon seeing when he finds a house offered as a genuine Tootsietoy. From the Evelyn Ackerman collection.

45

This Tootsietoy bedroom set, c. 1930, shows the ravages of time but is cherished nonetheless. The metal version, unlike the original wood, seemed unable to hold the paint permanently. Collection of Laura Ackerman. (*Photo by Evelyn Ackerman*)

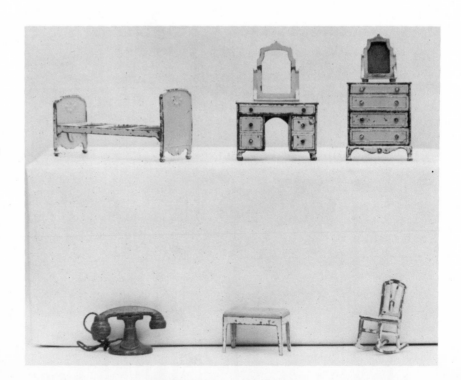

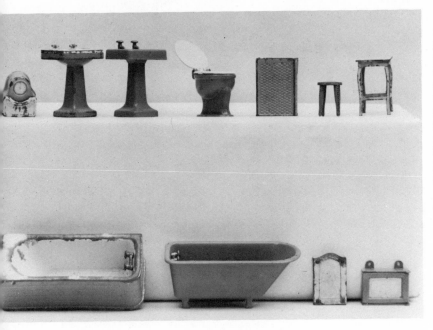
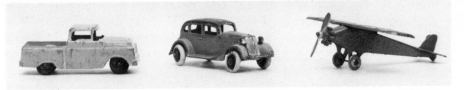

46

Tootsietoy furniture, which is available to the collector today, almost invariably is in the state of disrepair shown in these photos. However, its value continues to rise, and the decision as to whether or not to refurbish must be made by the new owner. These pieces are from the Laura Ackerman collection. *(Photo by Evelyn Ackerman)*

47

Demonstrating the completeness of the world in which the Tootsietoy family lived are these adjuncts for "keeping up with the Joneses." From left, the truck, four-door sedan, and private small plane date from the 1920s. Collection of Laura Ackerman. *(Photo by Evelyn Ackerman)*

tion, the author declined a bath set listed at $35.00 because of the poor condition of the pieces.

The 1932 Montgomery Ward catalog lists a variety of Tootsietoy houses from $.95 to $1.89; the $1.89 version even has a staircase. Listed also is the metal furniture at $.69 per room (seven pieces to each room, nine to the bath).

Unfortunately, the Tootsietoy furniture also was fragile, but the collector will sometimes encounter entire collections. A collection such as that of Mrs. R. B. Snyder of North Palm Beach, Florida, is very rare. The collector can familiarize himself with the pieces by studying figure 142 which shows her "Casa Tootsie," built to accommodate a collection that had long outgrown the regular Tootsietoy houses. Mrs. Snyder reports that at a recent auction she saw Tootsietoy bathtubs in a most hideous purple snatched up at $15 each, and she took great comfort from the thought that at home she had four that she, in a flash of foresight, had bought at about $5 each just a few years ago.

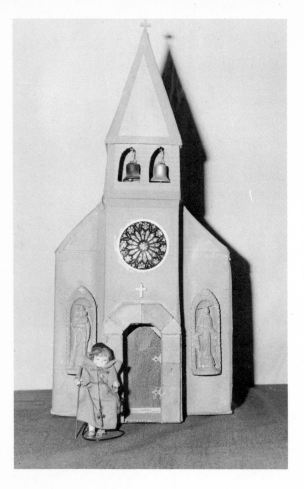

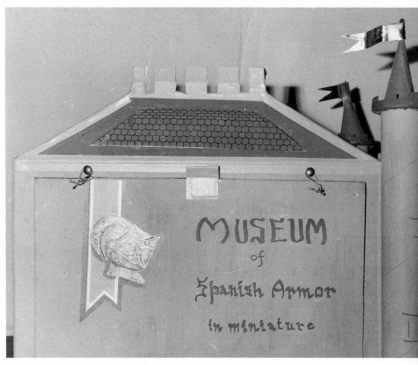

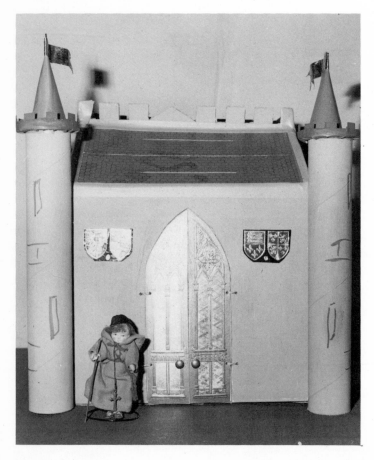

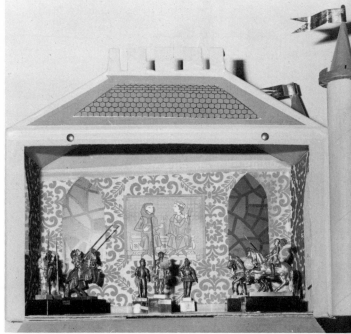

48, 49, 50 & 51

Dr. Jacquelin MacNaughton's creations from corrugated cartons are stunning not only because of their effectiveness, but also for the precision of the scenes they portray. Here we see first the chapel, then the entrance to the "Museum of Spanish Armor," then an inside door complete with a monk as guard, and finally the museum itself. (*Photos by Dr. MacNaughton*)

4

Corrugated Cartonia

WE HAVE NEVER COME UPON A REALLY OLD DOLLHOUSE MADE from a corrugated carton, in spite of an intensive search. Dr. J. A. MacNaughton, a lively lady who formerly taught at Hunter College in New York, is fascinated by medieval customs and so has fashioned a group of ex-cartonia. "That means," she once said, "I made them out of cartons I got at the A&P." (See figures 48–51.)

Intrigued since childhood by "Idylls of the King," Dr. Mac-Naughton used the dolls from her dollhouse to create knights, ladies, and pages, a Saracen, a Viking, and a wicked woodsman, plus many others. Catsup bottle tops were silvered for helmets; a coat of mail was fashioned from a silver mesh evening bag; the gallant steeds were originally toy firehouse engine horses. Caye MacLaren, writing in the fall 1971 issue of *Nutshell News*, adds that a Ballantine beer can was cut up to make a shield for a knight. Then, of course, she had to have a chapel, also made from a carton, and this was finished complete with a stained glass window from a Christmas card. Also, she made a re-viewing stand for the lady and her attendants, tents for the knights . . . every collector knows the way it goes. Recently, she made a cat's house out of cartons, and was deluged with orders.

H. W. Pirie, in his shop maintained for the Animal Protective Association of Missouri in Ladue (a suburb just outside of St. Louis), has done much the same thing. His project began as a vague idea to

Edith's Florist Shop
demonstrates the great
effect that may be achieved
with corrugated cartons.

construct an entire street of houses to amuse children who came into
the shop. Today, it begins with a post office at one end and continues
down through a warehouse, antique shop, barber shop, pharmacy,
bakery shop, Gene's Modiste Shop, and Edith's Florist Shop (figure
52). These are masterpieces so precise in their detail that it's not
likely they will ever be available to the collector, but they do give a
splendid idea of what may be achieved by the collector who has al-
ready amassed a number of miniatures. Mr. Pirie had collaborators on
this project who were not only foremost in their field, but also were
devoted to him. In the general store, Elsie Sullivan, proprietor of
Elsie's Doll House shop in St. Louis and a well-known collector of
antique dolls, houses, and miniatures, lent a hand, as well as in the
antique shop and the barber shop. Mrs. Pirie not only helped deco-
rate the bakery shop, but baked all the little goodies displayed there.
Edith Mason, a nationally known landscape architect and chief de-
signer at Missouri Botanical Garden, designed and helped furnish the

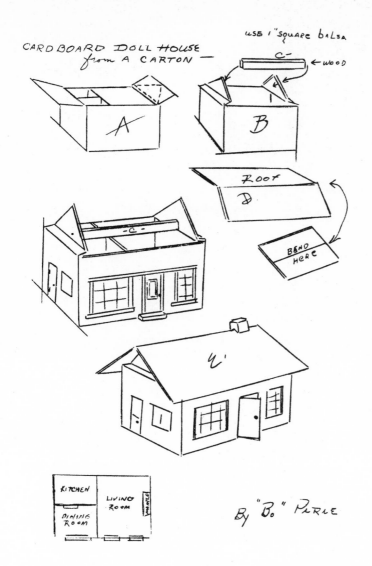

CARDBOARD DOLL HOUSE
from A CARTON —

USE 1" SQUARE BALSA

A

B

C ← WOOD

ROOF

D

BEND HERE

4'

KITCHEN | LIVING ROOM
DINING ROOM

By "B." PIRIE

53

H. W. Pirie's sketches for the basic work on a cardboard house. Single cartons may be divided into rooms as shown, or each carton can be used as a single room and put together to form a house.

florist shop. Gene Trammel constructed and furnished Gene's Modiste Shop as well as the box room shown on page 35. Collecting for the rooms has covered twelve years.

Figure 53 consists of Mr. Pirie's sketches showing how to make a dollhouse with a corrugated carton, just in case you haven't found such a house or room in your collecting rounds. You'll find satisfaction in creating one yourself—in this way your house really will suit your purpose. Another idea is to start with a "found" house or a commercial house, such as the one shown in figure 54, from the author's collection. This is a commercial house with six rooms and an open back and sells at around $75 to $100. The little wing shown at left of the house is a corrugated carton used as the kitchen; note how it "belongs" to the house. Another similar wing was later added at the

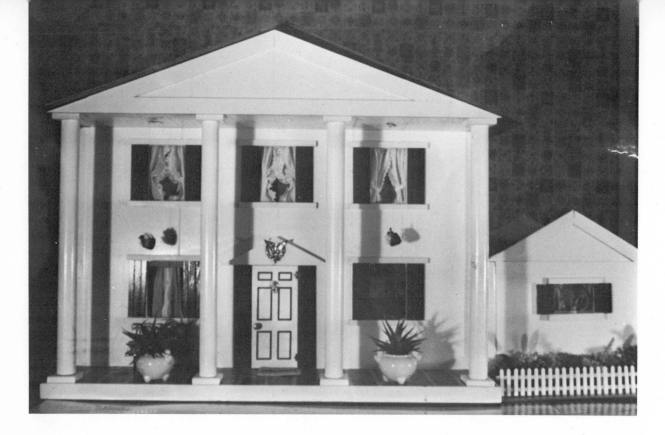

54

The plantation house, Tara, is shown here with a kitchen wing made from a corrugated carton in place. Notice how well this blends into the main building, producing a most pleasing whole. From the author's collection.

other side of the house (many large plantation houses were enlarged in this fashion in the late eighteenth and early nineteenth centuries) to house the music room. Figure 55 shows the music room completed; note the peak in front that is reinforced with balsa wood strips, and the scenic wallpaper that was actually painted by an artist in Connecticut. This was glued directly onto the corrugated board. The miniatures in the room are discussed in Chapter 13.

55

The music room of the plantation house is also made from a corrugated carton. Notice that "vines" have been planted that give a "lived in" look to the complete house. Doors between these additions are cut into the walls of the main house, thus furnishing a passageway for the inhabitants.

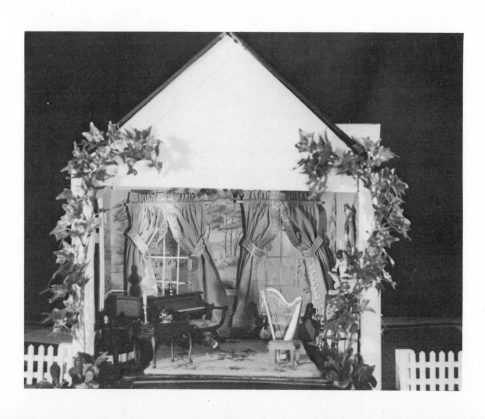

5

Dollhouse Classics

RARELY DOES A COLLECTOR SET OUT ON AN ACTUAL SEARCH FOR a dollhouse. For one thing, where would he begin? And for another, what would he look for? And, having found one that physically suits his purpose how would he know that it will be one he will enjoy living with, adding to, and keeping alive in the years ahead?

The truth of the matter is that doll-size houses are exactly like people-size houses, in that they take on a personality as they age. I have yet to see a collector buy a new dollhouse in a store, unsmudged by the fingers of long-gone children. Older dollhouses, on the other hand, tend to captivate collectors much in the same way Phyllis Rembert was captivated by her house (figures 3 and 4). She felt that no amount of trouble was too much to take as long as she was able to acquire that particular house.

Others do not have the zeal of the antiquarian, and for us a lovely new house, if it is gracious and of good proportions, is exactly right. It may not captivate us at first sight as do the old ones, but we see its possibilities and are eager to use it as a base for creating something original. The personality will come later, as our prized miniatures are installed and the right family is added.

Price has nothing to do with personality; we all know people-size houses of imposing stature, furnished with exotic pieces that have been culled from the four corners of the world, and that have little

personality, and, conversely, we've all entered modest homes that struck us at once with their warmth and ingenuity, even though they were furnished with cast-offs. It is exactly the same with dollhouses. One house that comes to mind is the Newbridge Dollhouse, which stands in the great entrance hall at Leixlip Castle in County Mayo, Ireland (figures 56 and 57). This is the first sight that greets the visitor, and has been a part of the castle's furnishings for more than 200 years. The Hon. Sir Desmond Guinness, president of the Irish Georgian Society and present owner of Leixlip and the dollhouse, writes us:

> The Newbridge Dolls' House is of truly enormous proportions. It must have been used in part as a nursery cupboard; utilitarian shelving is concealed behind the upper windows, and the front door is suspended in mid-air above two rows of drawers. The main floor consists of three rooms, two of which have black fire surrounds (fireplaces) of the simple, plain kind that are often found in bedrooms of Irish houses. The front hall has a chair rail of mid-eighteenth century type, and there is no staircase—the upper floor would in any case, have been out of reach. There is no other decoration on the interior apart from scraps of wallpaper that are now rather the worse for wear, and the remains of paper borders that have seen better days.
>
> Vivien Greene, the wife of the famous writer, . . . and the acknowledged expert in this field, on first seeing the house was so overcome with its beauty that she dropped to her knees before it, transfixed, as if in a trance. She then made it absolutely plain that on no account was anything to be touched, re-painted or altered in any way, and her wishes are law so far as this owner is concerned. . . .
>
> The exterior of the house has been marbelized and also at some stage painted in squares to resemble ashlar. The paintwork is erratic and it would be tempting to give it a coherent style at present sadly lacking—but in deference to Mrs. Greene, it has been left untouched.
>
> When my daughter, Marina, was little and there were some visitors to see the castle, we were astonished to find a notice board written in childish hand proclaiming, "Visit the Dolls' House only one shilling samwich extra!"

This is a house that exudes personality; it is not any one detail that draws us to it, but the sum total of all the details, of all the evidence of loving care that has been lavished on it through the years.

Another example is the quaint old house from the collection of Mrs. Jean Schramm, pictured in figures 58, 59, and 60. This is pure Victorian and she writes that it was purchased in 1966, just after she

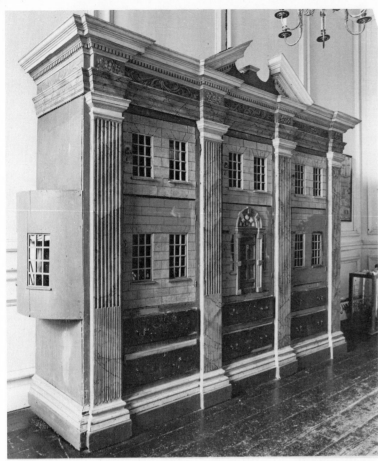

56

Newbridge Dollhouse, built in 1737 for the children of Thomas Cobbe, stands on a cupboard of drawers and has no stairs to reach the handsome front door and no stairway inside to the second floor. The rather ugly bay at left was probably added in fairly recent years. Collection of Hon. Desmond Guinness. (*Photo by J and S Harsch, Dublin*)

57

The front door of the Newbridge house is celebrated throughout Ireland for its simple beauty. The squares, which resemble stones, are merely marked into the paint.

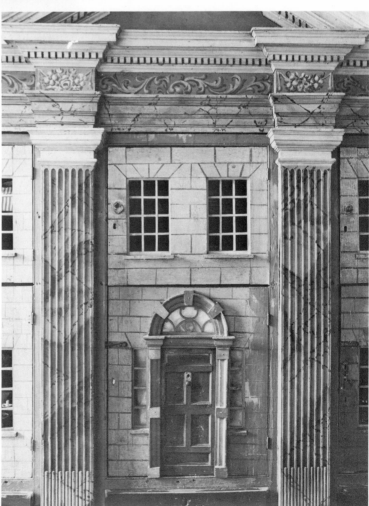

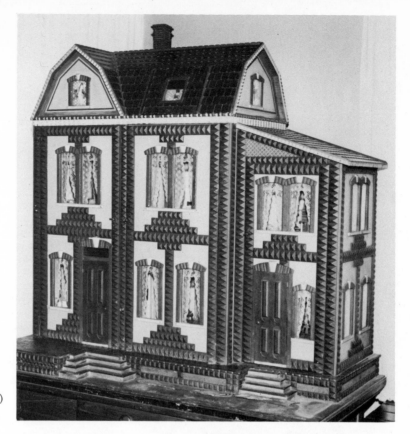

58

This dollhouse,
c. 1870, comes from a
Massachusetts estate. Notice
the elaborate beading
around the joints, the
drawer for storage in the
front of the stand. Collection
of Mrs. Jean Schramm.
(*Photo by Mrs. Jean Schramm*)

had opened a shop in one room adjoining her 1812 life-sized colonial house. She had become known to dealers through her buying for the shop; one such in eastern Vermont called simply to say that she had something very interesting. All she was able to learn was that it had come from a Massachusetts estate; the dealer had been told that it dated from 1870, but she found later that a smaller one of the same design was illustrated in the F.A.O. Schwarz catalog of 1897.

This was what we defined earlier as a "pure" house; the parquet floors, wallpaper, and curtains are originals, as is the furniture. She has touched nothing in the house itself, feeling that its charm derived from its years. Now she keeps it in her shop in Manchester Center, Vermont, for her customers and their children to enjoy. The visitors are told that the current family, bisque dolls c. 1910, live in Grandma's house.

Because Mrs. Schramm has preserved the house intact, it is valuable as a depiction of Victorian life. It shows us the wallpaper that was in use 100 years or so ago, and the inlaid floors are also typical of the period. No attempt has been made to beautify the house; some of the furniture, as a matter of fact, is downright ugly. The breakfast set in the kitchen is heavy and dark and the furniture in the bedrooms above is of the period that is often referred to today as "Ugly Victo-

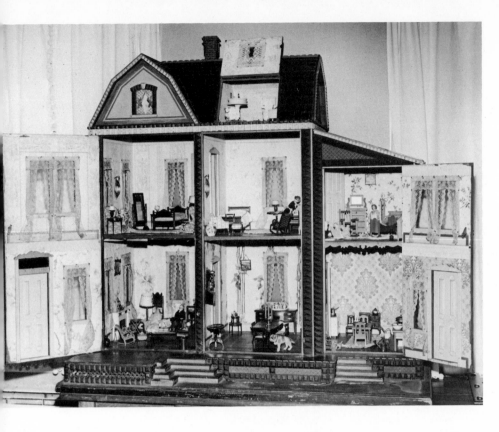

59

Wide-angle view of the house shows the way the front opens to allow entrance for the inhabitants. The room at the right might well be a separate apartment, often called the "mother-in-law house." The pugnacious pup in the living room is further testimony to the date of the house. (*Photo by Mrs. Jean Schramm*)

60

A close-up of the six rooms reveals that some of the furniture is contemporary, some from the same period as the house. The wallpaper and lace curtains have come through the years in a remarkable state of preservation. (*Photo by Mrs. Jean Schramm*)

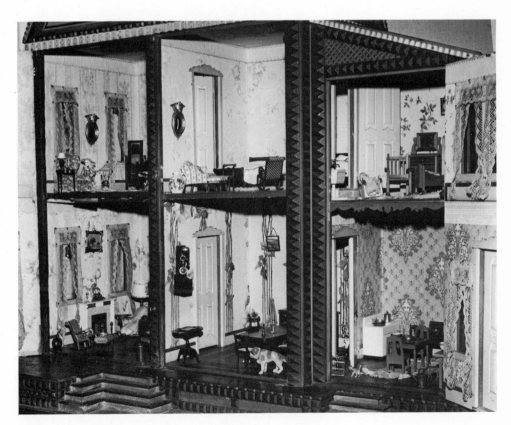

rian." However, notice how carefully the doors are paneled and the way the outside ornamentation has been worked into the overall design.

The Woodbury house (figures 61 and 62), from the collection of Catherine B. MacLaren, is almost identical to the Schramm house, bears the same date, but was acquired from an estate in California. It is fascinating to ponder the reasons for two such near-duplicate dollhouses, found at extreme ends of the continent. Mrs. MacLaren assumed the house with all of its furniture, but is not certain that it dates from the house's beginning. The Baxter prints on the walls are undoubtedly from the late nineteenth century and Mrs. MacLaren has traced others to 1905. The living room is furnished with authentic old pieces (note the chandelier with Bristol glass globes) and the whatnot is decorated with Dresden medallions. Mrs. MacLaren repapered the house in papers of the same period, since she didn't care

61

The Woodbury house is what collectors call a "sister house" to the preceding Schramm house, because of the many identical details. It measures 43 inches high by 33 inches wide and 20 inches deep. Ceilings are 14 inches high—the same as in the Schramm house. Collection of Catherine MacLaren. (*Photo by Robert West*)

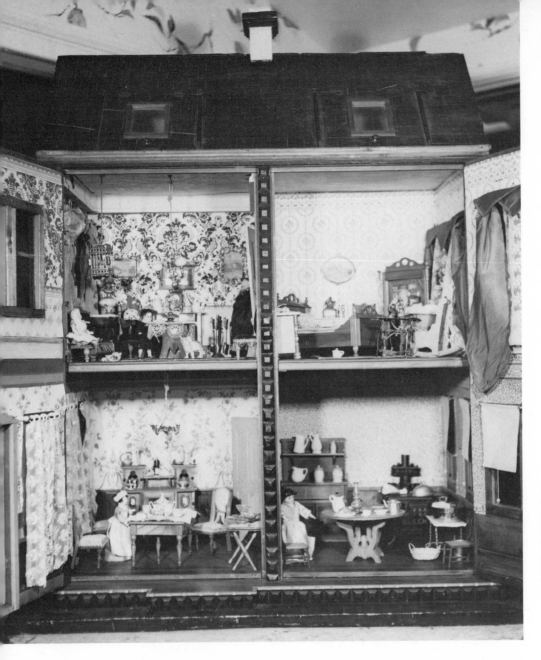

62

The details in the
Woodbury house are
important, including the
Baxter prints on the walls.
Some of the furniture is
probably later than the
house. (*Photo by Robert
West*)

for the original papers. It is most interesting, from the collector's
viewpoint, to note that the bedroom furniture, which the owner char-
acterizes as "golden oak with marble tops," is identical with the bed-
room set shown in figures 156, 157, 158, which is a set of reproduc-
tions by Americana Designs, a miniature venture headed by Dot and
Bob Farnsworth. Again, one wonders how it came to be that the Farns-
worths, who researched their miniature designs so carefully, should
have come across the very pieces that had been placed in this little house
a century ago.

The next house (the Penz house, figures 63, 64, and 65), also c.
1870, is now in the Henry Flagler Museum in Palm Beach, Florida,
and might also be a contemporary of the Schramm and Woodbury

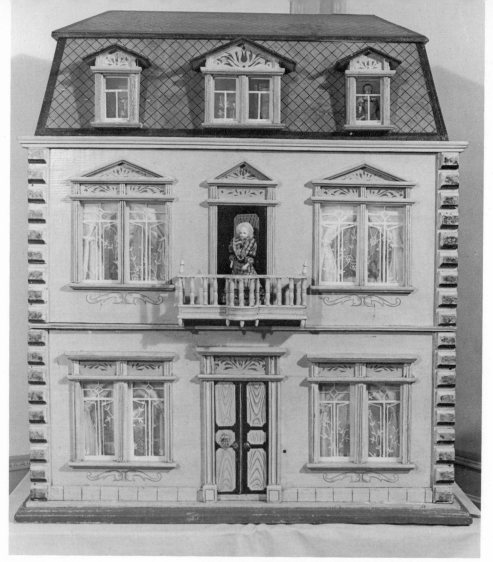

63

This house, c. 1870, now in the Henry Morrison Flagler Museum in Palm Beach, Florida, might well be a companion house to the Victorian example from Mrs. Schramm's collection. It is painted in two tones of green and the front opens in two sections. The upper part of the roof lifts off to reveal the third story. (*Photo by Lee Brian*)

64

The interior of the Penz house seems to indicate that the furniture was all made by the same person. Note the similarity of the armoire in the upstairs bedroom and the Victorian cupboard in the dining room, and that between the base of the dining table and the one in the corner of the sitting room. The cabinets and marble tops on the furniture are from the third quarter of the nineteenth century. (*Photo by Lee Brian*)

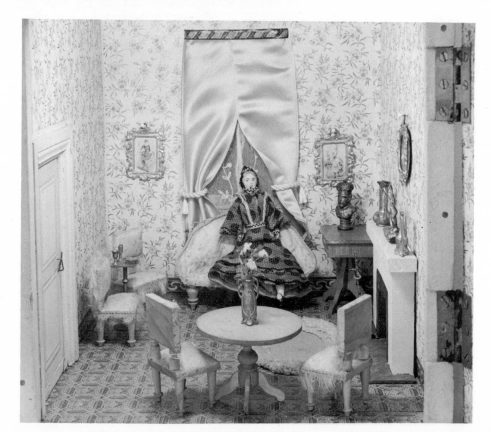

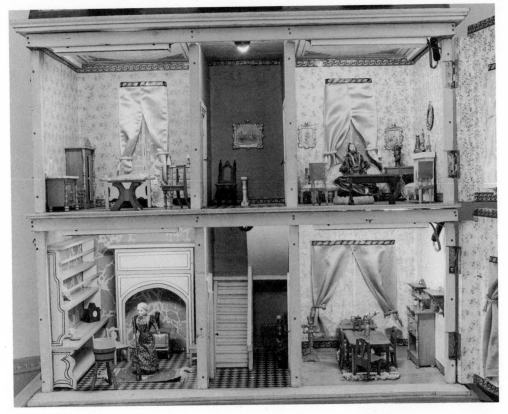

65

Satin draperies seem to have been added at a later date in the Penz house, as was marbelized wall covering in the kitchen. The wallpapers, however, seem to be the originals . (*Photo by Lee Brian*)

houses. The mansard roofs tie them together, as do the double windows that were characteristic of Victorian homes. Notice, however, the additional fine points of the Penz house; every pediment is an example of very fine hand decorating. The doors in the Penz house are more elaborately paneled than those in the other two houses. The balustrades on the little balcony, too, are the handwork of a fine craftsman, and the curtains are of a very fine lace.

While the furniture in the little sitting room of the Penz house is very elegant indeed, the fireplace gives one the feeling that it was constructed by a much less sophisticated carpenter than the man who made the rest of the house. The bust of George VI on the little corner table was probably a later addition. One can't help wondering what was in the two little staircase halls, and feeling a bit sorry for the lady in the kitchen who is trying to keep house with a bare cupboard. Also, the alcove in which the stove is set provides an interesting source of conjecture as to its purpose.

The two dollhouses that follow are of particular interest to the collector: first, because they are representative of similar periods; and secondly, because they were manufactured in quantity and can be

found at auctions. The name "Bliss House" has come to be almost a generic term; when it is used, it means dollhouses manufactured by R. Bliss in the late nineteenth century, and it is a house constructed, without exception, of lithographed paper laminated to wood. The collector finds himself wishing that all dollhouse builders had been as considerate as Mr. Bliss, who lithographed his name on various spots throughout the houses, and used a sort of Victorian architecture with overtones of the Queen Anne style that came back into vogue in the 1870s. Bliss houses boast isinglass windows in the front and lithographed curtains on windows in the sides, dormers, and gables. They can also be spotted by a profusion of bulbous turned-wood porch supports and a variety of porches and balconies that must have delighted the end-of-the-century lovers of ornamentation. The first Bliss house I encountered was made in 1895; the one pictured in figures 66, 67, and

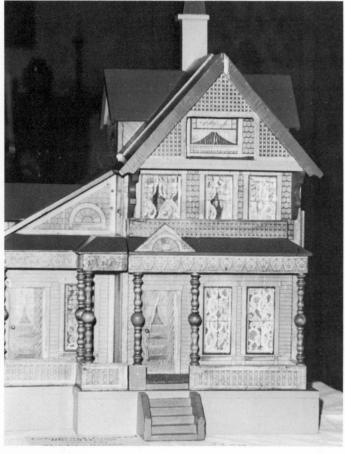

66

Front view of an original Bliss house that probably dates from the late nineteenth century. Owned by Mrs. John Houser of Kirkwood, Missouri, all of the original furniture is intact, all wallpaper is the original.

67

The Bliss house also has a side opening, complete with an additional door. The little added dormers and windows are pure Victorian, as is the cornice topping the front columns.

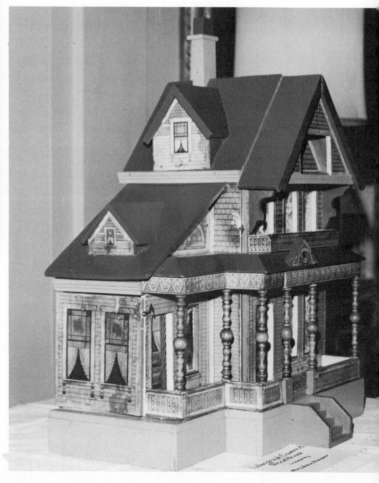

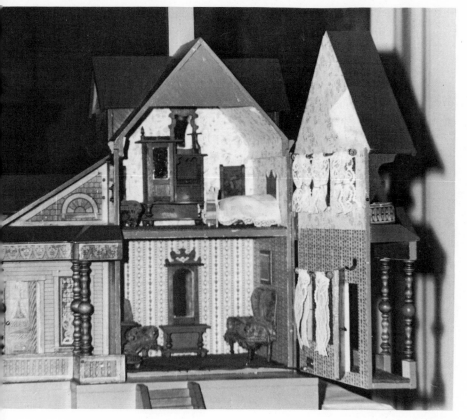

68

The front of the Bliss house swings open to reveal the original furniture. Notice that the rooms are very small, but do not seem crowded. The house has been well preserved.

68 is probably more likely to be of closer to 1900 vintage, but it is truly a choice example. It was photographed both from the front (figure 66) to show the curtain detail, and the side (figure 67) to illustrate the Bliss preoccupation with gables and dormers. As shown in the house in figures 69 and 70, the little side wall unhooks and opens, giving access to the upper part of the house. Thus there are two rooms on the first floor and one on the second. All Bliss houses are wallpapered, both walls and floors.

The second type of houses manufactured in such quantity that examples are still found were the Schoenhut houses, which were turned out by a firm founded in the early 1870s by Albert Schoenhut. The one shown in figure 71 is rare and consists of two stories. Schoenhut primarily made bungalow-style houses, many of which are still available today. Mrs. Evelyn Ackerman, from whose collection this house came, reports that she has never seen another of this size. It is in excellent condition except that the chimney is missing (all Schoenhut houses had chimneys, and two tiny holes on the roof are evidence that this one originally had one). Also, all Schoenhut houses were opened on the sides, both left and right, "so that the children can easily get at

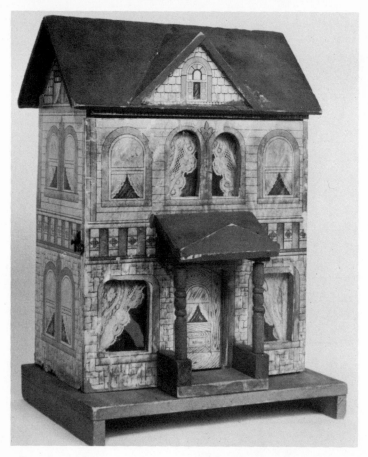

69

Another Bliss house has been partially restored but its front steps are missing. Notice the "R. Bliss" name on the door panel. Collection of Evelyn Ackerman.

70

Interior of the little Bliss house gives an idea of the task it will present to the collector who restores it. The furniture is Tootsietoy, from the collection of Laura Ackerman. (*Photo by Evelyn Ackerman*)

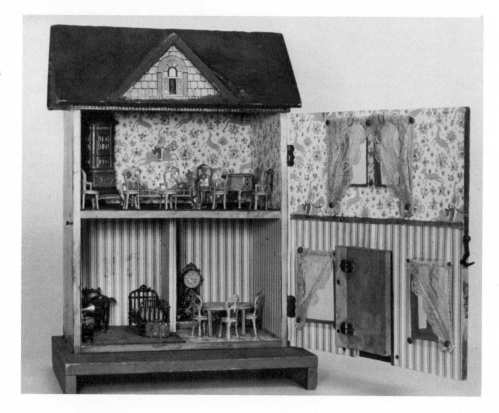

A two-story Schoenhut house is a rare find, but it is unmistakably identified by the nameplate on the side and the characteristics that all Schoenhut houses bear: the same curtains on doors and windows and lithographed doorways on the inside walls instead of actual openings. The roof opens to disclose further space. The gray "brick" exterior, simulated tile roof, and gray stone base are all signs of a true Schoenhut creation. From the collection of Evelyn Ackerman. (*Photo by Evelyn Ackerman*)

all the rooms," according to a catalog of 1917. "The front of the house remains stationary," the catalog goes on, "and, therefore, the appearance of the house is not lost by opening"—a good point for dollhouse builders. Mrs. Ackerman was especially taken by the charming "trompe d'oeil" wallpapers that not only are patterned after the fashions of the day but also have views into other rooms printed on the paper. This characteristic, too, is proudly listed in the early catalog:

> We went to a great deal of expense to have lithographs produced that would give a fine and modern inside finish. In doing this we have adopted a unique idea in not having doorways cut in the partitions from one room to the other, but have the doorways lithographed on the wall showing a perspective view of another room inside of the doorway frame, producing the illusion of a house full of fine rooms.

Mrs. Ackerman, a collector to whom expense is not often much of a deterrent, writes that she found this really costly item at a Santa Monica antique show a few years ago and bought it in spite of its price tag, because it was so reminiscent of the Midwest, where she grew up. It carries the original metal label that all Schoenhut houses should

have on the right side of the base, which reads, "Manufactured by the A. Schoenhut Company, Philadelphia, Pa." There is a beautiful staircase with turned wooden bannisters leading to the second story from the living room, and the windows are glass with the original lace curtains. When she purchased the house, it was without furniture, but it now houses her daughter's collection of Tootsietoy metal furniture, a type that is somewhat smaller than the ¹⁄₁₂ scale, but is exactly right for a Schoenhut house because the rooms are small with high ceilings. This particular house is 28 inches high, 23 inches wide, and 27 inches deep.

The house in figure 72 is c. 1910 and confirms our staunch belief that, even though old dollhouses are becoming harder and harder to find, occasionally one does find them. This one is owned by Mr. and Mrs. Homer J. Kennedy of Edwardsville, Illinois, and apparently is of the type done by a local carpenter on order. Mr. and Mrs. Kennedy are not collectors per se; they simply wanted a dollhouse for their two daughters and upon inquiring at the Jefferson Memorial Country Store in St. Louis, they were given vague hints that "Alice Somebody" had a house in her garage, "similar to what you are looking for." They could hardly believe that it would happen to them, but they actually did find Alice Somebody and she did, indeed, have just what they were looking for. It was in fairly good condition, and they didn't leave until they had consummated the deal.

72

This dollhouse was found by the Homer Kennedys of Edwardsville, Illinois, when they inquired about a house for their daughters. The workmanship seems to indicate a date about 1910. (*Photo by Eickmann Studio*)

Notice that this house isn't nearly so elaborate as the Schramm house—perhaps this is the difference between Midwestern carpenters and the workmen of Vermont. But it does have a certain charm; there is a forthrightness about the plain door and window moldings that commands respect. When the Kennedys acquired it in 1962, the roof of the house was unfinished; as they discussed what should be done about it, a friend contributed several bundles of cedar shakes and when a local carpenter was questioned about installing them, he quoted a price of about $25. (Remember that this was ten years ago.) Mrs. Kennedy reports that he spent days sitting on the floor in one of the girls' rooms, cutting the shakes by hand with his pen knife as he braced them on a board. He glued and nailed and stapled them as he cut them; the house had captivated him, too, and he was determined that the roof should do it justice.

The Kennedys are not collectors in the sense that we most often use the word; they have no wish to amass a large collection of dollhouse (or other) miniatures. They simply love this house and continually add to it with particularly nice things they encounter. Nearly all of the wallpaper had been used in a home of theirs before they came to Edwardsville, but most of the velvet draperies were in the house when they acquired it.

In the hall (figure 73), the table against the left wall was in the house when they bought it, as were the table and chair at the back,

73

Entrance hall in the Kennedy house. A noteworthy point here, for the collector, is the carpet, which apparently is a piece of regular carpeting. This should never be used, since the nap is out of scale with the rest of the furnishings. *(Photo by Eickmann Studios)*

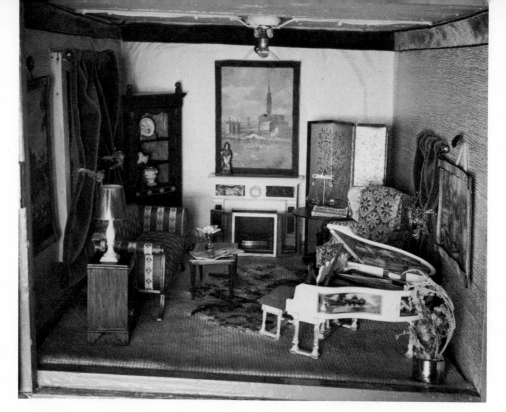

74

Living room of the Kennedy house spotlights the rare Petite Princess baby grand piano, which was decorated with scenes not only around the case, but on the underside of the lid as well. (*Photo by Eickmann Studio*)

where the father of the family, resplendent in a velvet smoking jacket, is relaxing from the cares of the day as he reads the news. No one has been able to unearth a clue as to why a large natural shell was used in the table base. The chair and desk on the right wall are the only ones of their kind, having been carved by B. Leo Fallert of Ste. Genevieve, Missouri, who specializes in one-of-a-kind pieces. The grandfather clock against the stair is a piece from a Princess Petite set, now avidly sought by collectors, as is the piano in the living room (figure 74). All of the needlepoint carpets were made by Mrs. Kennedy. Mary Nell, the older daughter, planned and framed all of the pictures on the walls and did the wallpapering, while Lucie, the younger, decorated the children's room. All of the furniture in the dining room is hand-carved by Leo Fallert. The Turkish rug is a genuine Oriental and the silver jardiniere at the front of the photo is from Mr. Kennedy's collection of old and rare silver miniatures.

In the bedroom, the prie-dieu against the rear window is from Chestnut Hill Studios, one of their special pieces, but the chaise lounge at the front of the photo is made from a large kitchen match box, hand tufted. The other furniture is from a commercial concern. In the kitchen, the cupboard at right is very old, c. 1870, as is the woven reed set that was found by Mrs. Kennedy in an antique shop. Notice the basket of kittens and the pair of rubber boots drying beside the kitchen range. This is the sort of care and attention that will develop the personality of a house, whatever its age.

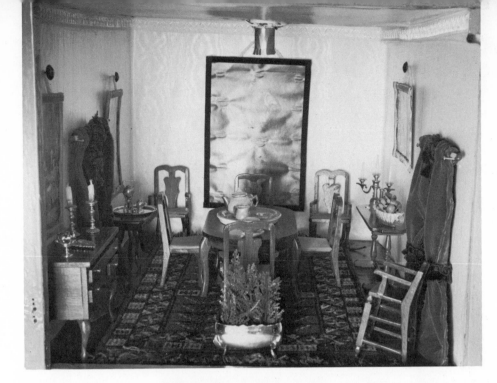

75

The dining room of the Kennedy house is sumptuously papered with silk moire; the carpet is a genuine Oriental. The entire dining room set was carved by B. Leo Fallert.

76

The bedroom of the Kennedy house presents a pleasing blend of old and new, commercial and homemade. Notice particularly the paintings on the walls; these and those in the remainder of the house were mounted and framed by a daughter, Mary Nell.

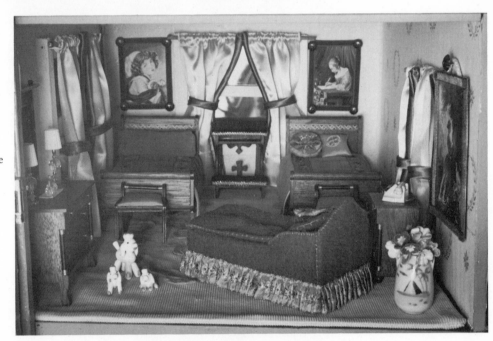

77

The cupboard at the right wall of the kitchen is very old, c. 1870. The furniture set was very popular around the turn of the century, but is seldom found today.

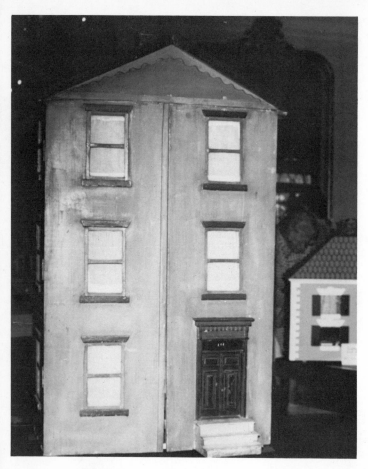 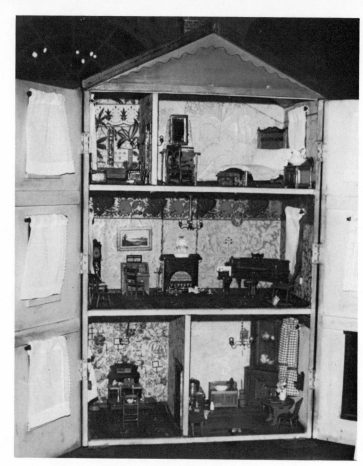

78 & 79

The three-story dollhouse shown in figure 78 was made by the great-grandfather of the present owner, Miss Kim Broderson, in 1885. It is well worth the collector's attention because many of these stark little houses date from that period, and their very simplicity is charming. The builder, George Small, of Harrisburg, Pennsylvania, intended it as a replica of his family home, and all of the furniture was copied by him from the life-sized pieces. The wallpapers are somewhat out of scale but emphasize the spirit of the house.

A real find, if the collector should come upon one like it in a shop, would be the three-story dollhouse owned by Miss Kim Broder-sen and built by her great-grandfather, George Small of Harrisburg, Pennsylvania in 1885 (figures 78, 79, 80, and 81). It was built as a replica of Mr. Small's family home, and all of the furniture, copies of the furniture in the house, was also built by him.

A very different dollhouse, one the collector is unlikely to find in a shop or at an auction but one he might very well plan on building or having built himself, is the Missouri farmhouse from the collection of Mrs. Louise Bradley of St. Joseph, Missouri. Mrs. Bradley belongs to our third class of collectors—the builders—and enjoys creating shadow boxes and houses that reflect different styles of living, as illustrated by her shadow boxes in figures 11, 12, and 13. The dollhouses she has completed are likewise examples of living styles and are important social commentaries on the periods in which the houses flourished. Every one is carefully researched down to the last little brick in the fireplace. Her first effort was a three-room Bavarian house inspired by a visit to the Oberammergau Passion Play; possibly it was her success with this that spurred her on to her present efforts. A year of research

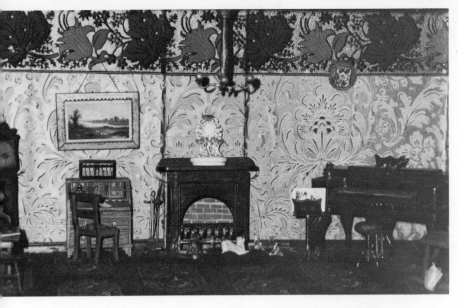

80

Close-up of the drawing
room, showing the square
piano and stool. The house
is replete with tiny pull
toys purchased by the builder
in France in the 1880s.

81

The little bedroom and
bath in the dormered
third story are most
engaging. Notice that a
scene has been placed
outside the door to give
depth, just as in many
other homes pictured
elsewhere in this book.
The treadle machine is a
rare piece, probably a
salesman's sample for
Singer sewing machines.

went into the Missouri farmhouse, which is intended to reflect life in
the Midwest in the period from 1830 to 1865 (see figures 82–86). She
admits that while it is historically as correct as possible, the decoration
is perhaps a bit more elaborate than that in the actual farmhouses of the
period. "I have never been able to do anything simply," she says,
recounting the story of the evolution of the house. A local architect in
her home town drew the plans from her specifications, then a local
cabinetmaker constructed a frame that could be taken apart to permit
the decoration of the interior of the rooms. Notice in figure 83 the
detail in the farmyard itself: the rain barrel at the side porch of the

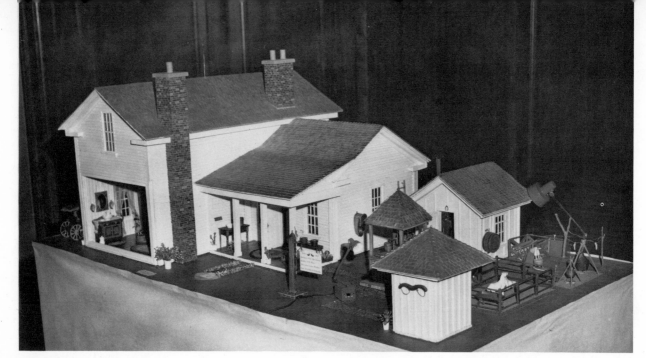

82 & 83

A farmyard reproduced in
astonishing detail serves as
the mounting for the
Missouri farmhouse of
Mrs. Louise Bradley. The
architecture of the house
is typically Midwestern,
mid-nineteenth century. The
oxen yoke hanging on the
side of the privy was made
by a friend, and the
furnishings of the side
porch adjoining the
kitchen are true to the
period. (*Photos by Lewis C.
Shady*)

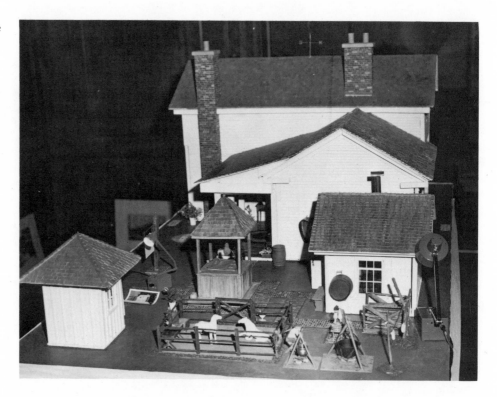

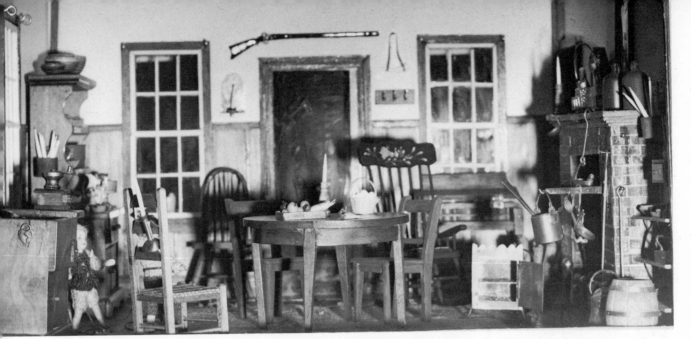

84

The farmhouse kitchen presents the sort of fascinating clutter that is noticeable in dollhouse kitchens all the way back to Nuremberg. The iron pots and kettles hanging at the fireplace are authentic replicas of early pieces, and the cruet set on the mantel is particularly noteworthy. Notice, also, the little warming oven on the floor before the fireplace. (*Photo by Lewis C. Shady*)

85

The bedroom is a fine example of the art of the miniaturist. Notice the hat boxes stacked atop the old-time "wardrobe" and the bordered wallpaper. The upholstery on the rocking chair is actual petit point. (*Photo by Lewis C. Shady*)

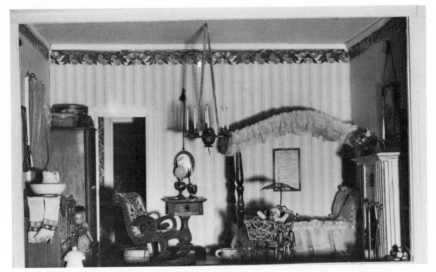

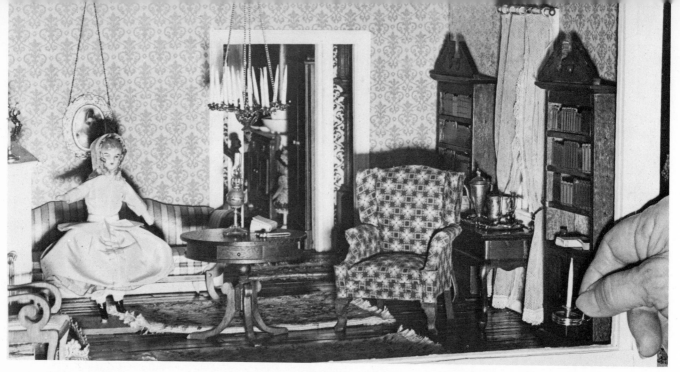

86

The sitting room of the
Bradley farmhouse is an
excellent replica of a
mid-nineteenth-century
parlor. Notice the elaborate
model of a student lamp on
the center table, and the lace
curtains, made of lace in the
exact scale of the room.
(*Photo by Lewis C. Shady*)

kitchen, the copper bathtub hanging on the wall beside it, the woman
doing the laundry in the yard with two kettles boiling over fires—one
for water and one for soap. The woodbox is well filled, and the privy,
at left, is shingled as expertly as the house and the well head.

While a great deal of the furniture and accessories that distin-
guish the house have been gifts from friends and purchases from the
Bradleys' own travels, her talents as builder and collector seem
evenly divided. She made each small shingle of balsa wood, reinforc-
ing it with a coat of glue and varnish; she finished the windows with
real glass rather than plastic, and when it came to the bricks for the
walks and chimney, she measured the actual bricks in an old house
and reproduced them from paper and red casein.

Venetian blinds were constructed of flat toothpicks, varnished
and glued together. Hardwood floors are made of ice cream stick
boards, varnished a dark brown. The candles shown in the several
very elegant chandeliers (figures 85 and 86) are round toothpicks,
dipped in liquid gesso, then painted white and tipped with red.

Another of Mrs. Bradley's houses, which may be seen at the Doll
Museum in St. Joseph, is a re-creation of the famous old Ogden House
in Fairfield, Connecticut, a saltbox built originally in 1690 (figures
87–91). Mrs. Bradley's replica was built around a large central chim-
ney. It was expanded through the years by the addition of lean-tos,
and while a year has been spent in bringing it to its present state, Mrs.
Bradley feels that it's still not really finished. She intends eventually to
mount it in the manner of the Missouri farmhouse with a yard show-
ing family activities. She plans to add an old mill, (a copy of the mill

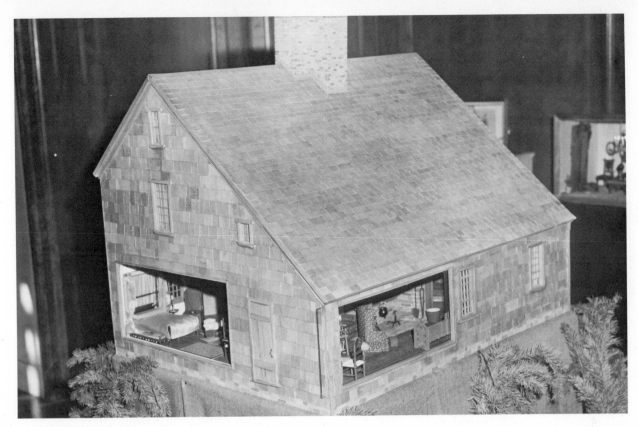

87

The collector who also enjoys building would do well to study the Ogden house from the Bradley collection. There is great charm to the long sloping roof and the authentically weathered shingles. The idea of leaving the two corner windows open so that the visitor may look in is another unique conception. (*Photo by Lewis C. Shady*)

88

Notice that there is a bed in every room. Often this was necessary in houses of this period, because the families were large and the houses were small. Here, in the parlor chamber, a handsome trundle bed has a half canopy; the other pieces are contemporary but excellent copies of old English pieces. (*Photo by Lewis C. Shady*)

89

The buttery was the room where food was prepared and beer was brewed. Note the "hog scraper" candlestick. The accessories are made of pewter.

90

The "keeping room" in the Ogden house includes, again, a bed and the ubiquitous "hog scraper" candlestick hanging over the back of a chair. (*Photo by Lewis C. Shady*)

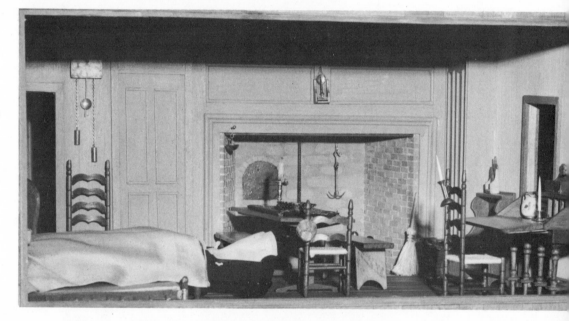

91

The "long room" was actually the office of the house. The "hog scraper" candlestick on the chair provides light for working at the desk. Both this room and the kitchen had large fireplaces with built-in ovens. Notice the utensils on the hanger in the kitchen fireplace and the yarn winder in the background. (*Photo by Lewis C. Shady*)

built in 1630 by Mr. Ogden which stands a quarter mile from the Ogden house), an herb garden, a stagecoach, and an early seventeenth-century well.

Mrs. Bradley also had architects make up the working plans for the saltbox and the same cabinetmaker who made the farmhouse executed them. This house is particularly interesting because of its authentic roof and shingles. All of the furniture has been made to order, thereby re-creating a mood of the early eighteenth century. The "accounting chamber," which was the original room of the house, looks elegant with whitewashed walls and old pumpkin-yellow paint on the fireplace wall; the "long room," the next addition, features a "one-post bed" that was much favored at the time because it could be folded up against the wall during the daytime. The fireplace shows one of the original baking ovens, which were built to take advantage of the heat from the fire.

Any number of commercial houses are available on which the collector might set the stamp of his own personality. In the catalog of the Enchanted Doll House shop, operated by Mrs. Jean Schramm in Manchester Center, Vermont, the collector is offered first an un-painted, precut, colonial dollhouse kit that offers four rooms. There is also a two-story house that is termed a "Pooh" house, because the decoration is tied in with the characters in the Winnie the Pooh stories. The "Pooh" house has only two rooms, but it is most attractive. Presented also are a contemporary California home, a simple colonial one, a manor house that consists of six rooms plus a secret attic, and an electrified version of the Nashville Hermitage house. Also offered are two 9 × 12 × 7-inch "carrying houses."

The collector should be encouraged by the fact that today dollhouses are being made to order as they were in the eighteenth century. The Regency-type house shown in figures 92–98 from the Mannion collection was made to order. Note the house's fine iron balconies on the second and third floors, and the handmade pale blue shutters on all of the remaining windows. This house was intended solely as a cabinet for housing Mrs. Mannion's collection of dollhouse miniatures. Mrs. Mannion presented specifications to a cabinetmaker and had it built to her order. It stands over 5 feet high, 32 inches wide, and 16 inches deep, on a base 15 inches high, which houses the transformer and other attachments for the electrical equipment. When the house was completed, Mrs. Mannion cut and installed the wood shingles herself, and also made the little roof garden. There are no stairs in the house, except from the attic to the roof, since these would break up the wall spaces, and doors are kept to a minimum. Like the early Dutch and French cabinets, her house primarily serves as a display

92

Regency-type dollhouse from the collection of Adelaide Mannion was conceived simply as a cabinet to contain miniatures gathered over the years. The pale blue shutters really work, and the wood shingles were cut by Mrs. Mannion. The ironwork consists of antique and contemporary pieces combined.

93

The kitchen of the Mannion house presents a picture of happy busyness; notice the kitten rolling on the floor and the baby in the buggy. The tiny copper chafing dish is a one-of-a-kind piece, and the corner fireplace, of Swedish origin, was made to order. Notice that despite the antique pieces that give character, the Mannion doll family is also blessed with a modern range, dishwasher, and refrigerator.

94

Crystal chandeliers and satin draperies add much to the opulent look of the Mannion house; the draperies are lined in French voile. Notice the secretary in the foyer and the large collection of sterling silver pieces in the dining room.

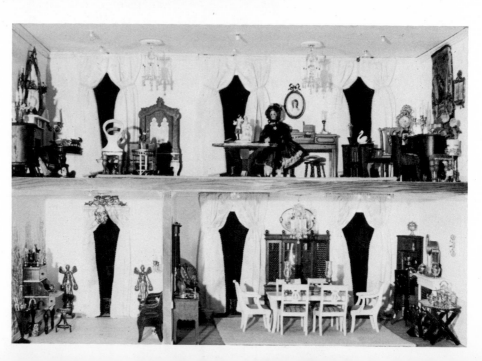

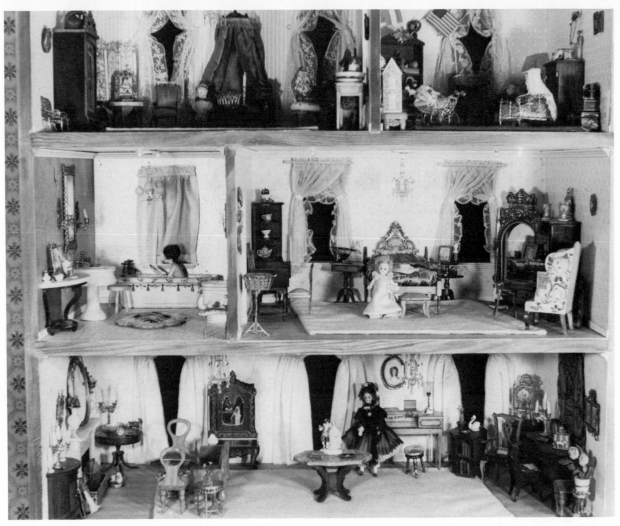

95

This over-all photo of the
second, third, and fourth
floors of the Mannion house
gives the collector an idea
of the advantage of rooms
large enough to display
everything and still retain
an uncluttered look. The
Chippendale chair beside
the desk in the drawing
room is an authentic piece.
The Dresden couple on the
center table is just over
1 inch high.

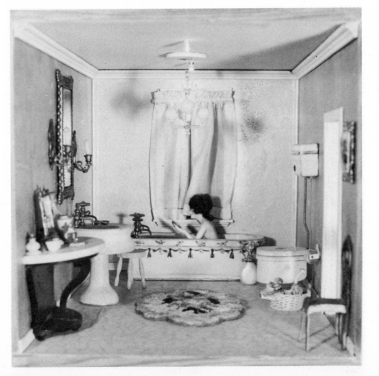

96

The bathroom is one of the
most fascinating rooms in
the Mannion house,
featuring a combination
of the old with the new.
The artwork on the old-style
tub was done by a friend.

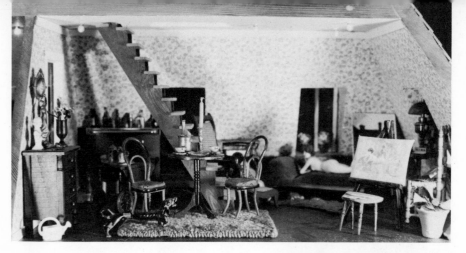

97

The artist's studio boasts
not only a nude model, but
a champagne bottle in a
silver cooler.

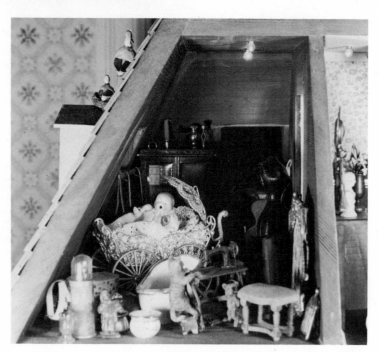

98

Every well-lived-in house
has an attic for castoffs, and
the Mannion house is no
exception. The tiny treadle
sewing machine is very
rare, and the small-scale
stock ticker is unique.

case for miniatures. Mrs. Mannion, however, has arranged a charming garden around the house, complete with antique lamp posts that really light, captivating flower beds constructed from the blooms offered by the English firm of Herald Models, plus a set of iron outdoor furniture and a fine display of sculpture, all of which are authenticated antiques.

Many early dollhouses were built with space beneath the house, which was occupied by horses, carriages, and wine cellars. The Queen's Dolls' House, which may be seen in Windsor Castle shows this arrangement. In the Mannion cabinet, the kitchen and a sort of workroom or utility room occupy the first floor. In the left corner of the kitchen (figure 93) one sees a Scandinavian corner fireplace with handmade tiles. The little table in the front is crowded with luscious food. A

butcher's block stands behind the chair at right, a baby buggy is next to the chair were mother has obviously been preparing vegetables. The floor is made of handmade deep red tiles. Next to the kitchen on this floor is a room arranged as a combination laundry, garden room, and storeroom, not pictured here.

On the second floor are the foyer and dining room, complete with a sterling silver tea set and a chest full of sterling silver miniature serving pieces; the entire third floor is devoted to the drawing room, lighted by two exquisite crystal chandeliers and featuring a handsome fireplace. A beautifully dressed French doll presides here, and there must be maids elsewhere in the house, for the mistress is simply too elegant to be concerned with the everyday routine of running such an elaborate menage.

We meet more members of the family on the next floor, where the master bedroom and the bath are situated. An antique sewing basket (picked up, incidentally, in an antique shop where the proprietor had no idea of its value) is complete with thread, darning egg, needles, and everything necessary for this domestic pursuit; another tiny antique doll is apparently looking for Mommy, and in the corner stands a very unusual heavy and elaborate pier glass mirror in a gold plated frame. The secretary, topped by a pair of real Limoges vases, is completely fitted. The collector will find more details of these rooms later on in the chapter on furniture and decorating. Notice the lovely Parian lady admiring herself in the tub. She, as well as the lady in the drawing room and the nude beauty posing in the artist's studio at the top of the house, are part of a group of Parian dolls c. 1900, turned out in various poses. They are beautiful and utterly charming, but difficult to dress, since they are frozen in their various poses. A few of these may still be found in antique shops. They are listed in many doll catalog; they are expensive, but well worth collecting.

On the next floor another lovely antique little girl doll is waiting in the spare bedroom, while in the children's room an ormolu cradle and buggy accommodate the doll family that lives with the dollhouse family. The attic again demonstrates Mrs. Mannion's wry sense of the appropriate; a nude Parian lady is posed on the couch in the artist's studio, and a nearly finished portrait, in oil, of her stands nearby. The reed-backed chairs are very old, and there is even a bottle of champagne cooling in a sterling silver wine cooler—a well known manifestation of the life of sin that artists were generally assumed to live in the gay nineties.

The little storeroom at the end of the attic floor (figure 98) presents the usual jumble of cast-offs found in any residence of whatever

size, with one noticeable exception—few of us, even in life-size houses, have a stock ticker in any room at all. The family in Mrs. Mannion's house is, we presume, so rich that they no longer need to follow the rise and fall of the market, so this one, in ⅟₁₂ scale, has been relegated to the attic. Also, notice the cat climbing up the tiny treadle sewing machine. An obliging spider has even constructed an enchanting web in this room—surely the ultimate in realism for any dollhouse!

The next two houses are presented in conjunction with each other since they are startlingly alike, and still basically different. Both were built by experts: The southern colonial mansion (figure 99) was assembled by Susan Hendrix on the West Coast, with her husband doing the heavy construction; and the eighteenth-century manor

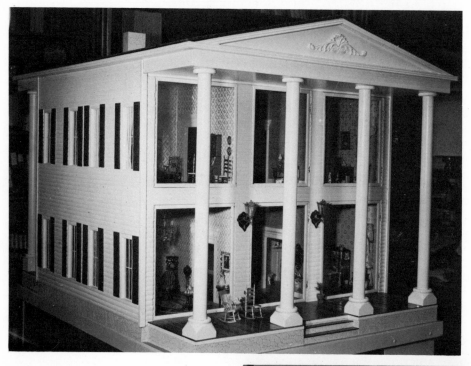

99 & 100

Take a southern colonial mansion from the West Coast and an eighteenth-century manor house from the Midwest and what do you get? A most interesting study in approaches.

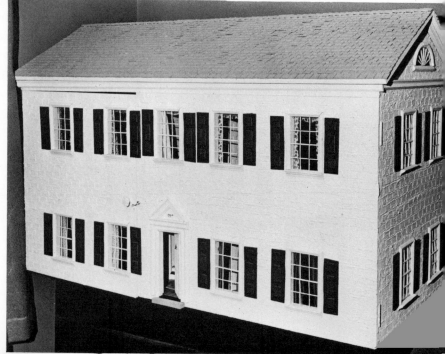

house (figure 100) was conceived by Mary Jane Hubers in the Midwest, with a carpenter making the shell and cutting openings for doors and windows. Mary Jane Hubers' house is 4 feet long, 2 feet wide, and consists of two stories plus an attic. The Hendrix house is just slightly larger. Both collectors are well known for their intensive research and careful attention to details, and both agree that shutters are about the most frustrating part of completing a dollhouse. There are thirty-four in the Hendrix house, each with its own working louvres, and about the same number in the Hubers house, made from old Venetian blind slats filed with an emery board. The Hendrix house is painted, as a southern mansion should be. To finish her house, Miss Hubers experimented until she achieved the outside stone effect that she wanted, finally using modelling paste made of gesso and marble dust. The impressions to form bricks were done with a painting knife, working only a small area at a time.

This writer is convinced that the two entrance halls are the finest ever seen; the Hendrix hall is highlighted by a curving staircase (figure 101), and the Hubers hall, somewhat narrower, has the impeccable straight staircase of a somewhat later period (figure 102). Mrs. Hendrix reports that she worked three months on her staircase, achieving just the right curve. Miss Hubers spent about the same length of time. Spindles in the Hendrix house are turned, in the Hubers house they are toothpicks, carefully sanded and stained. Take particular note of the upstairs hall in the Hendrix house (figure 103); these are sometimes neglected by dollhouse builders, but in the Hendrix house this one is beautifully done, the latticed window creating a beautiful effect, and the bust of Robert E. Lee proving that the family was faithful to its traditions.

A comparison of the dining rooms is equally fascinating. The cloth in the Hubers dining room (figure 104) seems a little out of scale and stiff, but it is her mother's wedding handkerchief, and Mary Jane wants it in the house for sentiment's sake. All of the furniture in this room was made by this incredible craftswoman, and the floors that can be seen in the photo were finished with tongue depressors throughout the house. Miss Hubers estimates that about 1,200 were used. Mrs. Hendrix estimates that she cut and laid about 2,000 pieces. Miss Hubers made the needlepoint seats for her dining room chairs (after making the chairs) and the "Delft" tiles in this fireplace were bought plain and decorated with colored pencils. In the Hendrix dining room the fireplace (there is one in every room!) is elaborately detailed, and Mrs. Hendrix built the curved glass china cabinet herself; the table is set with "Haviland" and sterling flat ware, and the handsome draperies are of brocade. The Hubers dining table, equally

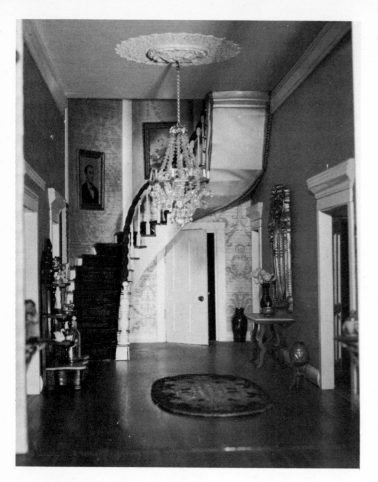

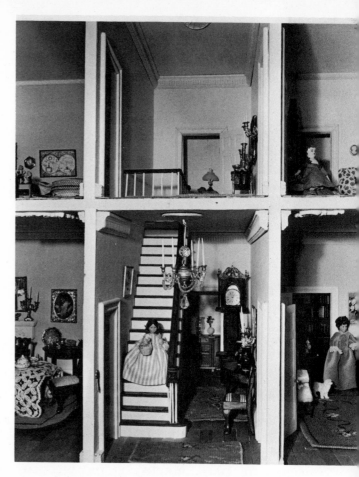

101 & 102

The two front halls are worthy of the collector's study. Chandeliers in each were made by the owners, and Miss Hubers made the grandfather's clock in her hall. The mirror in Mrs. Hendrix's hall is especially fine. (*Hubers photo by Bill McConnell*)

103

The Hendrix upper hall is especially fine and is sometimes neglected by dollhouse decorators. Notice the use of the large window on the stairs. (*Photo by Lester Hendrix*)

104 & 105

Compare the two dining
rooms as you did the front
halls to see the difference
in approach here. Details,
such as the handlaid floors,
give these rooms character.
Mrs. Hendrix's curved front
glass china cabinet is
especially noteworthy.

complete, is set with Blue Willow china made by Frieda Leininger,
and the glasses are handblown glass.

 Having no photo of the Hendrix drawing room, we must turn to
the upstairs "parlor," where the collector will find many other items
of note (figure 106). The petit point cover on the couch was made by
Mrs. Hendrix as was the charming Victorian mantel, and the platform
rocker, also upholstered in petit point, was made by a miniaturist in
New York who is in his eighties. The plasterwork in the Hubers draw-
ing room is worthy of special note (figure 107); a similar medallion is
used in the dining room and small pieces are in each of the halls.
These are from Craftsman Wood Service in Chicago and are termed
"wood grain trimings"; Miss Hubers merely nailed and glued them in
position, then painted over. Notice that in this room, too, one of the
miniature Japanese screens mentioned in the chapter on "Miniature
Art" adds a great deal to the elegance of the room.

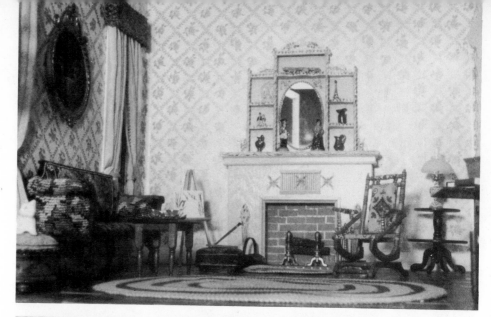

106

The fireplace in the upstairs parlor of the Hendrix house is worthy of particular study; we have never seen one with the carved mantel edge and matching curio shelf above, such as this. All furniture except the platform rocker was made by Mrs. Hendrix. (*Photo by Lester Hendrix*)

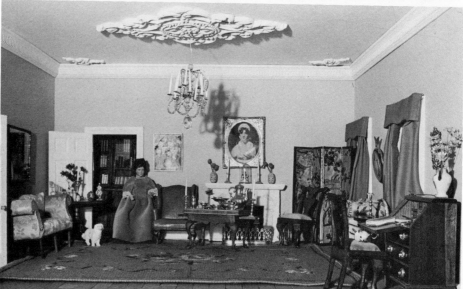

107

The wing chair in the drawing room was made by Miss Hubers and is of red leather with a wood base and Queen Anne legs. The chairs are Chippendale, also made by Miss Hubers, with needlepoint seats. (*Photo by Bill McConnell*)

The Hubers bedroom (figure 108) contains a few Shackman pieces, but the chest and chair in the foreground were made by Mary Jane. The fireplace is a Petite Princess piece, picked up at a sale. There is another fireplace in a second bedroom. The scenes behind the doors and windows, which Mary Jane calls her "pretend" rooms, were dreamed up because she wanted indirect lighting in the house. She left space in the back from which the light could come and these she decorated to simulate adjoining rooms—library, dressing room, etc. An unexpected advantage was that the light in the back made it possible to get the effect of a fire in the fireplaces.

The lace valances on the windows and the bed in the Hendrix bedroom (figure 109), made by Mrs. Hendrix, are of interest to every collector. Mrs. Hendrix does not care for dolls in dollhouses, but she couldn't resist the lovely Parian nudes.

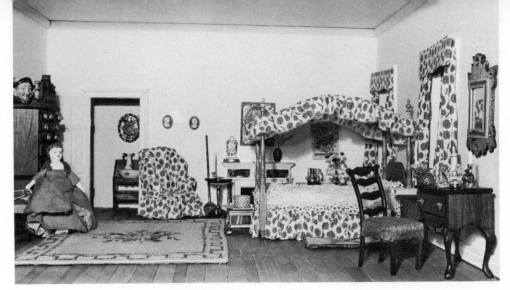

108

The Hubers bedroom illustrates Miss Hubers' attention to detail; note the hat box on the stand at the foot of the bed, and the tatted bedspread. Mirror at right is from Shackman.

109

All fireplaces and all chandeliers in the Hendrix house were made by Mrs. Hendrix. Here, the valances on the windows are of special interest as are the lovely nude ladies. (*Photo by Lester Hendrix*)

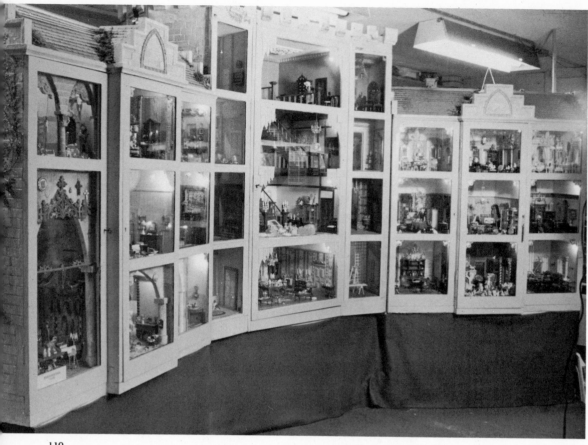

110

Maynard Manor is built
to resemble a castle. Note
the battlemented roof of
the center section and
the old-looking bricks and
vines on the sides. It may be
viewed by the traveling
collector if he will call the
Peddler's Shop in San
Francisco and make an
appointment. (*Photo by
John P. Probst III*)

111

Focus of interest in the
Blue Room is an exquisite
chandelier created by Mrs.
Blauer. The beautifully
executed petit point rug is
one of twenty and was
originally in the Soller
collection. Most of the
chandeliers and lighting
fixtures in Maynard Manor
have been created by Mrs.
Blauer, replacing commercial
wire and bead pieces with
authentic reproductions of
museum originals. (*Photo by
John P. Probst III*)

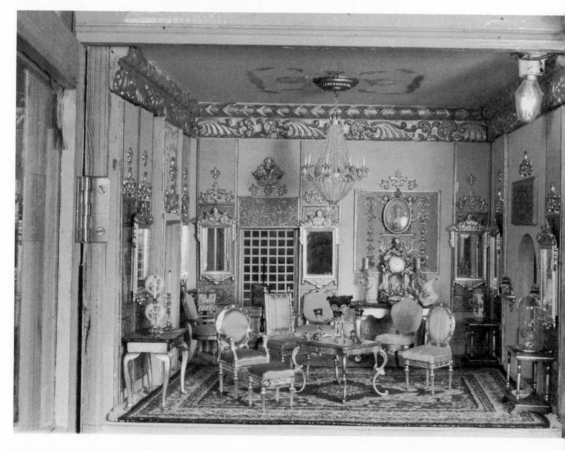

6

Dollhouse Masterpieces

I N DIRECT CONTRAST TO THAT GROUP OF COLLECTORS AND BUILDERS
who carefully research each detail of their work to assure au-
thenticity in both houses and furniture, there is another large group
who casts authenticity to the winds and finds pleasure in creating a
castle, a fort, or a mythical dwelling that springs, full-blown, from their
imaginations.

Castle themes seem to be popular among collectors. John Blauer,
the proprietor of the famed Miniature Mart in San Francisco, a shop
for advanced collectors, built a very impressive castle, Maynard
Manor (see figure 110). We quote here from his booklet, entitled
Maynard Manor: The Miniature World of a Modern Gulliver:

As in all projects of this kind, Maynard Manor did not materialize
overnight. A basically vivid and whimsical mind conjured it at an
early age, but it was actually created in later life.

The original rooms were all constructed independently but
the job of dismantling over 40 individual settings each time the
rooms were exhibited proved to be so tedious that it was decided
to house them all in one structure, thus giving way to a childhood
desire to own a "castle."

After drawing the plans, they were submitted to a contractor.
He and his craftsmen created the basic structure and to this frame-

work was added two six-sided towers and an indirect lighting system. Then, for over seven years, I devoted every spare moment to plastering, painting, carving, inlaying and decorating 40 rooms and the outer walls.

Seven years! That tops any of the estimates of the work done by feudal craftsmen on the miniature houses of the seventeenth century —and no one would dispute the fact that he has created a fairyland. Authenticity and microscopic perfection of detail are an obsession with John Blauer, and these qualities are reflected in the more than 6,000 miniatures on display in the Manor. They really must be seen to be believed. In the Blue Room (figure 111), seven pieces of rare Battersea enamel furniture are displayed against a background of rococo blue and gold. The smaller-scale ivory pieces in the master bedroom (figure 112) were a gift from Mr. Blauer's friend, another miniature enthusiast, Mrs. Edna Wolf. The intricate carving and detail on these pieces is magnificent. The resplendent crystal chandelier was created by Tom Devereaux especially for this room. Eighteen panels on the walls were painted in oil by Miss Berta Vargas.

112

The master bedroom in Maynard Manor represents one of the finest examples of carved and turned ivory in existence. The pieces were carved by a group of Chinese who settled in Central Europe in the 1880s, and were obtained from the Jules Charbneau and Mother Larke collections. The ivory and pearl rosary on the dressing table is one of the prizes of this collection—perfect in every detail even to the crown of thorns on the Christ.

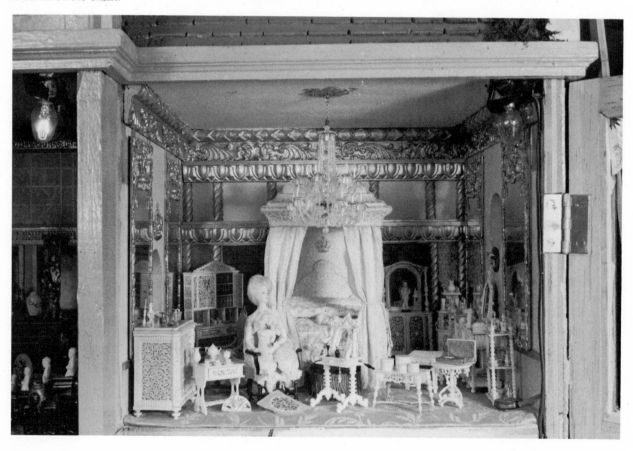

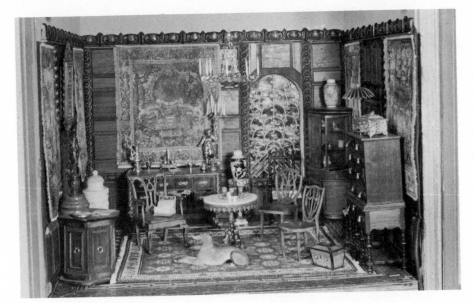

The Tudor room in the
castle is paneled in dark
walnut. The furniture here,
made by Eric Pearson and
Betty Valentine, is considered
by experts to be some of the
finest examples of miniature
carving extant.

All of these miniatures, however, are of museum quality, and it is
unlikely collectors would find anything comparable on the market.

The house and collection of Mrs. Robert Updegraff of Des
Moines, Iowa, is entirely different, although the building itself bears
some resemblance to Maynard Manor. Like Maynard Manor (and
most very elaborate "masterpiece" houses) Updegraff Castle just
evolved. Mrs. Updegraff and her small daughter began collecting doll-
house furniture when the little girl was only seven years old. It was
displayed in a cabinet-like two-shelf bookcase of the sort mentioned on
page 18. However, what with their own collecting and contributions
of friends they soon outgrew the cabinet. When their daughter was
sixteen, Dr. and Mrs. Updegraff had the 19-room "castle" built for her
birthday.

Updegraff Castle is constructed of three parts that are bolted to-
gether (see figure 114). Two end sections containing five rooms each
are topped by turrets: The left section contains a nursery, playroom for
the prince, library, chapel, and garden; and the right section houses a
maid's bedroom, a bathroom, the Christmas room, the dining hall,
and kitchen. In the center section are located the queen's and the
king's bedrooms, music room, formal drawing room, treasure room,
housekeeper's sitting room, and wine room, as well as the throne
room. The collector who is planning a castle to house his treasures
might well notice the interest created here by having the throne room
run up a full two stories, and even the little garden room breaks up
the floor line by being ceilinged just a bit higher than the garden that
adjoins it.

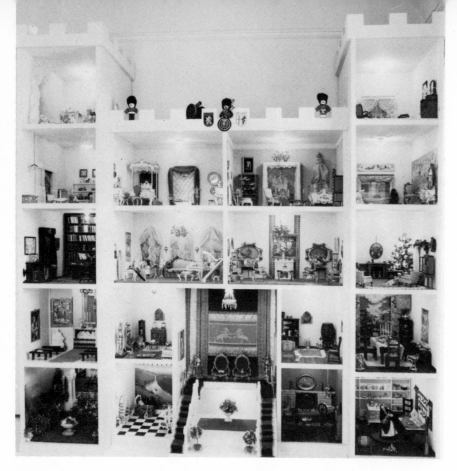

114

This detailed view of the Updegraff castle gives the collector an idea of how an effect may be achieved without undue expense or work. The "battlements" are merely cut wood toppings, the little "guards" are tiny dolls.

115

Detail of the first two floors of the center and left portions of the Updegraff dollhouse. The columns in the garden are from the Forum in Rome, and the rocks around the tiny pool were gathered from rubble in Greece and Italy. Notice the beautiful scenes that seem to be just outside the windows of the castle.

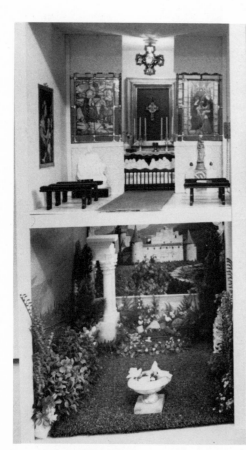
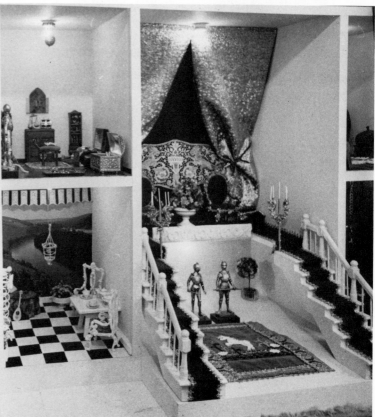

Many of the miniatures in the Updegraff collection are very rare or one-of-a-kind; however, the ideas that helped to build this castle are available to all collectors. For example, Mrs. Updegraff was less than happy with her talents as carpenter, so the window frames are made of small picture frames, and are glued directly to the walls. The scenes outside the windows, in the manner of the Thorne rooms, are actually souvenir post cards, which offer better colors and better weight for mounting than other cutouts. In the chapel adjoining the throne room on the second floor, the walls behind the statuary and the inside of the door frames between rooms are decorated with a heavy white braid that has crocheted-type edgings. This particular decoration is used throughout the house—note, for example, the cornice in the king's room and also the base at the foot of the thrones in the throne room. Mrs. Updegraff paints over the braid, after gluing it onto the base wall or frame, with many coats of Kemtone, and reports that the final product looks very much like carved plaster. The walls in the throne room are painted with a variety of "sand paint"—but she added canned bread crumbs to the paint to get the right texture.

In the close-up picture of the two-story throne room (figure 116), two armored knights stand guard; they started life as a statuary set,

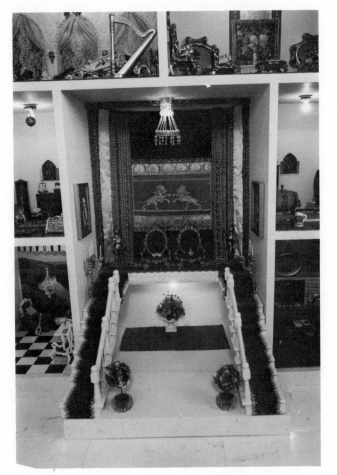

116

The throne room achieves a royal feeling first by the use of a full two stories of height, next by the richness of the furnishings, all a product of the owner's imagination.

four for $7.95. The stair carpets are velvet ribbon edged with braid, and the lace behind the thrones is a very old lace antimacassar "such as Grandpa leaned his head on," to quote the artist. The gold metal cloth draperies behind the thrones, which Mrs. Updegraff was never satisfied with, have since been replaced with panels of the ivory satin hair ribbons saved from the girlhood of Dr. Updegraff's mother. The carpet here has also been changed (one of the things that captures a collector's fancy from beginning to end is the possibility of constant change). The rug was originally blue velvet with braid edges, and the animal shown was a unicorn cut from felt. She is currently working the design out in acrylic, so it will resemble mosaic. The little holly trees are planted in cut glass salt dishes that had belonged to Dr. Updegraff's mother.

The Updegraffs, in addition to being collectors of antiques, are also travellers. For example, the scene in the window of the king's room (figure 117) was created from a postcard brought from Germany. The tiny ship on the chest in the library came from Portugal;

117

Detail of the third and fourth floors in the Updegraff castle gives an idea of the opulence of the furnishings. Furniture in all of these rooms is Spielwaren from Germany.

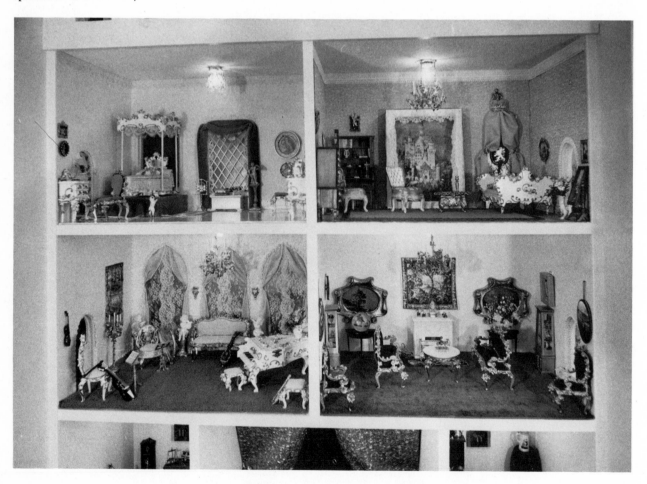

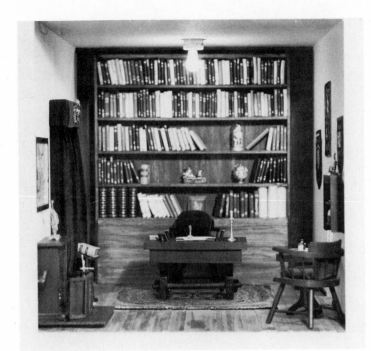

The library is a bit stark and quiet, as libraries should be; no fancy details to disturb one's thoughts. Mrs. Updegraff made all of the books by hand. The floors are planks of stained balsa wood.

statuary replicas of "The Last Supper" and "The Pieta" in the chapel came from the gift shop at the Vatican; the silver birdcage in the queen's bedroom came from the Netherlands; and the tapestry pieces in other rooms are replicas from Belgium.

Other examples of Mrs. Updegraff's ingenuity are even more apparent in the garden and terrace rooms. In the garden room, the columns are marble replicas of a section of the Forum in Rome; some of the rocks around the mirror pool are both interesting and highly illegal, she reports. Included are a piece of mosaic tile from Ephesus, another from Knossos, a chunk of tufa with a lion's face carved in it from Pompeii, and many others. They were, however, found in piles of discarded rubble. Our collector wants it understood that she has never defaced anything no matter how intense was her desire to acquire an interesting dollhouse decoration.

The ornate furniture found in the king's bedroom, the drawing room, and the queen's bedroom, was brought back from Germany (neither East nor West, but simply stamped "Germany") and is about ten or twelve years old. This writer, in many months of travel in Germany, had never seen it, but after viewing Mrs. Updegraff's pictures found a pair of chairs at a rummage sale that are of exactly the same lineage. Called "Spielwaren," the furniture is sometimes upholstered in velvet and sometimes in a fairly awful brocade, which is

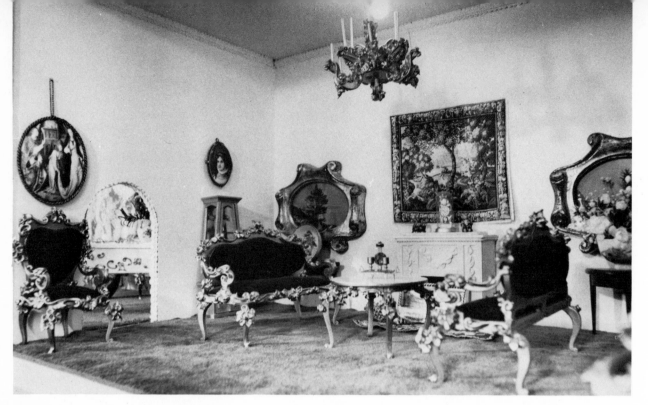

119

The formality of the drawing room would surely impress any diplomat. The carpet is the velvety side of a cut-nap terry towel. The very heavy picture frames balance the decor of the room.

what was on the author's pieces. However, Mrs. Updegraff simply re-covered what she didn't like. The furniture is very light, possibly made of plywood, and the carved effect is not plaster, which it resem-bles, but probably a mixture of fine sawdust and glue, put on with a cake decorator. Since the furniture is so lightweight, it could not be made of plaster. It is unlikely that the rococo curves were carved in a sawdust mixture. The furniture is, however, lovely and effective. The furniture in the blue drawing room is just as ornate; note, for example the intricately carved table legs. The curio cabinets, which are partly hidden by the settees, are from the Shackman catalog, but in order to give them a richer look, Mrs. Updegraff gilded them. Gilding gives furniture a lush and expensive look that the meager furniture finishes do not quite achieve.

The brass table at the window in the king's bedroom is the bot-tom half of a jewel box, topped with a handbag mirror that happened to both fit and match. These brass antiquelike items, Mrs. Updegraff reports, are of the sort one sees but rarely buys in airport gift shops or hotel drug stores—as witness our statue of the "Little Mermaid" (fig-ure 203) that was bought in the Copenhagen airport.

Jeanne Musselman Overbeck of Edwardsville, Illinois, created a castle behind the facade of a southern colonial mansion (figure 123). Asked what period the house is, she will answer "Imagination and Early Plywood, built to delight children!" and adds that her guiding theme was "When Knighthood Was in Flower." Mrs. Overbeck's col-

90

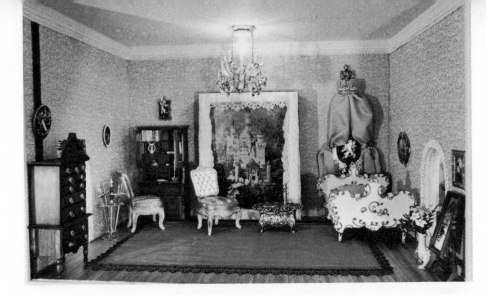

120

The king's bedroom has a fine view from the window— a postcard mounted on the outside. The draped canopy over his bed is of silk tied back with earrings, and the desk, highboy, and full-length mirror are from Shackman.

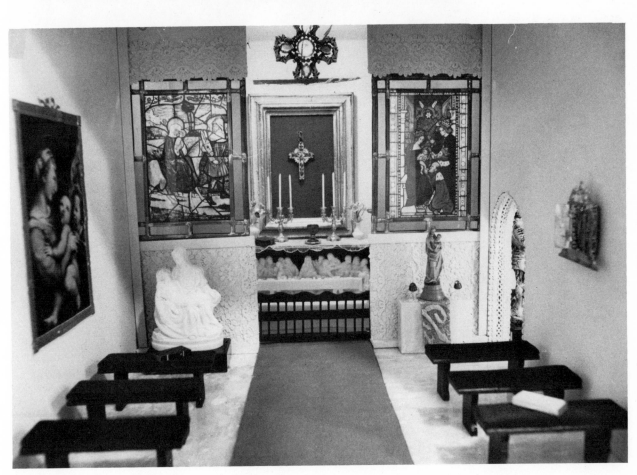

121

The chapel establishes an appropriate mood. Notice that the edgings mounted on the wall to left and right of the altar add a great deal of elegance. The stained glass windows are available from a mail order house (Downs) but the statuary came from the gift shop at the Vatican.

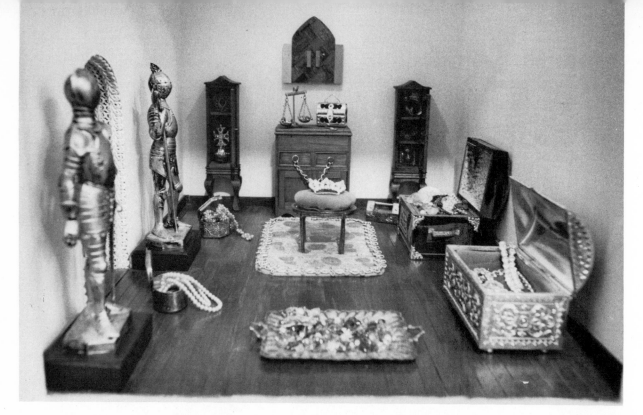

122

The treasure room, too, might serve as a lesson on how to achieve great effects with practically nothing. The cabinets in the back and one of the trunks are from Shackman. The "jewels," all costume jewelry, are strewn on a bare floor rather than a carpet, which might detract from their brilliance. The little table on which the crown rests is very old and made of sterling silver.

123

The Overbeck "Fantasy Castle" is constructed so that each room may be viewed individually through Plexiglas. Each room was constructed and decorated as a separate unit, then each was slipped into the wings that form the shell of the house. It stands 4 feet high by 4 feet deep and is 6 feet long.

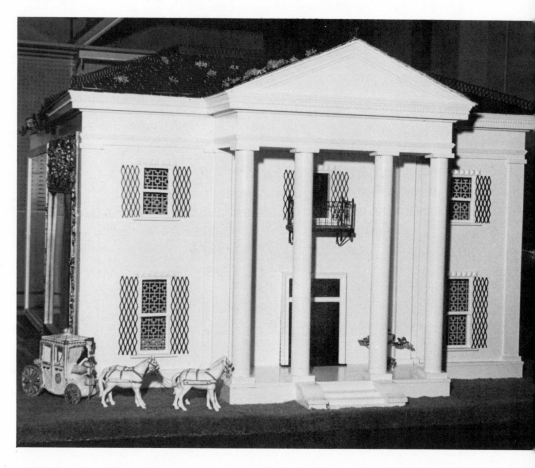

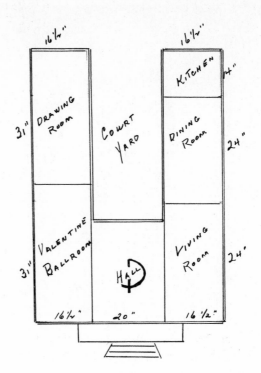

Floor Plan - Second Floor
Jeanne Musselman Overbeck
Fantasy Castle
Scale - one tenth 1/12

Floor Plan - First Floor
Jeanne Musselman Overbeck
Fantasy Castle
Scale - one tenth 1/12

124a & b

In order to truly appreciate
the achievement in
transforming a colonial
mansion into a castle, one
must really study the floor
plans and room
disbursement.

lecting began about nine years ago when a friend brought her a sofa
and two little chairs. She did a great deal of the building for her castle,
and it was only after the rooms were built that she contacted an archi-
tect who drew the plans for the mansion itself. Her husband built the
two wings that house all the rooms except the hall; various Edwards-
ville merchants supplied the necessary information and skill. Even the
semiprecious stones used on the king's bed and chair came from the
local jeweler.

Something Mrs. Overbeck often repeats should be remembered
by every collector: "Just setting furniture around doesn't make a doll-
house. One must see the characters moving and living in the house,
and try to visualize their lives. This is what makes a dollhouse come
alive. So, my little characters are a king and a queen in a southern
colonial mansion, and [I] enjoy them to the full."

The miniature southern mansion of Mrs. James Campbell of
Fort Lauderdale, Florida (figures 129a and b) is 7 feet high and 8½
feet wide, with three floors divided into nine rooms. The architectural
detail equals that found on the finest buildings, and the front swings

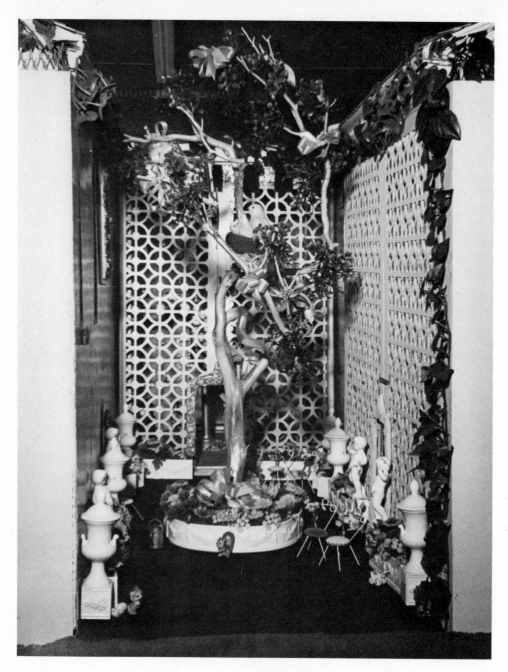

Mrs. Overbeck calls the garden the "glory" of the dollhouse. It stands two stories high and one wall is covered with mirrors, the other with gold lattice work. This is a view from the back. The crystal tree was carefully carried home from a trip, and the local florist provided the flowers and little animals.

open in three sections to reveal the interior. Mrs. Campbell designed the house herself and it reflects her own warmth, taste, and imagination. She had collected fine miniature salesmen's samples long before the house became a reality, and since she and her husband travel a great deal, she had combed antique shops, junk stores, and Goodwill stores to add to her collection.

Some of the kitchen miniatures came from Switzerland; Oriental rugs and wallpapers were found in Austria; the stair carpeting was found at the Paris Flea Market. The living room has four clocks that keep perfect time. The library houses a fifteen-year collection of real

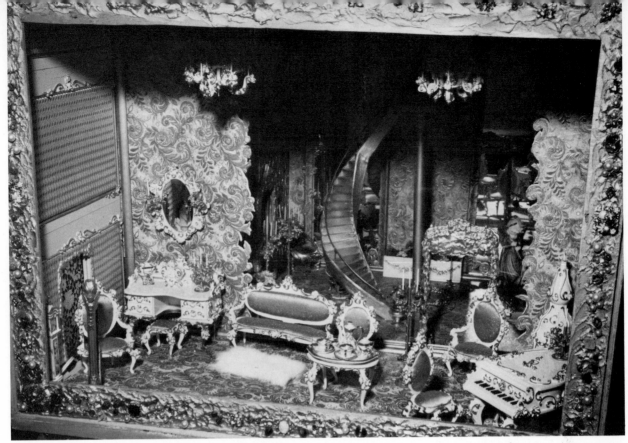

126

The drawing room, which took two years to complete, is furnished with the same Spielwaren furniture shown in the Updegraff house. All of the desk accessories are hand crafted. The walls are blue and gold brocaded paneling. The tea set is bone china. Many of the accessories were found in an antique shop in New Orleans.

127

The living room is keyed to the print on the back wall, which is signed by J. Chamberlain. The walls are painted Wedgwood green on canvas, and the piano is petit point under a glass lid. The door frames and spindles flanking the painting are from old chairs.

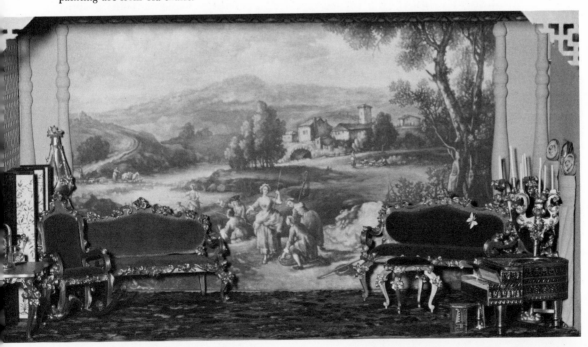

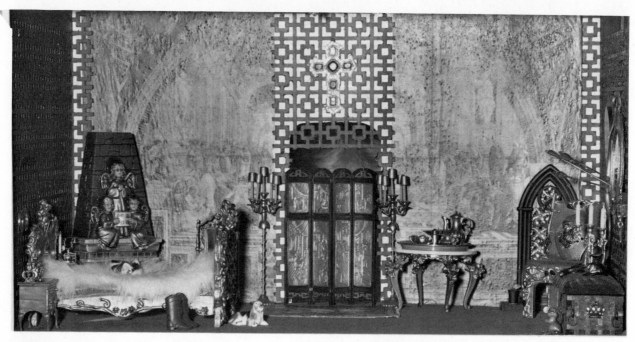

128

The theme for the king's room was inspired by the story of the Crusades. Mrs. Overbeck handcrafted nearly all of the furniture with a cake decorator and jigsaw. The print on the back wall was taken from a magazine and glued onto white latex paint with a little sand in it to give the effect of a rough wall; the print when actually seen shows up very distinctly. On the ceiling the star constellations (made with a cake decorator) are in gold; the prayer altar was formerly a white cake decoration, now gold. The king's crown, shield, helmet, and golden bow and arrow, all found at random in little shops, are seen at right.

miniature books; one of them, a hymnal, measuring 1½ inches by 2 inches, is dated 1835. She estimates that planning for the house took three years; construction on the 2/12 scale (2 inches equals one foot) took another year and a half.

When things are impossible to find, Mrs. Campbell simply makes them herself: for example, the chandeliers. Since antique dolls are also a hobby of Mrs. Campbell, the house is inhabited by a doll family. Notice mother at the desk in the library, grandma upstairs in the parlor, the children playing on the stairs, and the maids at work in the third floor rooms. Father is, no doubt, busy downtown trying to earn enough to support this impressive menage. This house carries a sense of history; from the tiny plaque near the side porch, just off the kitchen (a fire plaque, necessary in the old days to assure the volunteer firemen that you had paid your fee) to the closet full of elegant gowns in one of the upstairs rooms, every detail is perfect.

Last, but certainly not least, of the castle-type collections that are outstanding in this country, is the Reverend Stuart A. Parvin's Stuart Castle and Stuart Manor, which consists of a collection of at least a dozen miniature shops and exhibitions, gathered together in Rockerville Gold Town in the Black Hills of South Dakota.

Reverend Parvin, who has been collecting miniatures for over thirty years, first put Stuart Manor together in the early 1950s, and it has since been on display in department stores across the country.

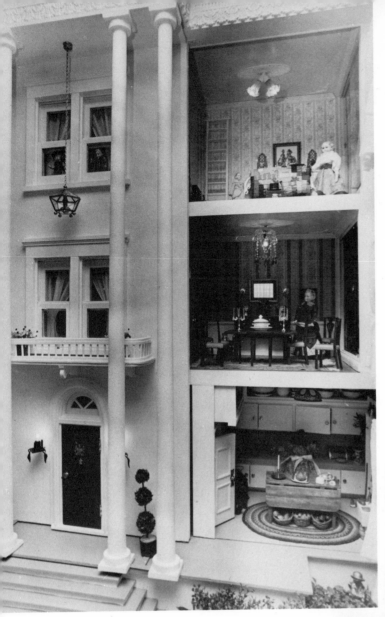

129a & b

The front of the Campbell house opens in three sections; this is necessary since the building is twice the size of the normal dollhouse. Notice the architectural detail on the cornice and the profusion of food in the kitchen. The right side of the Campbell house is a miniature museum of rare salesmen's samples, and the kitchen details are worth careful study. *(Photos courtesy of the Fort Lauderdale News)*

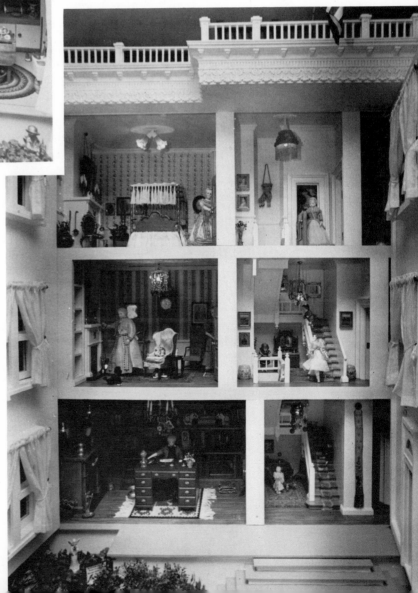

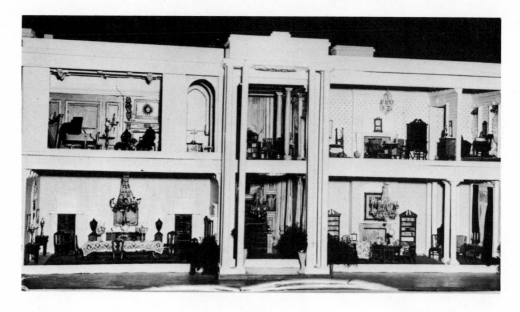

View of one section of Stuart Manor gives an idea of the care with which the halls, neglected in some houses, are decorated. The little arch with altar next to the second floor hall is especially noteworthy.

Designed on the 1/12 scale, the long gray building (figure 130 again, built not as a house but rather as a cabinet for miniatures) is comprised of twelve rooms connected by a hallway running through the center. Tall pillars and panelled walls decorate the first floor hall, while the second floor hall is papered in a handmade copy of an early American scenic paper. A handsome stained-glass window forms the background for the stairway. A room of particular interest is the library of Stuart Manor, for in addition to the many authentic miniatures shown there, it contains a collection of 208 handmade miniature books that represents one of the largest collections in the country.

Stuart Castle, however, is a much more ambitious project. Although it is not an exact copy of any one particular castle, it does reflect the grandeur and beauty of the castles of bygone centuries. This is one dollhouse building that has an art wing; it is a copy of the entrance hall of Syon House in England, done in striking black and white to show off to advantage the miniature art figures and copies of old masterpieces that line the walls. The great drawing room, which is part of the grand hallway, is a masterful piece of construction in miniature; some of the greatest miniaturists in the country have made pieces that are included here. King Arthur's room was designed from ancient drawings that illustrated this legendary tale and copies the details down to the cups and candlesticks on the table.

Houses such as the Campbell house are, of course, specially made and quite expensive, but it's not too difficult to obtain a handmade house today that will serve the collector long and well. Foremost in

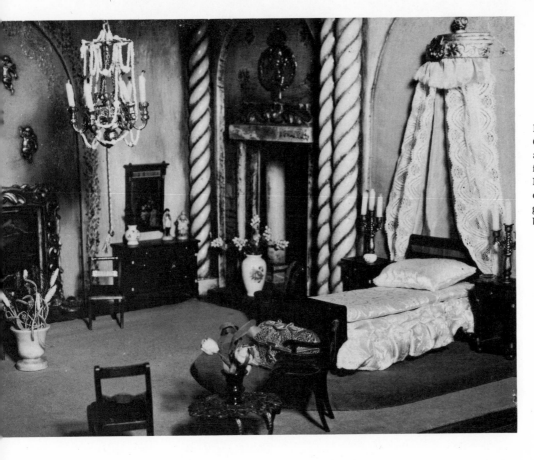

Princess's bedroom in Stuart Castle, done in palest pink and silver with miniatures from all over the world. Notice especially the chandelier and fretwork gold trunk at the foot of the bed.

the list of firms that do this work is a group in Wichita, Kansas, which, under the name of M-A-R Kreations and the guidance of Rita Krutsinger, a professional interior decorator, got together to use their individual talents and succeeded in producing a line of handmade, hand decorated houses that are selling in fine stores across the country. There are four types of houses: modern, Early American, traditional, and two styles of townhouses. Shown in figures 132a and b is a modern house they label "Susan's House," which they offer not only in any state of completion the customer prefers, but also as a prefab unassembled. The designs on this house and the next one are originated and executed by an artist known only as "Elaine" and the furniture that comes with them is handmade by the Handcrafts Group of St. Thomas Episcopal Church in Houston. Members of the Elks' Training Center in Wichita do other work; commercial artists paint pictures and accessories, housewives sew minuscule curtains, senior citizens crochet lacy coverlets for canopy beds. Food sits on the kitchen tables; each room is so completely decorated that in one boy's bedroom one sees a scale-model fishing rod, a can of worms, and a set of

132a & b

"Susan's House" can be
ordered without furnishings
if the collector wants to
furnish it himself, or
complete down to the little
dog in the basket if he wants
a dollhouse without effort.
Everything is handmade
and handfinished. An
especially valuable idea in
the M-A-R Kreations
houses is a floor plan that
designates where every
furniture piece should go.
Notice that even a fern in
a pot is ready on the bar.

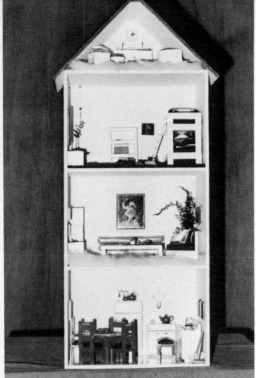

133a & b

"Anita's Town House" is a creation that would delight any collector or child. Notice that the furnishings include bunk beds in the children's room, a fern in the corner, and a teakettle on the stove. The plan for the contemporary furnishings of "Anita's Town House" even includes a lobster on the table and a dish mop in the sink.

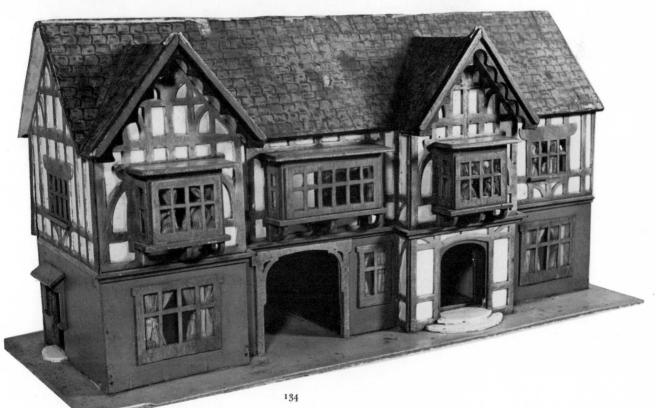

134

"Too Late to Classify" is a newspaper term that applies to this charming English Tudor house (c. 1900), which Marjorie Geddes of the Lilliput Shop found in a California junk shop. A tiny thing—11½ inches tall, 10 inches deep, 23 inches long—it is the traditional English "peek in" house, but the back could be removed and hinged to provide access to the inside. The detail is superb, and by peeking in the windows one can see the written instructions for assembly written on the interior walls. That's a carriage pass on the first floor, to enable carriages to come into the courtyard. The little room at right, only 1½ inches wide, will be called the "Ghost Room" until we get into the house, for there's something rattling around in there. There are four rooms on the second floor, three on the first complete with curtains. (*Photo by Dick Compton*)

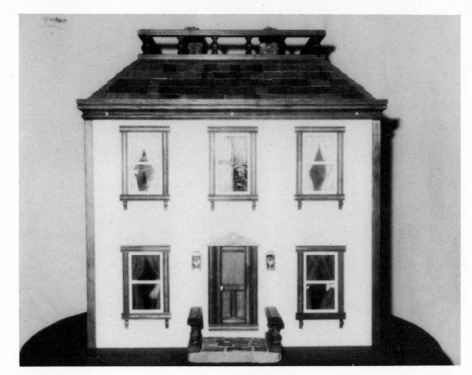

The 1902 house from the
Doll House Factory is topped
with a handsome widow's
walk and roofed with
handsplit cedar shakes.
Curtains are up, and there
is access to the attic from
the rear.

tennis rackets. Such a house, 14½ × 38½ × 31 inches, 2 floors, is offered in the prefab unassembled version at $30.25, completely furnished and finished, $165.00. Our personal favorite is the one shown in figures 133a and b called "Anita's Townhouse." This house, finished but no furniture, is offered at $49.00; with furniture, $110.00

Much more ambitious houses, handmade and one-of-a-kind, are offered by the Doll House Factory in Lebanon, New Jersey. These are turned out as the older, hand-fashioned ones were with wooden beams and handmade cedar-shingled roofs. In the English Tudor house shown in figure 134, the inside is finished even to a stairway, bannister, and curtains. Another house, labeled "Circa 1902" (see figure 135), has five rooms, a staircase, Tiffany windows, curtains, and a real flagstone porch. A little two-room cottage, equally complete, has a hinged roof that opens onto a roomy attic. It appears that there is no dearth of fine craftsmen who love to make miniature dollhouses; it is only a matter of hunting them out.

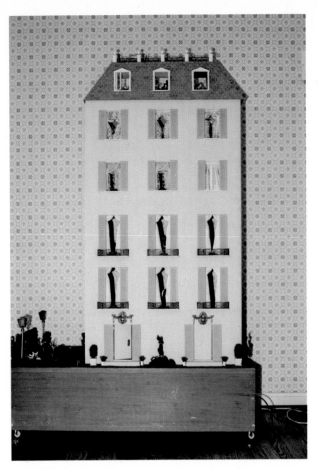

The Mannion house is a cabinet for displaying miniatures. It is mounted on a foot-high stand as were many old houses, and a complete garden decorates the stand.

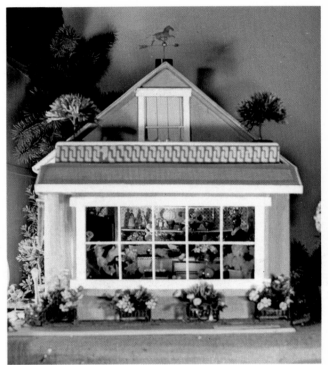

Edith's Flower Shop illustrates the effectiveness of a cardboard carton for a dollhouse building. Notice the elaborate detail, which heightens the illusion. From the Pirie collection.

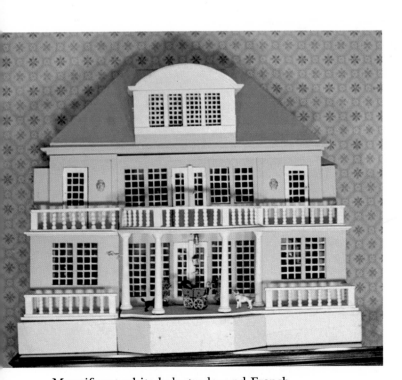

Magnificent white balustrades and French windows show up to great advantage in the Mediterranean mansion from the Adelaide Mannion collection.

The entrance hallway of John Blauer's Maynard Manor is probably one of the
most elaborate of all dollhouse rooms. *(Photo by John P. Probst III)*

This replica of the impressive entrance to the
Carter's Grove Mansion in Virginia represents the
combined efforts of John and Ellen Blauer and
is so complete that even the grain of the wood was
matched in scale.

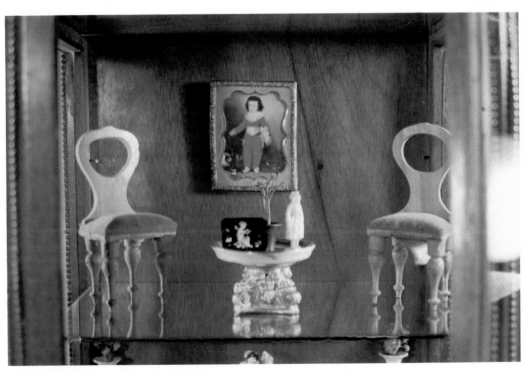

A French mantel cabinet is used here as were the
first cabinets from which dollhouses grew—as a
case in which to display Adelaide Mannion's
miniature collection.

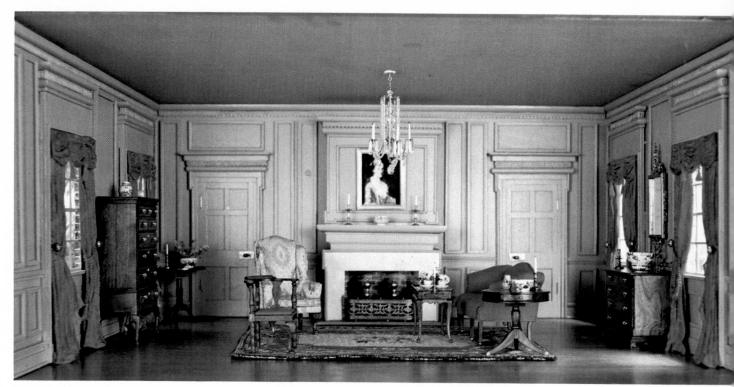

Reproduction of a James River drawing room by Chestnut Hill Studios, which preserves the flavor of the era.

Exquisite detail is apparent in the turn-of-the-century bathroom in Mrs. Mannion's dollhouse. Curtains are from an old silk handkerchief that had hand-hemstitched edges.

Foyer in the Mannion dollhouse is furnished
entirely with antiques. The secretary is French,
c. 1800. Both the stool and wastebasket are rare
pieces.

Betty Rockoff's wedding cake is a masterpiece
that would inspire any miniaturist to create a
wedding party.

The food made by today's miniaturists is almost
unbelievable. These food items are made by
Mrs. Betty Rockoff, who also made the tiny
ceramic pieces in the cabinet.

The hall is the largest room in the Overbeck Fantasy Castle. Two stories high, mirrors cover one wall, and a golden pillar supports a winding stairway. All of the furniture is Spielwaren.

The living room in the Overbeck Castle is keyed to the Chamberlain painting across the back of the room. Furniture is handcrafted and gilded; the grand piano is made of petit point under glass.

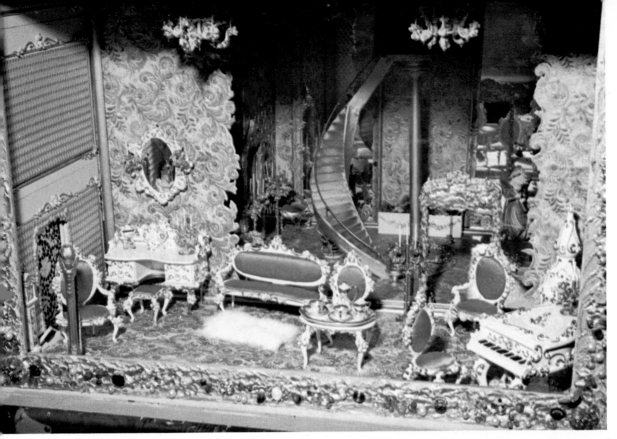

The King's Room was inspired
by the story of the Crusades. The
colors are gold and purple, and
all the furniture was hand-
crafted. A jigsaw and cake
decorator were used to make the
bed and chair. On the rear wall
is a print of "Gathering of
Great Philosophers" by Raphael.

A three-foot pink and silver
crystal tree centers the garden,
which is filled with tiny ceramic
animals. The china flower beds
were originally table center-
pieces; the flowers were obtained
from and arranged by a florist.

Ceramics by Barbara Epstein from the Microbius kilns are impressive. The Wedgwood on the fourth shelf actually has the raised motif characteristic of this ware.

A sampling of the handpainted oils by Jo Redfield from the Lilliput Shop. These may be ordered in originals or copies of old masters; even portraits are available.

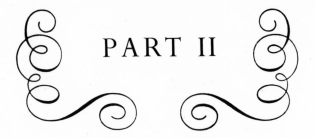

PART II

7

Introduction to Dollhouse Miniatures

ONE OF THE MOST SATISFYING ASPECTS OF COLLECTING, PARticularly with dollhouse miniatures, is that one's life takes on a whole new dimension—that of awareness. The collector knows that everything is grist for his mill, and yet few of the really worthwhile fittings for his dollhouses are to be found by going into a shop and asking to see their miniatures. But if you'll take time to browse with awareness, you may find a very heavy little brass candlestick, about 1½ inches tall, that is packaged with imported incense. Or a tiny, 1-inch diameter crystal salt dish, which will make a lovely dish garden. In just such a shop, I recently picked up a set of four tiny porcelain dishes decorated to simulate a Chinese sampan; they were about 3 inches long and 1 inch wide, curving to points at the ends, and complete even to the little cabin, carefully colored, on the top. They are used for resting one's chopsticks on after eating, the shopkeeper told me, and they may not be old, but I shall find some way to float one of them on a little garden pond in the grounds of the Victorian house to complete one of the little miniature "walking gardens" the Japanese so love and which the Victorians tried so hard to emulate. Measured to scale, my sampans are a little less than the ¹⁄₁₂ I use in most of my houses, but they'll be lovely, and my joy at finding them knows no limits such as scale.

Shells are particularly wonderful, since they fit so perfectly into old houses. Once you fall prey to the collector's itch, you'll never

again stroll a seaside beach looking at the waves; your eyes will be on the sand, searching for intriguing shells. The little pond in the angle of the fence of the plantation mansion in my collection is a shell. Tiny shells are often found in beautiful hues and with ridges and curves that challenge the imagination. They make wonderful ash trays, once tiny beads have been glued to the bottom for feet.

Roam the discount stores—this is a thrill almost equalling a visit to Indian bazaars or Honolulu's International Market—looking not for bargains but for possibilities for your collection. In such a store I recently found a tiny wind chime, an exact replica of those favored on Victorian piazzas, for a dollar. Even the strings from which the tiny pieces of glass were hung were colorful and beautifully woven. In that same store, believe it or not, I found a stack of rabbit skins at $1.37 each, nicely cured and dried and about the right size for the floor covering in my Ozark log cabin. Oddly enough, they were marked, "Made in Italy." I plan to cut mine down and make a small rug for the floor plus two or three even smaller skins to hang on the wall. Items such as these are new, of course, but even though you favor antiques, welcome them. They'll age.

Just keep your eyes open and make the rounds of the shops regularly, so the people in charge grow to know you and will set aside the things that may appeal to you.

And, especially, try to get into attics. For example, the one surviving example of the "peep" (poppy) show we acquired came to light at a dinner party when we were telling the story of the search for one, and one of the guests said, "Oh, I'm certain I have one in my attic; Charles made it when he was in the sixth grade!"

The two sets of furniture shown here in figures 150 and 154, old enough to appeal to the most dedicated of antique hunters (the bent reed set, top, is illustrated in the Sears, Roebuck catalogue of 1909 and the stencilled set of the Biedermeier rosewood class dates from about 1875), also were inadvertently turned up in attics. A friend of the author was clearing out the attic of a very elderly aunt living on the outskirts of St. Charles, Missouri, and came upon them still in place in an old dollhouse. They had been in the family since the mid-nineteenth century.

8

Decorating with Miniatures

THE FORTUNATE COLLECTOR WHO HAS ACQUIRED A SO-CALLED pure house, that is, one in its original condition with original furnishings (see the house in figure 59), doesn't have to worry about decorating his treasure; beyond a little renovation, he can enjoy it as it is.

Increasingly, however, collectors are searching for cabinets to contain their miniatures or are having houses built based on their own designs, either because they cannot afford or find the old ones or because they really prefer contemporary ones. Thus, the collector continually faces the age-old but ever-new question of which comes first, the chicken or the egg—in the collector's language, the dollhouse or the miniatures that go into it. As a group, we have widely divergent opinions. The fascinating thing about dollhouses, however, whether they are of primary or secondary importance to us as collectors, is their infinite variety—in the ways in which each owner unwittingly imposes his or her personality on the houses.

There should never be an instance where the collector, like the nouveau riche homeowner, buys a set of books for the living room because the bindings match the carpet, or invests in an Oriental rug in order to impress his friends with the amount of money he has to spend.

Dollhouses warm as they exemplify our spirit. Here we can indulge all decorating impulses. And we can decorate to our heart's content; we can begin with about a quarter yard of material and a half pint of paint and proceed as though we were charter members of the American Institute of Interior Designers (A.I.I.D.). A side benefit is that our nerves, frazzled from the frenetic pace of life, are calmed and restored by the therapeutical effect of working in the tiny rooms.

We gain confidence in ourselves: If we like to combine pink with purple and Jacobean with Queen Anne, we can do that, because our house is to be a reflection of our own likes and dislikes.

Be that as it may, it behooves the new owner of a dollhouse to learn a bit about interior decorating, if only to enable him to stamp his house with his own personality. I would suggest that the collector will gain a great deal and have a lot of fun if he will study a few of the books on interior decoration available in his library so he will know not only what is appropriate but what he wants to do.

First, you want to set a mood. Notice, in the kitchen pictured in figure 136, which is from the author's "Tara," a pre-Civil War mansion, that a certain amount of clutter brings a feeling of life to the room. The bowl of knitting on the seat of the hutch chair bespeaks motion and life; the herbs hanging from the beamed ceiling, the pots and pans ready on the mantel, the churn at the sink, all tell us that someone lives here. I should have liked to have added one more touch —perhaps a bit of potato peel curling from the edge of the table, or a smudge of flour on the floor. Even without these touches, however, we know that this is a living house. The furnishings show off to best advantage (notice the "pie safe" made by Suzanne Ash of Mini Things in the far left corner) because they seem real. Set aside a little corner of your mind so that you can watch for such touches, and see how much more alive your dollhouse will become.

Don't be a slave to period, unless you are endeavoring to create a house that will be an exact picture of a period. Some collectors, because they have a Victorian house, confine their searching, their efforts, largely to Victorian things, but that isn't the way life-sized houses are furnished. The houses we live in are often furnished with the carved chair that came down from our grandfather, the campaign bed and chest that was left us by Aunt Herminie, the dishes that a letter from another ancestor proves were actually eaten from by George Washington. To say nothing of wedding gifts we didn't really need, but must have on view because they came from a close friend or relative.

In figures 138 and 139, the Faurots of Willoughby's 18th Century have actually created true eighteenth-century moods by making every

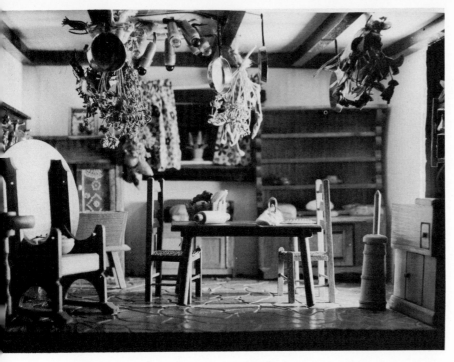

136

Typical of the unlimited
possibilities in decorating to
accent the mood is this
kitchen wing from the
author's plantation house,
simply because it shows so
many signs of being lived in.
Notice the loaves of bread
on the cabinets at the back,
the knitting bowl on the
hutch chair, the herbs and
pans hanging from the
beamed ceiling. The floor
is a modern kitchen tile in
a slate pattern.

137

Every room must have a
focal point, and in the
author's southern mansion
the fireplace fills this need.
It was handmade at
Chestnut Hill Studios with
handpainted herb tiles; the
Buddha on the mantel is a
smoky topaz pendant found
in a New Orleans pawnshop;
the Staffordshire dogs on
either side are from Mel
Prescott. The brass fireplace
fender is a piece of brass
banding, bent to fit, and
the andirons are lamp
finials. Hand embroidered
screen is from Willoughby's
18th Century, the harp a
gift to the author from
Joseph H. Gray, a collector.

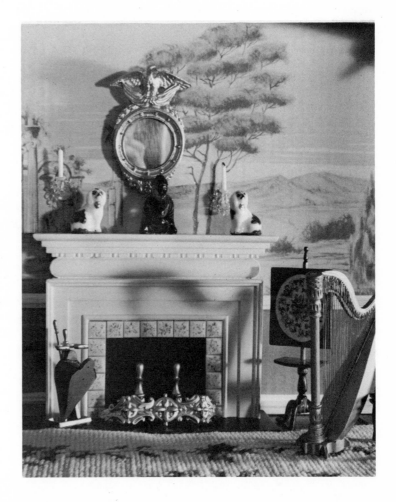

138

In the eighteenth-century
milliner's shop, period and
mood are established by
many details, but
principally by the glimpse
of the living quarters beyond
the door. The picture on
the wall at left is a color
photo from the Williamsburg
Craft House catalog, one of
a group of four depicting
the four seasons and in
exactly the right scale.

139

In this Willoughby
"common room" or
"meeting room," something
like the lobby in today's
motels, the eighteenth-
century mood and the season
of the year are established
by the judicious use of the
proper pieces for an
"ordinary," or stopping
place.

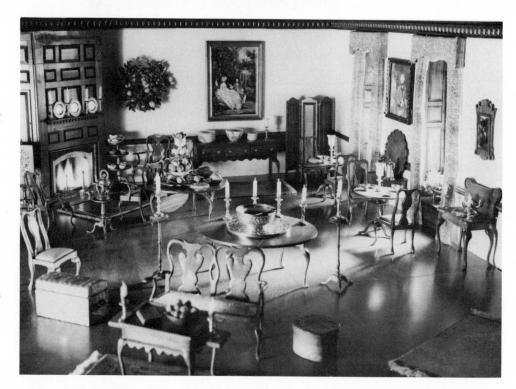

detail conform. The first is a milliner's shop with the shopkeeper's
parlor visible behind the shop as was the custom. Notice the little
casual touches: the scissors on the floor, the little baskets beside the
desk, the hats and ribbons on display.

The next photo of an eighteenth-century "ordinary," while a bit
cluttered, does the same thing. We know that this is the winter season
because of the fire in the fireplace. The table in the background as

well as the muffin stand are loaded with food; the punch bowl is ready for the travelers. All of these miniatures are from Willoughby's 18th Century.

In the bedroom, also from Willoughby's, we almost feel the presence of the person for whom the room was created. The leather hatbox and trunk have just been unpacked; the chess set stands ready for the players. Madame's hat is on the stand at the extreme right, and the towel for her bath is on the rack. Notice here, too, the use of the same design of material for walls, bed finishing, and draperies, as are shown in figure 141.

Casa Tootsie in figure 142, from the Snyder collection, also has its own ambience. Mrs. Snyder had this cabinet built to accommodate her collection of Tootsietoy furniture, but notice how careful she was to

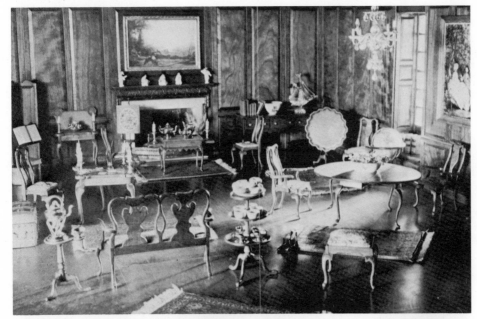

140

The Willoughby drawing room is an authentic picture of the eighteenth century with reproductions by Wes and Jeanne Faurot of Los Altos, California. Notice the silver coffee set on the Queen Anne table, and the settee with fiddle-shaped splats—one of the earliest settees of the period, c. 1720.

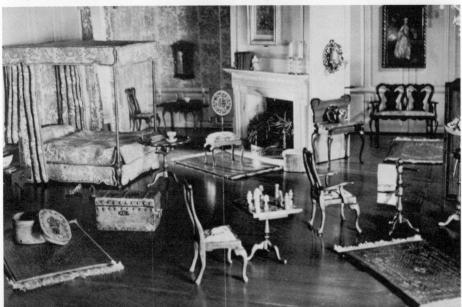

141

Bedroom of the Queen Anne period, c. 1725, showing another use of chintz material used on both walls and bed, by the Faurots. All pieces here are from Willoughby's 18th Century.

111

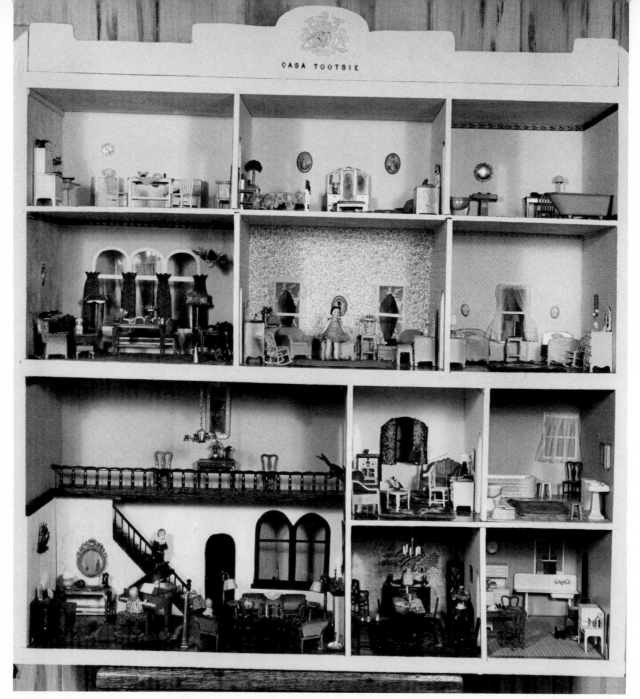

CASA TOOTSIE

142

Even the name, "Casa Tootsie," is borrowed to help produce a setting appropriate for Mrs. R. B. Snyder's collection of Tootsietoy furniture. The cabinet, on a $\frac{1}{12}$ scale, contains virtually every piece made by the Dowst Company in their fifteen years of manufacturing dollhouse furniture. The living room has pecky cyprus paneling and balcony. The cabinet was constructed from a bookcase.

preserve the Tootsietoy mood. The two-story living room with a Spanish flavor could have come right off a Tootsietoy box; the triple curved windows in the drawing room just above are all equally important. In addition to preserving the particular flavor of the furniture, Mrs. Snyder has put a family in the house. Notice the little girl at the piano, the mother coming down the stairs, and the teenager in the upstairs room. Mrs. Snyder makes some of the dolls herself, just so she can be sure that she has "people" in the house who really belong in it.

9

Miniature Furniture

I N THE FURNITURE CATEGORY OF THE MINIATURE WORLD WE AGAIN
seem to divide naturally into classes: as collectors into begin-
ners, intermediate, and advanced; and as decorators into those who
decorate simply for pleasure, those who decorate in order to reproduce
a period of time, and those who don't decorate but simply want to
display their prizes.

Just as Tootsietoy opened new vistas for miniature collectors in
the 1920s and Tynietoy introduced plastic furniture in the 1940s, the
Shackman Company is one of the most innovative miniature manu-
facturers for today's neophyte collector. Federal Smallwares, the retail
outlet for the Shackman Company, is located at 85 Fifth Avenue in
New York. I have heard (unofficially) that when the Shackman peo-
ple come across a piece of very fine miniature period furniture, they
figure out how to mass-produce it and then have it made in Japan.
They use good craftsmen; Hermania Anslinger of Spokane, dean of
carvers of miniatures, once made miniatures by the gross for Shack-
man. Their catalog lists more than 200 pieces of furniture and ac-
cessories, all at prices the middle-income collector can well afford. The
collector can find everything she or he could possibly need in the
Federal Smallwares catalog—not only basic things, but also necessary
refinements.

Sheraton, Duncan Phyfe, Hitchcock, and the Adam Brothers are

all represented. There are pieces from every English period, from Jacobean to Queen Anne, and every American period that is classified by decorators. Some pieces are made of cherrywood; most are made of a coarser wood. In most cases the hardware is nicely reproduced and the finish, while not what the real artist can produce, is quite good. In addition, I'm told that Federal Smallwares puts broken or less-than-perfect pieces on sale once a week or so at vastly reduced prices. These pieces are easily repaired and emerge as good as new.

However, collectors don't remain neophytes for very long, and as the learning collector becomes more discriminating, he soon becomes disenchanted with such details as the legs on Shackman pieces, which for the most part are not turned, but cut with angles at the edges, or with the finish, which in some cases shows signs of having been turned out somewhat hastily.

The Faurots of Willoughby's 18th Century decided that the eighteenth century was the period they most wanted to reproduce in miniature and spent several years engaged in researching the era. Their efforts were rewarded; now they are able to offer magnificent miniatures on a scale of an inch to a foot that any collector would be proud to own—at reasonable prices. Here is shown their commode, pole screen, globe, kettle stand and warmer, and Queen Anne table, together with their sterling tea set (figure 143). Following is their armchair (figure 144) with bracketed legs that, drawn up to a card or chess table, is one of the loveliest pieces of the collecting world. A shaped splat and inversely arched cresting distinguish the design, and the slip cushion is of lovely brocade.

143

Studies of various periods greatly assist the beginning or intermediate collector in making wise selections. Here, we show an assortment of Queen Anne pieces from Willoughby's 18th Century, together with a sterling silver tea set from the same miniaturists. From the author's collection.

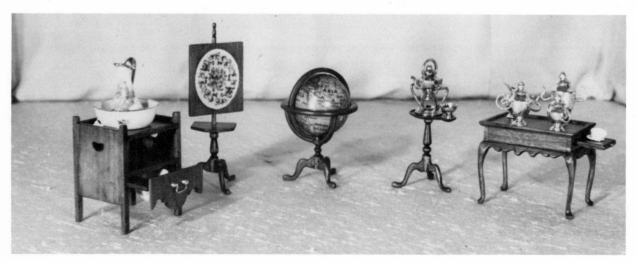

144

This Queen Anne side chair with bracketed legs is a classic. Such pieces, even those from the original designers, may be found in antique shops today.

145a & b

The Queen Anne bed, also from Willoughby's, is shown here both dressed and undressed; the silk used is a gold-on-beige pattern that is offered by the yard. From the author's collection.

146

Of particular interest to
the collector is the winged
fireplace in the Willoughby's
18th Century collection.
Here, solid beveled cherry
has been used.

147

This 5-inch chaise longue
was made by Elizabeth Zorn
and Jean Kirkwood, the
proprieters of the Ginger
Jar. c. 1725–50, the
reproduction features a
caned seat and adjustable
back.

A Queen Anne bed is pictured in figures 145a and b both dressed and undressed. This one is an exact copy of the original now in the George Wythe house in Williamsburg, Virginia. Notice, particularly, the construction of the bed; the roped spring and plain headboard. These are beautiful things no matter what their age.

The winged fireplace, pictured in figure 146, deserves every collector's study. It is the only reproduction of a winged fireplace that is currently available. It is made of solid cherry beveled paneling, and the hearth and facing give the appearance of European marble. The firebox is appropriately smoked for a lived-in look. The fireplace is provided with paneled wings, which can be swung to the wall or swung out spread-eagle fashion, for an elegant corner.

Another fascinating piece for collectors is the miniature chaise longue (long bed in France), also known as a couch in the United States and a day-bed in England, which is made to order only by Elizabeth Zorn and Jean Kirkwood of the Ginger Jar (figure 147). The original life-sized chaise longue is mentioned in inventories as early as 1645 and was considered a piece of considerable value. It was usually part of a set of corresponding chairs. The reproduction is fashioned after the Dutch-style couches of the 1725–50 era, with cabriole legs with turned stretchers, and it features a caned seat (126 holes; really to scale) and an adjustable back. It measures 5 inches long, 1⅞ inches wide, and 3¼ inches high at the back posts.

The secretary pictured in figure 148, from the Mannion collection, should appeal to the last group of collectors—those interested in

148

The antique secretary from the Adelaide Mannion collection was found in an English antique shop, but it is most certainly French, c. 1800.

antiques. It was found in an English antique shop, and has been appraised by various experts as being c. 1800. It carries no hallmark, but the handwork on it seems to mark it as French. The inside of the drop front is covered with padded tooled leather, and the stool is an equally rare and old piece of French enamel found in a local shop. The very handsome wastebasket looks like silver but isn't; the basket weave pattern at the bottom marks it, too, as very old and it certainly is rare.

The collector who favors antiques might keep his eye open for a set of the French nineteenth-century miniatures shown in figure 149. French furniture pieces of this period occasionally turn up, and although there is no mark on the pieces, a collector will readily recognize them from the bulbous underpinnings and the nice work on the edges. Notice the similarity between these chairs and those shown in the Mannion cabinet in figure 7.

During the last half of the nineteenth century, the furniture variously called "rosewood" or Biedermeier was manufactured in large quantities in Germany and to some extent in this country. Many pieces have survived, and the alert collector may come across individual pieces at antique sales and in antique shops, and with special luck may find entire sets. This furniture is almost always made of a fairly dull black, with a stenciled decoration printed on paper and then glued to the wood base so that it has the appearance of a stenciled design. The decoration shows up very clearly on the little commode in figure 150. The sofa is in a fine state of preservation except for the silk covering, which has disintegrated. In the background, the dresser, chest, and little armoire with the row of hooks (very tiny shoulder hooks) are probably of a later date. The table at which the chair is drawn up is also stenciled, although most tables were devoid of deco-

150

Rosewood or Biedermeier
furniture was turned out in
quantity in the last half of
the nineteenth century in
Germany. These pieces are
from the Hulda Goebel
collection.

ration. The table at lower left is plain, but with a marble top. Chairs,
too, were usually undecorated, as are the chairs in this figure and the
desk chair in figure 151. The desk, a really lovely piece, has one bit of
trim missing, but we can't imagine a collector spurning it because of
this one small mishap.

Another set from the Goebel collection not so readily found but
still obtainable at antique shows, is the pine furniture shown in figure
152. This American primitive furniture, which collectors find so
charming and intriguing today, was most common in the middle of
the nineteenth century but, because of its fragility, is rarely found
now. The pieces are made of twigs from pine trees (notice the prickly
appearance where the needles have dropped) and are put together

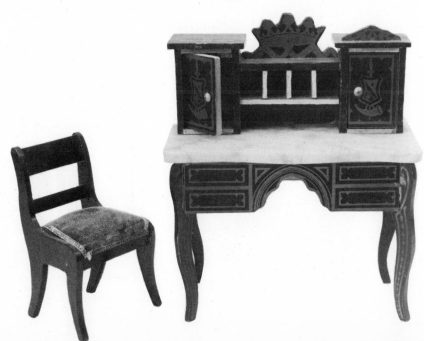

151

The same furniture, but
from the Evelyn Ackerman
collection, shows how exactly
the rosewood pieces were
copied. Watch for a fairly
dull black finish with
stenciled gold decoration.

152

Pine pieces, c. 1850, are an excellent example of American primitive that are rare nowadays because they were so fragile. These pine pieces were made at home and held together with pins. Note the artist's use of pine twigs with "buds" as finials.

with pins instead of glue or tacks. Then the seats are made and set in. This set needs a bit of renovation because one of the back panels is missing, but otherwise is in fine shape. The chairs are upholstered, oddly enough, in two shades of velvet; some sets of this type included a table made of a 3-inch diameter slice from the pine trunk fastened to the legs with more pins. A find indeed for the collector who comes across one—and remember that this set was found, long forgotten, in an attic.

The two cupboards pictured in figure 153 are of the same period, c. 1840, and also were undoubtedly made at home. There is a bit more expertise shown here, though, for someone apparently has acquired some sort of saw and applied the carved backs at the top. The one on the left has distinct panels of orange paint on each side, giving almost a Pennsylvania Dutch appearance. They are a bit larger than the $\frac{1}{12}$ scale, but they must have added a fine bit of color to a dollhouse long ago.

153

These pine cupboards were made by one of Hulda Goebel's ancestors, c. 1840, perhaps for a child's Christmas. From the Hulda Goebel collection.

154

In the late nineteenth and early twentieth centuries, reed furniture was in great favor; it is illustrated in the Sears, Roebuck catalog of 1909 and was carried for about five years after that. From the author's collection.

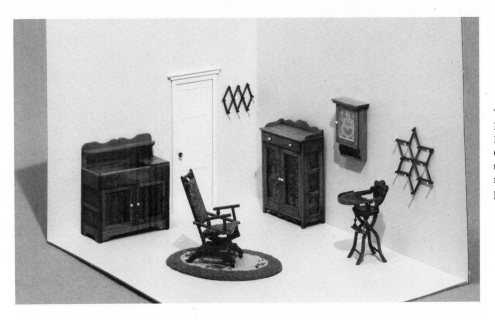

155

Victorian pieces made by Morley Miniatures of Huntington Beach, California are true miniatures. All have been reproduced from full-sized pieces.

The collector who doesn't insist upon antiquity will find much satisfaction in the Victorian pieces pictured in figure 155, which are done by Morley Miniatures of Huntington Beach, California. Bear in mind that these are true miniatures, and not the same as a great deal of small furniture on the market that is simply produced to look like miniatures. These pieces are originals, each piece signed, and thus are made in very limited quantities. For example, the little high chair, 3¼ inches high, has a tray that swings back and a movable foot rest. The back and seat are constructed from three pieces laminated together to give the slatted effect. It has been faithfully reproduced from a full-sized chair in the Morleys' own collection. The same is true of the pie safe; the scrolled top makes a fine place to display other miniatures, and the double doors and both sides are of antiqued pierced tin. Over 100 separate parts go into such a piece. Finishes on all the Morley

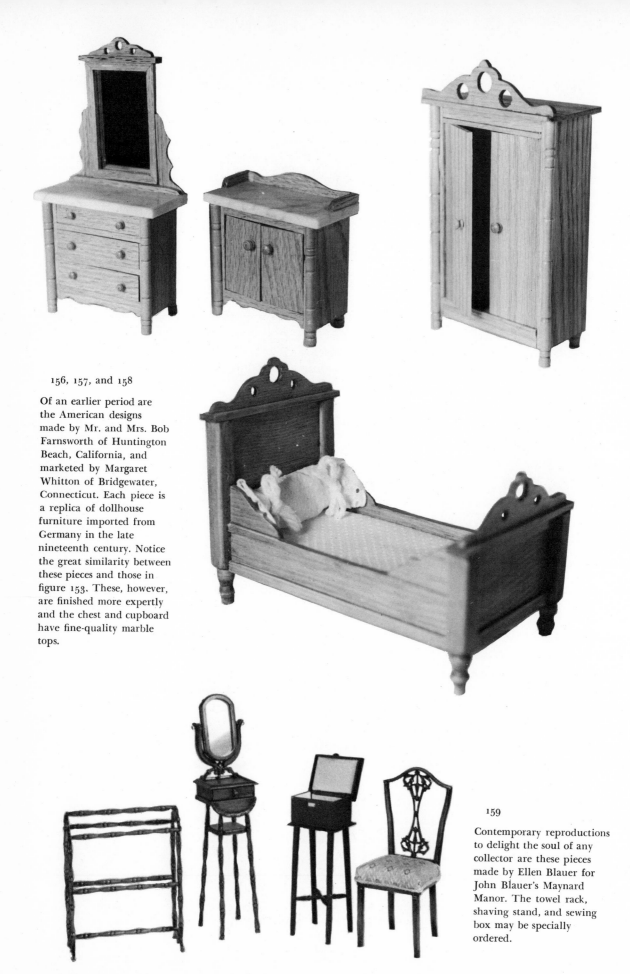

156, 157, and 158

Of an earlier period are the American designs made by Mr. and Mrs. Bob Farnsworth of Huntington Beach, California, and marketed by Margaret Whitton of Bridgewater, Connecticut. Each piece is a replica of dollhouse furniture imported from Germany in the late nineteenth century. Notice the great similarity between these pieces and those in figure 153. These, however, are finished more expertly and the chest and cupboard have fine-quality marble tops.

159

Contemporary reproductions to delight the soul of any collector are these pieces made by Ellen Blauer for John Blauer's Maynard Manor. The towel rack, shaving stand, and sewing box may be specially ordered.

pieces are beautiful, and the reproduction of tiny details is almost incredible.

The little square piano and pair of candlesticks in figure 211 are of the same period but of a more formal style. These were executed by Mrs. Mel Prescott of Warrenville, Connecticut, and are beautifully made pieces. However, Ms. Prescott is one of the vanishing tribe of accomplished miniaturists who makes everything by hand. The Prescott pieces will never flood the market as, for example, the Biedermeier pieces did, and, consequently, will continue to rise in value.

The first half of the twentieth century didn't produce much in the way of fine miniature furniture. However, in 1942 the Carl Forslund Company of Grand Rapids began to offer a line of "salesman's samples," which were available until around 1952. These pieces are beginning to pop up today in collections and shops. They are copies of the well-known Forslund life-size pieces. Forslund's miniatures were an adaptation of salesmen's samples. They were beautifully made, but were discontinued because the craftsmen would no longer make them and many of the original craftsmen have passed away.

The miniatures of the Forslund line, called Quaint American Cherry Furniture, are Victorian styles. They were handmade, scaled an inch to the foot, and had a genuine deep cherry finish. Some of them seem slightly smaller than the 1/12 scale, but they are beautiful in any 1/12 room into which they are put. The table on the left in figure 160 is the Oliver Lee candle table, 2 inches high and 1⅛ inches square at the top; it originally sold for $3.95, but if one finds one today at $25, it is a great bargain. The table at right in figure 160 is the Cherry Lee occasional table, 2½ inches high and 1⅝ × 2⅜ at the top. It sold for $5.25 and has appreciated in value at the same rate as the candle table.

In addition to the separate pieces, Forslund offered cherry shadow boxes for display purposes, and they made charming containers for the miniatures. The backs were covered with tiny documentary wall paper, and with a $15 order for the miniatures, the collector received a shadow box free. By 1952, the box with nothing more than a desk and chair was $9.95, which they called a $22.75 value. However, finding one today at $22.75 is just a dream; a more likely price would be

160

The Oliver Lee candle table from Carl Forslund, left, 2 inches high, and the Cherry Lee occasional table, right, 2½ inches high, were two fine pieces issued by Forslund that may still be found. Collection of Mrs. R. B. Snyder.

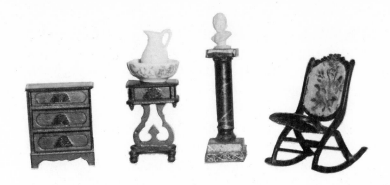

Rare Forslund miniatures, all signed and dated, are from the Phyllis Rembert collection. The folding rocker with petit point back and seat is particularly fine. The dresser and stand by Forslund show the usual finishing finesse. On the wash stand is a rare flow blue bowl and pitcher. The statuary is unidentified.

$122.75, and that would be possible only if you didn't have another collector bidding against you.

The pieces may be spotted by the exceptional finish and by the stamp underneath or on the drawer bottoms that reads "Copied exclusively for Carl Forslund by Hilleary House." Mrs. R. B. Snyder, who specializes in the Forslund miniatures, reports that the word "Hilleary" is somewhat smudged on her little table, as it is on this writer's, so neither of us can be positive as to the actual identity of the artist.

With a few original pieces, the collector might turn to the great reproductions of period pieces that are available today. Good reproductions are not cheap, but they make it possible to put together an interesting collection. For example, Mel Prescott makes an American highboy with broken-arch pediment, carved rosettes, three ball and spike finials, cabriole legs, pad feet, and single ball-drops at the bottom that is an almost exact copy of an 18-inch-tall highboy in the Winterthur Museum. Highboys in the $\frac{1}{12}$ scale are rare indeed. They were originally made in the style of Queen Anne with cabriole legs, in William and Mary style with trumpet legs, and in Chippendale style with bracket feet.

Mary-Dudley Cowles and her husband, Arthur, of Chestnut Hill Studios in Churchville, New York, make a similar piece (the Connecticut highboy described above dates from 1750 to 1780; that from the Cowles is a Delaware Valley design dating about 1730–50) that is a little less elaborate than the Prescott piece, but does include a skirt of pleasingly intricate fretwork edge and cabriole legs with drake feet. On either piece the brasses are beautiful. However, the collector is not likely to come across such pieces unless he is lucky enough to find one included in the dispersal of an estate. Both these miniaturists sell by mail only.

The Tootsietoys and Tynietoys of the 1920s were turned out by the million, and were sold in dime stores all over the country. In spite of this today they are much sought after by collectors. There persists a

small band of collectors who are constantly looking for these pretty houses and sturdy, irresistible pieces of furniture. We quote here from an article written by Mrs. R. B. Snyder for the Spring 1973 issue of *Nutshell News*:

> Tynietoy furniture is very distinguishable in its construction, finish and decoration. Most pieces were done on a jig saw, glued and nailed, and have working doors and drawers. "Curving" legs are actually flat [Editor's Note: like present-day Shackman]. Only a few pieces were lathe-turned such as the Victorian bedroom and butterfly table. Finishes were a warm mahogany, black walnut, maple and paint. Oak and pine finishes were available a few pieces at a time.
>
> All upholstery was hand-painted by artists. Panels, inlays, decorations and a few drawers were also painted and stencilled. Drawer and door pulls were mostly of turned brass, but some are of wood.
>
> The Tynietoy mark, stamped in the wood, shows a two story house flanked by a toy pine tree on the left and a ladder-back chair on the right. Earlier pieces say "Tynietoys" under the mark and later pieces say "Tynietoy, Inc." I am told that some pieces had paper stickers. Some had no marks at all, but this is a rare exception. . . .

Mrs. Snyder, warming to her subject, goes on to say that, like Tootsietoys, the array of pieces is overwhelming, as is the number of accessories. And, to prove our point that lightning does sometimes strike twice for faithful collectors, she closes with a report that a collector, one Dorothy Grenewitzki, had a piece of luck that renewed every collector's hopes; she bought a sackful of dollhouse furniture from the Goodwill store for sixty-nine cents and found that it was a full selection of Tynietoy pieces. Admittedly, many of us will not be as fortunate.

162

The Tynietoy cradle from the Ackerman collection is stamped with the Tynietoy hallmark. Mrs. Ackerman reports that Tynietoy even produced a series of miniature watercolors signed by Grace Dayton and stamped "Tynietoy" on the back.

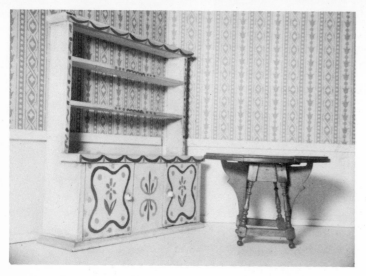

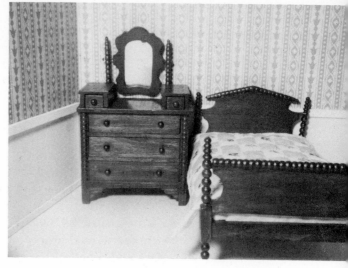

163

Early peasant dresser and butterfly table from the Tynietoy line. Notice the delicacy of detail in the decorations. Collection of Dee Snyder.

164

Tynietoy Victorian spool bed and dresser. The dresser originally sold for $5.00; it would be a bargain at many times that price today. From the Dee Snyder collection.

Brandt House, named after the collector's husband who built it, is a turn-of-the-century home of seventeen rooms. Standing four feet nine inches high, five feet wide, details of interest to any collector are the doors opening into back halls, the attic rooms under the mansard roof, and a sliding glass front. It is furnished in Old German, Old French, Old Iron, Tynietoy, and old and new handcrafted pieces. Mrs. Synder herself made more than seventeen reproduction pieces for the house and a large family of twenty-six dolls inhabits it. Three Florida miniaturists are represented; Frieda Leininger made the dishes, Frances Davis some of the dolls, and Marty White some of the furniture.

There is a new line of eighteenth-century French miniatures that is simply exquisite. They are carved and finished by hand of mahogany with a carefully antiqued off-white finish. In addition, the upholstery is a fine scarlet velvet instead of the dull browns, blacks, and greens that some miniaturists use in the hope (a vain hope, alas!) of pleasing everyone. So far as we know, the Windfall Shop in Sharon Springs, New York, is the only source that has secured these pieces for distribution in this country. They are expensive, but are worth the collector's consideration because they will live on, with no diminution in value.

165

Tynietoy eighteenth-century pieces: bonnet-top bookcase and Chippendale high and low boys. The finish on these pieces was superb. They can readily be identified by the hallmark on their undersides. Collection of Dee Snyder.

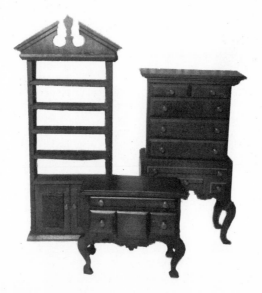

166

Brandt House, named after the collector's husband, who built it, is a turn-of-the-century home consisting of seventeen rooms. Standing 4 feet 9 inches high and 5 feet wide, its doors open into back halls, the attic rooms open from the mansard roof, and there is a sliding glass in front. It is furnished with Old German, Old French, Old Iron, Tynietoy, and other old and new handcrafted pieces. Three Florida miniaturists are represented: Freida Leininger made the dishes, Frances Davis made some of the dolls, and Marty White made some of the furniture.

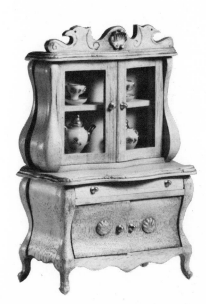

167

The buffet highlights the dining room set, which includes a table and straight chairs. All of these pieces are made of solid mahogany, handcarved, with antique white decoration.

127

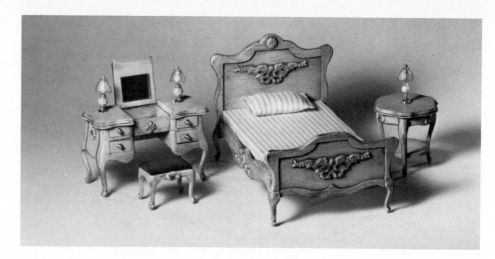

168 & 169

These miniature bedroom
pieces are French. Shown
are the furnishings for a
complete bedroom including
a desk and armchair,
dressing table and stool,
bed and lamp table,
complemented by a commode
and armoire. Their carved
trim is elegant, and the
brass hardware is beautiful.

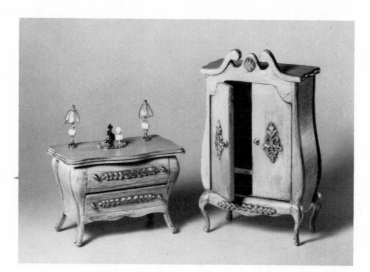

170

In a new French line of
reproductions, the collector
might well compare this
handcarved piano and stool
with the Petite Princess
piano and the Spielwaren
piano shown in the
Overbeck castle, figure 126.
The decoration is scalloped
shells and garlands touched
with gold. The harp above
the simulated pedals is
made of brass.

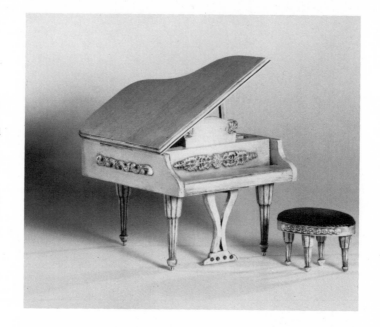

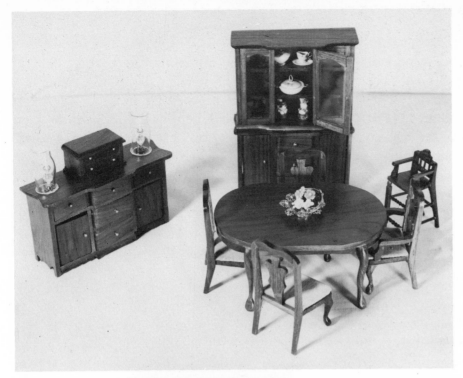

171

Handsome dining room set, silver chest, and high chair are made of handcarved mahogany by B. Leo Fallert. The tiny gold basket on the table is from Florence, c. 1850. From the author's collection.

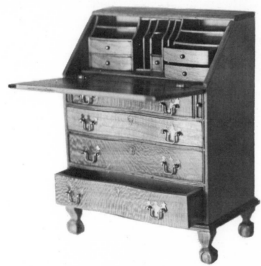

172, 173, & 174

These pieces are from Edward G. Norton, one of the most accomplished of miniaturists, and are for the advanced collector; they are expensive, but will prove the heirlooms of tomorrow. The first is a serpentine front desk with turned and carved legs, copied from a museum piece. Next is a desk on frame in cherry wood with cabriole legs and pad feet, a pierced skirt and inlaid drop front. The third is a block-front chest copied from one c. 1800, with carved shell decoration.

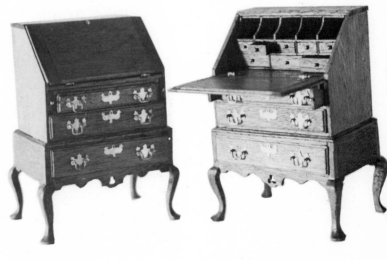

Another talented wood-carving miniaturist is B. Leo Fallert of Ste. Genevieve, Missouri. Fallert has no lists, no brochures, but has outlets in a few places: Trinkets and Treasures in New Mexico, and the prestigious Country Store in the Jefferson Memorial in St. Louis. He can make only a few pieces—every bit of his carving is done with a pocket knife—but if the collector can locate them, they are not only moderately priced but exquisitely done. Pictured here is a dining room set similar to that shown in the Kennedy dollhouse in figure 75; the breakfront and the silver chest atop the buffet are particularly notable. Fallert works in mahogany, cherry, and oak, and the list he has researched is breathtaking. He's one of the wood carvers who will be known many generations from now.

An equally talented wood carver and maker of miniatures is Edward G. Norton of Westbrook, Connecticut. He started with dollhouses for his three daughters and went on to make miniature furniture when he became dissatisfied with commercial pieces. His furniture pieces were designed after authentic life-size antiques and also made according to designs shown in books on antique furniture. He uses the same woods that made the originals, cut to a thickness of $\frac{5}{64}$ inches. We show examples of his work in figures 172, 173, and 174, which rival that of the artisans of the 1600's. His Windsor chairs (arm, comb back arm, bow back side, and comb back side) are masterpieces in miniature.

10

Miniature Metallics

WE HAVE NOTHING DEFINITE TO GUIDE US IN TRACING MINIA-tures made of metals as we have with furniture. Tin, brass, pewter, copper, silver, and iron were all readily available in the eighteenth and nineteenth centuries both in Europe and America. Many similar utensils and accessories were produced by more than one man. In addition, artisans who made brass articles often worked in tin as well, the pewterer sometimes doubled as a silversmith, and the blacksmith found time to make many a household article from his medium.

Also, few of these workers felt they were important enough to mark their wares, so it is difficult now to date or trace their surviving pieces. Even when we find objects in a collection that we know dates from a certain period (as with the Hulda Goebel collection mentioned earlier) we can only apply approximate dates, since there is no absolute method of determining the era in which they were made. Fortunately, many metal workers who made adult pieces also made miniatures, and these miniatures can be keyed to the life-sized pieces and so identified.

For example, miniature Nuremberg kitchens in the Victoria and Albert Museum in London are simply bulging with metal utensils, so some of our finds in such metals may be keyed to the dates of these kitchens, which are fairly well authenticated. Miniature pewter dishes were advertised by a pewterer in New York as early as 1781, and

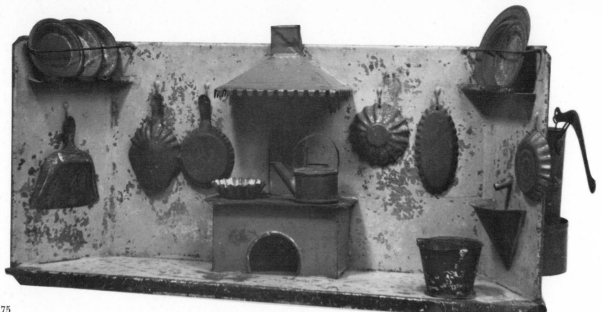

175

Evelyn Ackerman believes that this American tin kitchen is an original. It was found by a friend at a local auction and presented as a gift. Made of stamped and painted tin, these furnishings were made in quantity in the last half of the nineteenth century. There was always some sort of woodburning stove in the center of the back wall and a pump at the side. Notice that in Mrs. Ackerman's version there is also a small basin on the side wall, into which water could be pumped.

entire kitchens of tin were made both in America and Europe from the middle of the century on. These were favored toys of the Victorian age and were turned out in quantity, so that the collector does run across one every now and then. Oddly enough, no matter what the size or completeness of furnishings, the tin kitchens seem to have all been made from the same pattern, one that recalls those Nuremberg kitchens of an earlier date. In figure 175 a stove with a hood is in the center back and a pump is off to one side (pumps did not always have the basin shown), but it is so simple for dealers to replace missing pieces with later ones that the collector must beware. Mrs. Ackerman was fortunate in securing a kitchen with all of its original pieces.

Tin was used profusely for other items. Notice the two tin trays at right and left of the lower tier in figure 177. These trays are about 2 inches long, one black and one a sort of orange-red—which identifies it immediately as English. They were picked up at a flea market for $2.75 each. They had been made into brooches, but when the pins were removed from the backs, the marks of the maker, although once indistinguishable because of the solder, were easily seen. The dates read 1850. They are exact copies of a miniature tin tray (this one blue with yellow border and 4½ inches long) displayed at the Henry du Pont Winterthur Museum and described as being of Pennsylvania origin in the period 1830–60. Many other items in this photo are available as originals if the collector is willing to search for them. For example, at the extreme left and right of the top tier are two pairs of firedogs of authentic design and weight from the late seventeenth and

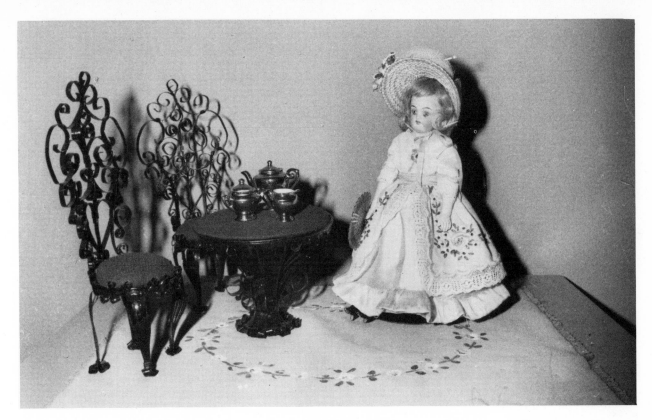

176

Modern "tin can" furniture,
black with red velvet seats,
from the Mastrovito
collection. An idea from
the last century, a few
craftsmen are still turning
out pieces of this fanciful
ware. The doll is an antique;
the rug is by Bertha Snitzer.

177

Brass, tin, copper, and iron
pieces, both antique and
contemporary, are shown in
this group. From the
author's collection.

early eighteenth century. Those at left are goosehead andirons that are line-for-line copies of the type made by early blacksmiths and are from Chestnut Hill Studios. Those at right are of the same period, made of metal treated to look like wrought iron, from Suzanne Ash of Mini Things. Next, from left, is a brass scale of the Victorian era, this one found in an antique shop and marked on the bottom with the date—1860—but in this case the collector should be a bit skeptical about the authenticity of the date.

The little light-colored piece is a tin candle mold from Chestnut Hill Studios, an exact copy of the ones used by the Pilgrims. The large black pot behind the mold was made by a friend to fit a certain fireplace in the author's collection; it began as the top of a mouthwash bottle, but after treatment with flat black paint and the addition of a bail handle it is most impressive hanging on the crane in a log cabin kitchen.

The large piece shown at the extreme right is a reproduction of an old reflector spit, also from colonial America days. This is a piece made to order only by Suzanne Ash of Mini Things; originally made of tin in some areas, they were also made of copper. They were placed before the fire and, although this one is turned by hand, some of the originals were turned by a sort of pulley arrangement suspended from the ceiling, and in some instances a dog on a treadmill furnished the power (perhaps giving origin to the term "fire-dog").

Pictured in the front row, from left, are a black log stand, behind it a fire screen in brass from the Peddler's Shop, a tiny lunch bucket from the Doll Cupboard, and then an original brass coal scuttle found in a box of antique toys, which were bought en masse at a sale. This piece is found in many catalogs for adult accessories, and undoubtedly was one of the salesmen's samples. The little black metal pot, to the right, and the one behind it on the upper shelf, are simply good reproductions. The little foot warmer beside the pot, however, is an authentic miniature of a formerly indispensable household device. It was made with sides of pierced tin, as shown here, and was filled with coals when the family went to church or away on a trip in the carriage or wagon. At the very front are two more reproductions: a long handled bread paddle and a little tin cake mold.

Pewter, an alloy of tin and lead, was used in great quantities during the seventeenth, eighteenth, and nineteenth centuries. In the Victoria and Albert Museum there is a Nuremberg kitchen furnished in pewter. Katherine McClinton, in her book, *Antiques in Miniature*, reports that miniature pewter dishes were unearthed in Revolutionary camps in New York. Pewter was being made in America at this

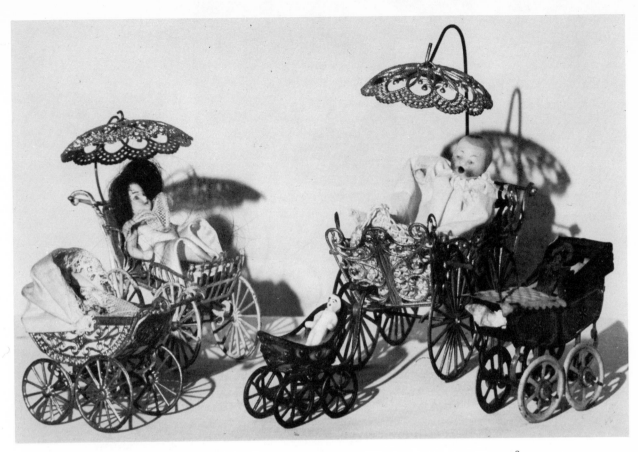

178

Great attention has always been given baby accessories by miniaturists. The two large carriages with shades are made of pewter, the small one at left, of ormolu. Center front is a small carriage probably of ormolu but never verified. At right is a very rare painted tin buggy. All are early nineteenth-century pieces, from the Adelaide Mannion collection.

time, but it is not certain whether these dishes were made by American craftsmen or were imported.

Pewter in the proper proportion of lead to tin was a very durable metal, but then, as now, there were always a number of craftsmen who tried to increase their profits by increasing the proportion of lead, so that eventually a great number of miniatures were put on the market that were extremely fragile; legs, arms, and buggy hoods bent or broke upon the slightest pressure. We picture in figure 178, however, a number of baby buggies made of fine-quality pewter, which are in astonishingly good condition. The quality of their pewter plus the style of the buggies suggest that these miniatures were made in the early or mid-nineteenth century.

Perhaps the only American working in pewter today is K. Ewer of Cape May, New Jersey. Each piece that he makes is a faithful rendition of an earlier piece. His workmanship is unimpeachable; the metal used is described as "English Pewter–No Lead," and it is so hard as to be practically indestructible. In figure 180 his tiny, covered mustard cup, hardly a half inch high and with detailed engraving on the base,

179

Sewing basket of ormolu
lined with old pink silk,
c. 1800, 3 inches high.
Accessories are
contemporary, from Anne
Johnson.

180

Candlestick, candelabras, and
the copy of a Queen Anne
tray are from R. Ewer,
pewterer, as is the exquisite
little mustard pot at right.
The pewter tea set and ash
tray are commercial pieces.

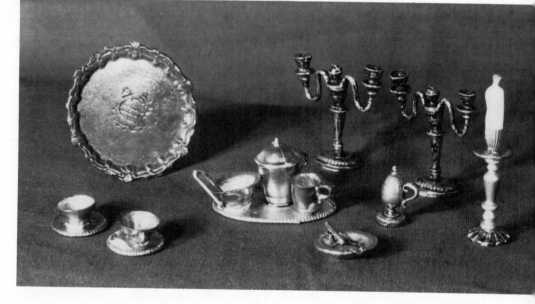

is something that might well become a miniature collector's heirloom.
His footed salver is equally beautiful with its antiqued surface and
shell pattern on the rim. However, in addition to other hallmarks, it is
marked on the back, "No Lead Pewter–1814," which might lead to
confusion in later years. Who, after all, is able to distinguish between
a true 1814 piece and Ewer's faithful reproduction? Because Ewer's
work is so truly exceptional, we feel that each reproduction should
bear a distinguishing mark.

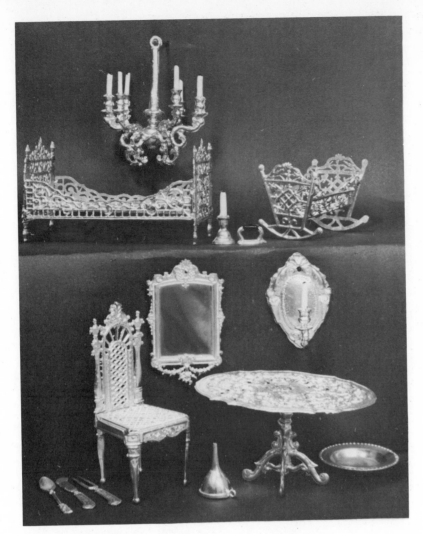

D & E Miniatures of Culver City, California is one of the few
dealers who handle pewter in this country. This company imports
Swedish pewter products that are made from eighteenth-century
molds by a seventh-generation pewterer. This pewterer, like his ances-
tors, earns his living by creating adult-size pieces. As with the Ewer
creations, the Swedish pewter miniatures are made of fine-quality
metal and are most reasonably priced. The collector should note that
the fork in the serving set (figure 181) has only two prongs and the
design is an old one with curved handles.

The table and chair set at the top of figure 182 have the look and
feel of pewter, but are definitely not made of that metal. They are
smaller than $\frac{1}{12}$ scale: The chair is 2 inches high and the table about
1⅜ inches. From the type and quality of the work, Mrs. Ackerman
suggests that they may have been made in Mexico or Spain. They
date, according to appraisers, from the turn of the century. The two

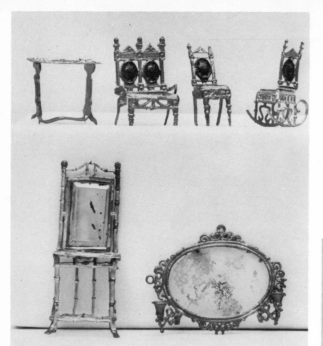

The turn-of-the-century
pieces, top, are smaller than
scale and have Spanish
characteristics. The two
pieces at bottom are ½12
scale; the dressing table is
made of a bamboo pattern
in metal; and the mirror
seems to be pewter. The
collector will come across
such pieces fairly often.
From the Evelyn Ackerman
collection.

183a & b

Intriguing little pieces of
metal, picked up in various
shops and resale emporiums,
are the vacuum cleaner (all
metal including the bag,
origin unknown), the altar
piece (related in size and
style to the metal furniture
shown previously), and the
washer with working rollers,
which was a gift from a
friend. From the Evelyn
Ackerman collection.

pieces at the bottom are likewise difficult to catalog. The antiquing of the mirror may be deliberate or the true result of aging; it is, at any rate, a graceful and beautiful piece that any collector would delight in finding. The dressing table is of metal in simulated bamboo style, also bought in the hope that related pieces would turn up later to bear some information as to their origin.

The engaging little piano and bench, and the sewing machine and chair in figure 183b are also in the smaller scale, but difficult to categorize.

There are few antique silver miniatures still to be found. Those that do exist are so dainty, and their metal so thin, that few could possibly survive the rigors of past centuries. Miniature silver toys were made for the royal children of France, and there are English doll-houses of the seventeenth and eighteenth century that house the dainty pieces—the Ashmolean Museum in Oxford, England, for example, houses the fine collection of Lady Henriques. Also, there is a fine collection of antique silver miniatures in the Henry Francis du Pont Winterthur Museum, as well as a group of German pieces in the Metropolitan Museum of Art. It is the English, however, who left us the most impressive pieces in this precious metal. In figure 184 the two pitchers at lower right are very old, and probably date from the eighteenth century. Both carry hallmarks that are not quite legible. On the middle shelf of the corner cabinet is a punch bowl that is also very old, having been appraised as early eighteenth century, as are the silver hurricane lamps at lower left. All of these seem to be English in origin, since the mark of the lion *passant gardant* is legible in the hallmark. The bowl has three other marks, and the pitcher at extreme

184

The Mannion collection includes many nineteenth-century pieces found in antique shops, a few pieces bought simply because they were beautiful. The tea set, center, and salt and pepper shakers are modern; the other pieces are from the last quarter of the nineteenth century.

185

Georgian sterling tea set is contemporary and was made by Willoughby's but the tray is an exact copy of one in the Winterthur museum.

186

The little handmade cannon, 4 inches long, is dated 1870 and is handcast with a brass barrel. Victorian toys such as this one were made in quantity and are often found in antique shops. The handmade wrought-iron fire screen from Shackman is also made in quantity but is of fine quality. This one is trimmed with brass. From the author's collection.

right also has three marks on the outside of the top. However, the hallmarks (or lack of them) shouldn't influence the collector; the small size of miniatures made marking difficult, and many done by masters of the art were not marked at all. The hallmarks are usually on the main body of the piece, rarely on the bottom as hallmarks are placed today. All of the pieces in the little breakfront are old but not marked. The silver basket at left is the same one shown with the secretary in figure 148, and the silver picture frame, again, is obviously of English manufacture and carries the mark of the lion. They are worthy of reproduction simply because of their innate beauty. The

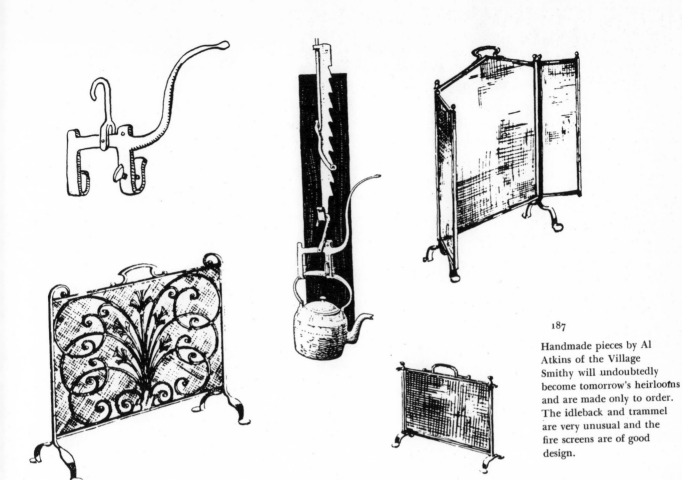

187

Handmade pieces by Al Atkins of the Village Smithy will undoubtedly become tomorrow's heirlooms and are made only to order. The idleback and trammel are very unusual and the fire screens are of good design.

little dinner bell and the three serving pieces at front center are particularly fine, whatever their age, and the Queen Anne bowl on the bottom shelf of the corner cupboard demonstrates magnificent workmanship. The little flower basket arrangement atop the cupboard is particularly interesting; Mrs. Mannion is convinced that it is very old, and the dealer from whom she bought it told her that it had been one of a pair, but the mate had disappeared. It is a flat piece, about 1 inch high, with a piece of metal soldered onto the back to form a stand.

There are few miniatures made of iron and brass on the market that are really old. The little iron cannon shown in figure 186 was found in a Vermont antique shop and is imprinted 1870 on the undercarriage. It is undoubtedly one of the iron toys made in the late Victorian period for children. About 4 inches long, the wrought iron undercarriage is crudely made, as though by hand; the barrel itself, of brass, is equally rough. There's something about the little piece, however, that is endearing; one cannot help wondering whether it was

made from the life-sized cannons that were melted down after the Civil War. The little fire screen is from the Shackman line; it is handmade, one of their "Collector's" line, of wrought iron with brass trim.

The finest source for wrought iron miniatures, however, is the Village Smithy, Al Atkins' designing and blacksmithing establishment in Bronxville, New York. Everything that was used in the early establishments, Atkins reproduces for today's dollhouses: three different fire screens, for example, of different periods; at least a dozen different fireplace tools; balconies; bedsteads; chandeliers; door fittings and hinges; the idleback and trammel shown in figure 187; kitchen utensils; and lanterns. You name it, and Al Atkins will make it.

I I

Ceramic, Porcelain, and Glass Miniatures

I T GOES WITHOUT SAYING THAT FROM THE TIME THE FIRST DOLL-
house was built, someone must have felt the need for small
dishes to complete the appointments. It is difficult to pinpoint the date
of the first tiny tea set, but we know that brown stoneware with slip
decoration was made in miniature dimensions as early as 1750. Origi-
nally, many miniature tea sets were made as copies of the adult-size
sets; several sets exist today that have been traced to 1830, and a tea set
in the Otto M. Wasserman collection from Leeds Pottery is dated
1788. Wedgwood also made many miniatures in the late eighteenth cen-
tury, and we note that in 1795 Queen Charlotte ordered two toy tea
sets of their ware. Later, even Wedgwood's celebrated Jasper ware was
listed as miniatures in their catalog. However, most of these older tea
sets are now in private collections or museums and are rarely found in
the open market. Today's collector would be wise to content himself
with some of the really beautiful contemporary reproductions that are
now available.

France produced many fine miniatures in porcelain, which seem
to have survived in greater numbers than the English or Chinese min-
iatures. A late-nineteenth-century miniature Sevres tea set was found
quite unexpectedly in a Chicago shop, and is now part of the author's
collection. Other examples of early porcelain miniatures are the pieces
shown in figure 188, which are from the Mannion collection. The

188

Cabinet porcelains include a Staffordshire pug dog and cat and a Dresden couple, center, 1 inch high. From the Adelaide Mannion collection.

little pug dog and cat are Staffordshire pieces, c. 1810, and the couple in the center, just 1 inch high, are Dresden, c. 1800. The little vases in the background are about the same size, bought simply for their beauty, since their age is undetermined.

There are a few ceramists working today in miniature sizes who are turning out spectacularly fine ware. Ellen Krucker, now Mrs. John Blauer, has made tableware for many years that was somewhat disconcerting to handle because it actually is eggshell thin, just as the description says. It is extraordinarily sturdy, however, and doesn't crack or shatter. It is possible that the clay and glaze is fired onto a metal base. Her tableware looks lovely on a $\frac{1}{12}$ table, as may be seen in figure 189, which shows the Tara dining table ready for a meal (El-Kru in the Tea Rose pattern), and in figure 190, which pictures her captivating Blue Onion pattern. The scale is perfect; the cups are less than $\frac{1}{4}$-inch in diameter, plates are 1 inch. All El-Kru pieces carry Miss Krucker's hallmark, EK.

189

A table from the author's Tara house is set for company with sterling flatware and napkin rings, and Ellen Krucker Blauer's Tea Rose china. The rug was made by the author, and the table mats were woven especially for this table.

In figure 191 two more examples of her work are shown. At bottom right, third from left, is a 1971 issue of her Christmas plate, and then her exquisite copy of the 1880 Copeland plate, both 1 inch in diameter. At left in the photo are two more commemorative plates, from ceramists Jean Kirkwood and Elizabeth Zorn of the Ginger Jar Shop, part of a series that will feature dollhouses as decoration. The 1972 plate pictures the Hayes dollhouse, and the 1973 version the famous South Jersey Victorian house owned by Flora Gill Jacobs. These are 1⅜ inches in diameter, and are prizes for any collector. If one collected the complete series, their value would be considerable.

In the cupboard shown with these plates is an assortment of the ware from Suzanne Ash of Mini Things, a ceramist with both imagination and great skill. In the center two shelves and on the tray at the front of the cabinet are samples of her slipware; this is a reddish-brown earthenware that was made in quantity (and also in miniature) in the latter half of the nineteenth century. Colored slip (thinned clay colored with oxides) and sgraffito (scratching through the slip) was used to decorate the pottery. Ms. Ash has used both the sgraffito and flower and bird designs. These decorating techniques are characteristic of Pennsylvania Germanware. The "Colly Flower" ware on the bottom shelf was first produced in 1759 in England, and a few miniature cream jugs may still be found. Her jug, bowl, and teapot are unique.

It is in the making of Chinese Export ware, however, that Suzanne Ash particularly excels. This was a porcelain made in China for the export trade both to Europe and the United States. She uses the designs that were especially made for the American trade. The pistol-handled urns, at left on the top shelf in figure 192, are made with "blotched on" gold handles and decorated with unbelievably tiny scenes, exactly as were the originals. Decorations on other pieces of this ware took the form of individual crests (armorial designs) and marine scenes; eagle designs were also popular and were meant, apparently, to please the patriots in this country. The Ash designs are typical of the types used on the ware from 1785 to 1840.

Mary-Dudley Cowles of Chestnut Hill Studios makes equally attractive pieces of Export ware in various forms; her bowl with dried flower arrangement is particularly fine (and exactly to scale) and the punch bowl is outstanding. The only thing for the collector to do in cases such as this is to obtain the catalogs and then study the pieces to determine which he prefers.

192

Suzanne Ash makes reproductions of Chinese Export Trade porcelain. It is almost impossible to find the originals today. The pistol-handled urns at top left are the author's favorites. (*Photo by Loraine Yeatts*)

Ms. Barbara Epstein of the Microbius shop in Dayton, Ohio, uses a different technique. Her dishes and odd pieces are made of the finest French porcelain, and fired three to five times at high temperature. The designs are painted under a magnifying glass. Her Wedgwood Blue Jasper is a tiny replica of the classic ware that has been popular since the nineteenth century, and it exhibits the familiar raised motif. She makes, in addition, a number of classic designs from Staffordshire, Coalport, Sevres, and others, some made with a recessed plate center. They are extremely thin and fine.

Japanese decorative ware also was imported to the United States at the end of the nineteenth century, but little of it was reproduced in miniature. Both Ms. Epstein and Chestnut Hill Studios make some Imari pieces, and in figure 195 we show a tiny Satsuma jar, 1 inch high, which is the smallest this collector has ever come across. It dates from the St. Louis World's Fair of 1904.

147

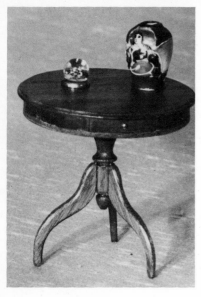

195

Satsuma ware vase from Japan, 1 inch high, is the only example of this ware in miniature size that the author has ever found. It was usually made in large jars about 3 feet high that stood on the floor. The tiny *mille fleur* paperweight, a big fad during the Victorian era, was made from a button found at a sale that was then glued to a brass washer. The table is by Mel Prescott. From the author's collection.

Today, a great deal of pressed, molded, and handblown miniature glass is available in the antique shops both here and in Italy. The collector, however, must be cautious in accepting the word of the dealer as to its age. Although German and Dutch glassblowers have dwindled in number, workmen in Venice, Murano, and a number of other Italian centers are turning out handblown pieces in fantastic numbers. They are one of the most popular souvenirs among tourists.

There were a bewildering number of glassmakers in England in the eighteenth century, and glass toys were turned out in great quantities, in spite of the fact that glass is so fragile. Perhaps, because glass is so bright and attractive, myriad glass toys were used to enhance eighteenth- and nineteenth-century cabinets and shelves. At any rate, a trip through the Corning Museum of Glass convinces the collector that miniature glassware is not only abundant but also one of the most satisfying of the dollhouse collectibles.

Two or three shops in this country have fine glassblowers "in residence," so to speak, and it is possible to obtain contemporary glassware as well. The South Shore Woman's Exchange in Hingham, Massachusetts carries a full line of handblown glass pieces, in addition to five sizes of handblown glass chandeliers, which are truly superb. The chandeliers are pictured in the Mannion house in figure 94.

The Lilliput Shop in Beavertown, Oregon carries a full line of both clear and opaque glass in both the $\frac{1}{12}$ and $\frac{2}{12}$ sizes. All of their glassware is made with Pyrex and, consequently, is extraordinarily sturdy. In addition to the clear glass, which is made into fanciful shapes, usually with fluted stands and tops, the same pieces are offered in colored transparent glass exactly like the toy pieces turned out in the mid-nineteenth century by Westmoreland Glass Company. The colors are red, yellow, blue, green, purple, shocking red, and shocking orange. The work is exquisite.

The opaque glass shapes shown in figure 196 are available in clear glass as well; many colors are available, including milk white, pale green, mottled brown, black, and cobalt blue. Oddly enough, not much of this glass is found in antique shops and fairs as in earlier years when many dollhouse accessories were made of this material and in colors that closely approximated those of the Westmoreland pieces. The mottled brown glass gives the appearance of an old-time bean crock and makes particularly attractive kitchen ware.

I particularly treasure the candlesticks and chandeliers made in clear glass (figure 197). True, these pieces have no older counterparts, but they are delightful nonetheless. The tea and coffee pots are also charming.

Opaque glass pieces, such
as these from the Lilliput
Shop, are hard to come by.
The mottled brown glass
reproduces old-time crocks,
and the colors closely
approximate the ware of
yesterday.

197

The collector will find it almost impossible to find miniature glassware in
the shops, but several miniaturists carry some fine examples. The South Shore
Woman's Exchange is one, the Lilliput Shop is another; their glass is
handblown and may be ordered in colored, transparent, or opaque ware.
It is made of Pyrex.

198

Something completely
unique is the blown milk
glass gazebo offered by
Lilliput. Not quite 1/12 scale,
it is fairy-like in effect and
would add great charm to
any garden scene.

For tableware in three sizes, goblets, wine glasses, and sherbets, 1/2-inch high, pieces are made only on order.

The little milk glass gazebo illustrated in figure 198 is the *pièce de resistance* of the glassblowing world. We have never seen one like it, even in the glassblowing shops of Venice. This one is a little less than scale—6 inches tall to the peak—but who would insist upon exact scale with such a lovely creation? It dresses up any garden scene, and there is an ice-cream table and two chairs that go with it.

12

Miniature Art

THERE ARE ART GALLERIES IN A FEW OF THE MORE FAMOUS DOLLhouses, including those of Colleen Moore, Queen Mary, and Titania's Palace. Art galleries within private dollhouses are quite rare, although a fantastic house that contains an art gallery and belonged to the three Stettheimer sisters is now on view in the Museum of the City of New York. The paucity of rooms in which art can be displayed is especially odd, since dollhouse art has always been plentiful. Perhaps it is due to the fact that a dining room, a kitchen, or a nursery is easier to design than an art gallery. Another reason for this slight to the muse is that an art gallery must be more selective with its hangings; one suspects that many such rooms eventually become sitting rooms due to the impulsive and acquisitive nature of collectors.

The Stettheimer sisters hung only "originals," with the exception of Marcel Duchamp's "Nude Descending a Stair," which the artist copied for the dollhouse. Apart from original oils, however, there are astounding possibilities. Chestnut Hill Studios list no less than eighteen tiny oils painted on fine linen, mounted and framed in gilt. They carry, as well, one example of the early Victorian tinsel "painting," c. 1850, in a gilt frame. The one shown in figure 199 is a copy of an actual tinsel painting owned by the Cowles. Although the art of painting on the reverse side of glass is centuries old, it was the early Victorians who used tea-paper foil behind the glass, crumpled to catch the

199

"Tinsel painting" was very popular in early Victorian times. The painting is done on the reverse side of the glass and tea paper foil is then crumpled and affixed behind the glass to catch the light. This one is made by Chestnut Hill Studios, an unusual contemporary reproduction.

light and add a silvery glow that would illuminate the flower hues painted on the glass.

The Lilliput Shop has its own resident artist, a well-known virtuoso in oils, who uses a magnifying glass to see each stroke of her brushes, which range in size from a "large" of oo to the smallest, which has only two hairs. Her work includes copies of old masters, copies of contemporary artists, as well as originals. She will fill all special requests.

Pickwick Miniatures in Glenview, Illinois, also offers a variety of "oil-type" paintings, as well as handpainted plaques with delightful subjects. The Blauers, of the San Francisco Peddler's Shop, not only offer a variety of subjects but an interesting variety of frames. A. Atkins of the Village Smithy creates a series of 1½ inch nudes, and also lists a number of etchings in aquatint that are rich and satisfying examples of the intaglio method of printing.

For the collector who wants to make his own, however, we would suggest simply a close and continued perusal of the advertisements in magazines and the brochures advertising fine books. In figure 201 we show the four celebrated Currier and Ives prints depicting the seasons of the year, printed in magnificent five colors and framed in pretty little composition frames from the ten-cent store. They are slightly enlarged here to make them more visible, but in reality they are only about ¾ inch by 1 inch. In figure 202 the slightly askew print at top left, is a Rousseau taken from a catalog and hand colored. Next to it is a painting from the Williamsburg collection that has been laminated on wood just as they were mounted centuries ago. Beneath that is a little bronze frame found in a pawnshop in Florence, Italy, and

Maltnomah
Falls
7/8" x 1 5/8"

original
1" x 1 1/2"

original
1" x 1 1/2"

"Van Gogh"
1 1/8" x 1 1/2"

"Cezanne"
1 1/8" x 1 5/8"

Scenes of Mt. Hood, Oregon

Ore. State Capital
Building

Haystack Rock

Silver Creek
Falls

"Wood"

In the style of
Constable

original
portrait

"Wood"

"Van Gogh"

original

200

Jo Redfield, a well-known Northwest artist, turns out a limited number of oil paintings for the advanced collector, including reproductions of famous works by the old masters, originals, and even portraits made to order. Most are about 7/8 × 1 or 2 inches.

201

Finding suitable frames for miniature art can be a great problem. These little frames shown somewhat larger than life (actually 2½ by 2 inches) were just right for the Currier and Ives "American Homestead" series that was cut from a magazine. From the author's collection.

This assortment of art, both
old and new, includes a
French print at top, left,
from a French art
catalog; a portrait,
center, shown in an antique
frame from Italy; and a
little sampler, about an
inch high, worked in
thread count method.

fitted to a painting from another book brochure. At the bottom cen-
ter, and also slightly askew, is one of the Williamsburg prints depict-
ing the fruits of the seasons, printed in beautiful color on fine paper.
It is available in the catalog of Williamsburg reproductions, and is
produced in the exact size that is needed for a dollhouse.

June Dole in Rockville, Connecticut, offers kits for making the
little sampler, third in line at left, the finished size being 1¾ by 2
inches. They are made by thread count, just as the original samplers
were made. The Chippendale mirror at bottom left is from Shackman
with pearl detail added by the author, and the three mirrors at right
are from other firms.

One other source of art that the beginning (and even the more
advanced) collector will find interesting, is the Post Office Depart-
ment. Here we have an inexhaustible source of fine small prints on
any subject we favor: famous paintings, famous personalities, modern
art, butterflies, conservation subjects, professions. The collector will
be amazed to see the display he can produce by mounting stamps on
textured board and either fitting them into a small frame or finishing
them with a frame of passe-partout. This writer has just finished fram-
ing a series of nine stamps dedicated to scientists; these engravings are

done by the finest artists in the country, and properly framed they are most impressive.

In the realm of statuary, very few pieces are carved in wood except for the pieces made by Hermania Anslinger of Spokane, Washington. Miss Anslinger works only on special order, but some of her pieces may be seen in John Blauer's Maynard Manor, and she can reproduce almost anything of which you show her a photo.

Just to demonstrate the unlikely places in which art miniatures are often found, we call your attention to the bronze of "Little Mermaid," who perches on a rock in Copenhagen harbor (figure 203). This is a fine piece of sculpture, and was bought for five dollars in the airport gift shop at Copenhagen, minus the rocks. She is 2¼ inches high, exactly to scale for placing in a garden pool of a dollhouse or in the conservatory of a Victorian doll mansion.

The sterling silver horse in figure 204 is beautifully molded also, and less than an inch tall; he is mounted on a handsome piece of agate. The little giraffes are in a class by themselves. Obtained in a group of twenty-five pieces for a $30 overall price at the dispersal of a collection of miniatures, they seem to be blown from some sort of opaque glass, with the spots painted on. They are an inch tall and are mounted on a small piece of teak. On the under side of the stand is scratched, "Venice . . . 1880." They were undoubtedly made by an inexperienced glassblower, but the effect is charming.

The small statuary pieces at the bottom of figure 205 are pure Victorian. One may assume that these small pieces are lead castings, and are painted white, but they are beautifully done. They are from the Peddler's Shop in San Francisco. The Chinese figures on the pedestals are most amusing and will occupy honored places in the projected conservatory of the author's Victorian house. They were re-

203

The Little Mermaid who presides over Copenhagen harbor, is 2¼ inches high and made of a bronzed metal. The rocks are strictly local.

204

This sterling silver horse mounted on agate is a contemporary piece. The blown glass giraffes mounted on teak are c. 1880. Both make fine mantel or chest decorations. From the author's collection.

205

Plastic statuary with the feel of ivory is mounted on columns meant to hold wedding cake tiers. At bottom are three pieces of classic work in lead, painted white. From the author's collection.

206

The antique Japanese screen is one from a set of six found in a used-book store. The umbrella stand made from a plastic pill bottle (1 inch in diameter), has been covered with tea chest paper and finished with gold braid. The canes are from Pickwick Miniatures, and the parasols from Ruth Janecke. From the author's collection.

cently purchased through a mail order sponsored by the manufacturers of a certain margarine, upon payment of $2.00 plus a label. They are surprisingly well made, although they do not photograph well. They are apparently made of a plastic that molds well and has the warm, firm texture of ivory. Even the tiniest of features is reproduced surprisingly well. They are mounted on columns, which originally supported tiers of a wedding cake. These columns are obtainable in almost all sizes and are perfect for dollhouse art galleries, once the cake has disappeared.

The scenic screen shown in figure 206 and six other lovely versions were picked up in a used-book store for what might be termed even less than a song. They are a group of the masterpiece screens of the Momoyama period (1575–1615) and were published by the Charles E. Tuttle Company of Rutland, Vermont and Tokyo. Just 6 inches high, they are perfect for dollhouses and, in addition, were selected in pairs, so that their artistic worth is doubled. A description of the subject of each accompanies the screens and each one is backed by a gold-mottled paper that is itself of extraordinary beauty. One could fill an entire chapter describing miniature works of art in detail.

There is one more area in the field of art that the miniature collector should investigate—that of the maritime art turned out by Jack Jarque of New York. Many eighteenth- and nineteenth-century homes displayed miniature models of ships, as any student of history knows; the men on board whiled away the long hours at sea with the whittling of the tiny replicas. Thus, when a friend of Jarque's, aware of his interest in maritime history and ships, urged that he turn his talent to marine miniatures, this extraordinary man did just that.

The little ships mounted on a waterline base are 2 inches by 2 inches; ships with a full hull on a pedestal base are 2 inches by 2¼

207

Two Jack Jarque miniature models are shown here, 2 inches in length. At left is a sixteenth-century cargo and transport hulk; and at right, a sixteenth-century Armada galleon. Jarque also offers handpainted oils of the ships, signed and framed. From the author's collection.

inches. In this writer's collection is a treasured model of the clipper "Flying Cloud," fully rigged with various sizes of thread. In addition, he turns out original paintings, signed and framed, that are done in striking colors. In our own collection the ship stands on a mantel with the picture hanging above it on a fireplace wall—the focal point for the whole room. These small touches breathe life into a miniature room. In addition, such pieces, turned out one by one and completely by hand, will become the miniature treasures of tomorrow. Models and paintings from a long list of ships from a fifteenth-century Portuguese caravel to a nineteenth-century full-rigged clipper ship are offered; or the artist will duplicate any vessel the collector wishes.

13

Miniature Accessories

TODAY WE "ACCESSORIZE" EVERYTHING—AND WITH GOOD REASON, for the right accessories add warmth and personality to what could otherwise be cold and impersonal. To the collector of miniatures and dollhouses, accessories are most important, for they not only establish the period of a house or rooms, but they establish the feeling that someone really lives there—something that the collector of miniatures is constantly striving to achieve.

The little pair of spectacles on a table beside a chair may not be especially important, but, coupled with a book on the table and a lamp beside the book, they create the illusion that an inhabitant of the house has just left the room. In life-sized houses, one might say that accessories add a "lived in" feeling, and the same thing is true of dollhouses.

For example, the prie-dieu shown in figure 208 may also be seen in the Kennedy dollhouse in figure 76. That bedroom would be quite as attractive without the prie-dieu, but with it in place, we can visualize the parents kneeling for prayer at the start of the day. This fine piece for the collector comes from Chestnut Hill Studios. The game room in Mrs. Firmin D. Fusz's ten-room mansion displays a fascinating collection of miniaturia, but the little billiard table shown full size (figure 209), conveys the feeling that people have just laid down those cues. Made by Marjorie Walrond, this table, like the prie-dieu, is an exact miniature reproduction, rather than just a miniature.

208

This unusual reproduction
of a prie-dieu is from
Chestnut Hill Studios.
From the author's
collection.

209

The billiard table executed
exactly to scale by Marjorie
Walrond for Mrs. Firmin D.
Fusz. The tiny cues have
rubber handles and the balls
are minuscule ball bearings.
The Tiffany glass chandelier
is made of true Tiffany glass
with leaded seams.

210a & b

Complete equipment for carding wool, winding yarn, spinning,
and weaving is provided in these four pieces in the "keeping
room" on the third floor of the author's Tara mansion. The
double harness loom is made to order by Suzanne Ash of Mini
Things. The entire piece, of pegged construction, is made
exactly to scale and is workable, if one could get his fingers
into the threads. From the author's collection.

The pieces in figures 210a and b were collected as accessories for the "keeping room" on the third floor of the Civil War mansion in the author's collction; the yarn winder, spinning wheel, and wool comb are from Shackman, but the loom, an especially prized piece, is made only on order by Suzanne Ash of Mini-Things. Notice in the close-up that this is a double harness loom, which is the type that was used in that period, and every detail is included, even to the point of the pieces being put together with pegs.

Any of the art mentioned in the previous chapter might be termed an accessory, of course, and in figure 211 we find further deference to establishing an atmosphere of culture with the use of the miniature Japanese screens and various musical appurtenances. The piano at left is an upright of the 1920s period. At center is Mel Prescott's Victorian square piano, a beautiful piece of work that comes complete with a little padded velvet stool. At right is Shackman's baby grand. In addition, Princess Petite made an exquisite piano, which is occasionally found in collections or antique shops.

Notice, too, the beautiful little crystal candlesticks on the piano, which Ms. Prescott makes especially to glamorize this piece. On the floor at front center are further accessories that would add an illusion of life to a dollhouse: The two little horns are brass, and the banjo and guitar are actually pieces of jewelry found in Spain, with inlaid mother of pearl on the sides.

211

In testimony to the cultural attitudes of the family, the Tara mansion boasts three pianos, two of them music boxes, and an assortment of musical instruments. The center piano is by Mel Prescott. The screens are from the same group of Japanese miniature screens mentioned earlier. From the author's collection.

212

Chandeliers and other forms of lighting such as lamps, sconces, and candleholders require a very different approach. In our experience, these are difficult to find at the usual sales or antique shops, possibly because they are so tiny and so fragile. Many collectors make their own, simply because prices asked by established miniaturists are quite high. And, everything the collector needs to make his own chandeliers, no matter how elaborate, is available at the Peddler's Shop in San Francisco. This same shop offers a wide variety of chandeliers they make: For example, in figure 212, from left, is a William and Mary, English c. 1724, of brass with six tapers—the bird at the top is a detail typical of this design; next is a French piece, c. 1700, made of gold-plated brass with tiny Austrian crystals; the authentic six-globe Victorian chandelier, c. 1860, with handblown milk glass globes, is offered both by the Peddler's Shop and by Margaret Whitton; and the last chandelier at far right, is made in the four-globe Argand-type Victorian style, c. 1880, with lots of tiny sparkling lusters. In figure 213 is shown the Faurot's eighteenth-century chandelier from Willoughby's, which features a clear fount spraying forth thirty-eight Austrian crystals. All parts are clear and have a lovely sparkle when hit by the light. This

213

This crystal chandelier made by the Faurots of Willoughby's is an exact reproduction of one used in an eighteenth-century home. From the author's collection.

particular design was adapted from an Irish creation of about 1765. After 1785, many were sent here from the glassworks at Waterford and helped establish the reputation of Waterford glass.

Crystal or glass chandeliers enhance any dollhouse since they not only have a light, fairy-like quality that seems in keeping with the world we are depicting, but the reflection of light adds a great deal to dollhouse interiors, which are apt to be dark. Chestnut Hill Studios makes three or four, with sconces to match, but their ballroom chandelier and James River chandelier (eighteenth and nineteenth century) top everything we've ever seen. Each is five-branched with elaborate cut-crystal center standards; each separate candle bears five tiny drops; it is estimated that 1,200 minuscule beads go into each one.

The hand-blown glass chandeliers marketed exclusively by the South Shore Women's Exchange in Hingham, Massachusetts, are of an unbelievably fragile appearance, and the sparkle of the glass is simply exquisite. They are rarely seen at sales but the Exchange offers a size to suit everyone, even though you may have to wait a bit to get one, since each is handmade. Several of these are in the Mannion dollhouse (figure 94), and two are in the writer's Tara mansion, in the music room. The Exchange offers, in addition, two three-branch kerosene lamps with bases in red or yellow, and three six-branch chandeliers that look as though they really did belong in a fairy castle.

Consider all of the flower arrangements offered, and those you can make yourself once you gather a few shells for containers. Give some thought to the wide assortment of fireplaces offered. Willoughby's 18th Century, makers of the little globe-on-stand shown in figure 217, suggest removing the globe and inserting a crystal salt dish for a punch bowl, if a party is in the offing.

214

A great variety of fireplaces are available to collectors: At left, the fireplace is covered with an enormously successful paper that has a pebbled surface exactly like rock and is imported from Germany by Pickwick Miniatures. The white fireplace is of cast hydraslone and is one of a series of three from the Peddler's Shop.

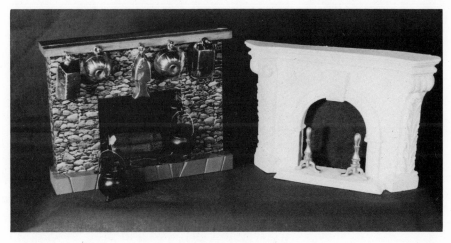

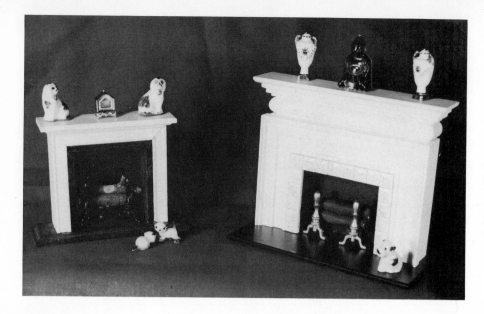

Left, a Shackman fireplace
with a coat of white paint.
Right, Chestnut Hill's
beautiful 1750 Delft tile
fireplace with handpainted
tiles.

217

The Faurot's globe-on-stand,
from Willoughby's
18th Century, is a
reproduction. The globe
twirls and may be lifted
out so the stand can
accommodate flowers or a
punch bowl.

216

Photographs to stand on
tables are sometimes
difficult to find. This one,
from the Mannion
collection, shown full size,
was found in a Paris
antique shop, and is
studded with semiprecious
stones.

This writer's preoccupation with miniature books began a few
years ago when, just after the publication of her *Bible Cook Book*
(which is itself now published in miniature form), a reader of her
column in the St. Louis *Globe-Democrat* called and asked if she might
stop in for a visit; she had a gift for her. It developed that she had
recently lost her husband and, to show her appreciation of the plea-

sure she had gotten from the newspaper column and the cook book, she wanted to present one of her husband's dearest possessions, a miniature Bible.

Already badly infected with the miniature collecting bug, that Bible completed the capitulation, and miniature books took their place with miniature everything else, so that we now have a fairly respectable collection of some fifty volumes, some quite fine, some fairly amateurish, all less than 2 inches high, all prized dearly.

The Bible that did the conquering is a most fascinating volume. Two inches high by 1¾ inches wide and about a half inch thick, it is bound in beautiful calf and includes both the Old and New Testaments. It is printed on India paper so thin as to be almost impossible to handle, and was actually printed from type, rather than by the trick photography that is in use today.

James D. Henderson, generally considered the most successful collector of miniature books since he had acquired some 8,000 to 10,000 before his death in 1940, and Wilbur Macey Stone, another small-book enthusiast, used 3 inches high as the maximum book size. For the collector who has decided upon the ¹⁄₁₂ scale, however, this is outside the rules; even the little Bible from the author's collection, at 2 inches, would be 2 feet high, and consequently too large. And, as in all collecting, one does have to decide where to stop. With me, it's at 2 inches; another collector in Lake Forest, Illinois, calls anything up to 4 inches a miniature.

It subsequently developed that the Bible in question was one of four books now designated by the name, The Kingsport Press Books. There were three, in addition to the Bible: *Addresses of Abraham Lincoln, Washington's Farewell Address,* and *Extracts from the Autobiography of Calvin Coolidge.* These volumes were printed as mementos for the members of the American Institute of Graphic Arts Convention in 1929. A sufficient number have survived to keep the collector on the *qui vive.* The latter three are bound in red, green, and blue calf, respectively, and marked in gold.

Many tiny books have been made up as mementos for a variety of historical occasions. One of the smallest books that I have ever seen is ¾-inch high with four pages. It has an American flag on the cover and the title, *World's Fair 1904,* on the inside together with views of a number of the fair buildings. In the Mannion collection there is a similar metal book only ½-inch high, commemorating the Paris Exposition. This book has a beautiful enameled cover. It is interesting to note that one of the unusual miniature books discussed in early issues of the News Letter of the XLIV*mos Club,* a newspaper devoted to the discussion of small books, is the Mezuzah, the doorpost parch-

ment folded into a metal case and affixed to the doorways of Jewish homes. On the parchment of the one in the James Henderson collection, now in the possession of his son, are written the passages of Deuteronomy 6:4–9 and 9:13–21.

In this country today the most notable makers of miniature books are Ms. Carol Wenk of the Miniature Book Studio and Ms. Judy S. Jacobs of Merry Miniature Books. Ms. Wenk's books are most satisfying; 1-inch long by ¾-inch wide, they are nicely proportioned and bound in a good quality of leather. But, despite a judicious choice of titles and a really fine quality of printing, the books somehow leave a cold, somewhat impersonal impression, not at all the feeling the collector should have when he holds a fine book in his hand. The leather covers are tooled in gold but there is no printing either on the spine or on the cover.

On the other hand, Judy Jacobs' miniature books, while not nearly of the precise quality of the Wenk books, are obviously made by hand and simply pasted up. This gives the volumes a rather amateurish look. Ms. Jacobs obviously works from photographs of the text that have been reduced. The spines carry the titles. One, which consists of excerpts from *The Prophet* by Kahlil Gibran, is even offered in a slip cover. Another one, which Ms. Jacobs calls the smallest book in the world, is an ABC book less than ¼-inch high and ¼-inch wide with the title on the spine and the ABC's actually showing on the tiny pages. These books are made only to order and are usually one-of-a-kind; this writer has the feeling that they will one day be of value to the collector, and in the meantime will afford him some pleasure.

There is a Bible offered currently, postage-stamp size, for $.50, which is worth just about that; the printing is poor and the cover is simply black paper. However, we have found some fine miniature books at Dawson's Book Shop in Los Angeles, and for the advanced collector Jack R. Levien of Enkhuizen, Holland, offers some rare numbers. He has offered at various times a tiny 1673 edition of one book of which there were only four copies in existence, and the ultimate in distinction for the miniature book collector is to be placed on his elite list.

Miniature Food

There was a time when the molding of artificial food, usually of wax, was limited to the full-sized bowls of apples, pears, and grapes that graced our dining tables between meals, but that time is long gone. Today, we have artists such as Betty Rockoff and Peggy Barnes producing miniature food on the ¹⁄₁₂ scale that is realistic enough to

make one's mouth water. Ruth Janecke of the Doll Cupboard in Branson, Missouri, also turns out remarkable food items.

The whole idea of miniature food has been attributed by some miniature historians to Mrs. Helen B. Cook of Joliet, Illinois, who became impressed with the possibilities in 1930 when her daughters begged her to fashion a watermelon from some of their modeling wax. However, in the Mannion collection there is a tray of miniature wax food, very well done indeed, which is dated 1900. In various museums there are butcher shops that display astonishing stocks of meat so true to life that it seems that every vein, bone, and muscle is shown. The collector begins to feel that while Mrs. Cook may have been the first artist who thought of creating food out of wax, there are many others who have created miniature food in other mediums.

Whatever the medium, miniature food rendered by today's artists is indeed entrancing. Ruth Janecke makes what she calls "button foods"—tiny dishes of beautiful foods made actually in buttons that are concave in shape and less than ½-inch in diameter. The little buttons are then backed with tiny white beads to hold them steady. The food within the buttons is truly remarkable. One little white button contains a dozen or so tiny prunes; another holds some sort of chopped composition that looks exactly like Jell-o, and a yellow one even sports a sprinkling of what must be nutmeg. A serving of green peas is in another button, and a half dozen pickles in another. This artist also makes the finest whole ham, uncooked, ever discovered, a tiny bowl of Irish stew complete with potatoes, peas, and carrots, and the handsomest pie ever seen—made in a bottle top. Mrs. Rockoff makes practically anything the collector might think of in the food field, including a wedding cake that is just 3 inches high and decorated so profusely as to cause the most experienced pastry chef to turn green with envy. Peggy Barnes is equally expert; her platter of deviled eggs makes one's mouth water, and her serving of bacon and eggs is so real that the collector can almost smell the bacon. She produces, also, a hot dog with authentic looking potato chips, as well as a hamburger with french fries that would tempt even a dieting collector. To this writer, however, what we call her "dead" chicken is the prize. Miniaturists have produced roasted chickens and fried chicken pieces and many other versions of this truly national delicacy, but this dead chicken, nicely plucked but retaining the feet and comb, is something completely unique. Even the tiny apple with a worm curling out of it can't match it.

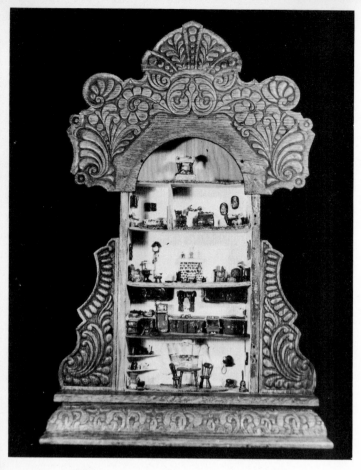

218

This dollhouse made from a
clock case, is furnished
entirely, even to the
curtains, with bread dough
furniture.

219 & 220

These charming adjuncts to
a dollhouse collection are
part of the author's
collection of "oddities."
They are Advent calendars
showing a dollhouse and a
street in "Doll Town."

14

Oddities

THE VAST NUMBER OF "ODDITIES" FOUND IN THE DOLLHOUSE AND miniature world suggests that there are a great number of miniaturists in the world who have a wry sense of humor, or else a vivid imagination.

Clock cases have always been particular favorites. A very elegant example is the furniture and tea set arranged in the clock case by the Faurots of Willoughby's, shown in figure 10.

The clock-case arrangement shown in figure 218 is very different. It is obviously of the Victorian era, and its creator, Deen Heavenridge of Cambridge City, Indiana, has made all of the furnishings from a very old medium, bread dough. I have a collection of bread dough Christmas tree ornaments but I had never seen bread dough furniture. Ms. Heavenridge explains that she first became aware of the multitudinous uses for bread dough when, on a television show, she saw a guest mix 1 slice of bread, 1 tablespoon of white glue, and 3 drops of lemon juice and then make flowers of the mixture. She experimented until she was able to produce dollhouse furniture, and the resulting dollhouse-in-a-clock-case is truly a notable oddity.

The Advent calendars, pictured in figures 219 and 220, can be hung next to dollhouses or as a background setting for miniatures. Figure 219 shows a complete dollhouse that hangs on the wall, and the windows can be opened on each day of the Advent season. The print-

ing and coloring is so beautiful that it occupies an honored place with our dollhouses. Figure 220 is also studded with little windows for opening during Advent, and it's titled "A Street in Doll Town." This calendar would make a marvelous subject for a shadow box or room. These Advent calendars are printed in Germany and are distributed by Sormani Calendars of Greenwich, Connecticut.

Termed "Fantasy Furniture" by the makers, the Petite Princess line came out in 1964 in molded plastic and in beautifully detailed design. It caught the fancy of miniature collectors at once and was displayed in stores in the two-story, electrically illuminated dollhouse pictured in figure 221. The display house shown, from the Snyder collection, was made of wood and fiberboard with vertically sliding glass covers in the front; every piece of furniture was included here, and the house was peopled by the original Fantasy Family. The decoration and detail were truly fantastic; the Royal Grand Piano has since become a collector's item and is represented in both the Overbeck and Kennedy houses described earlier. Gilt-framed paintings came with the sets; notice in the photo, lower right, a gold paper screen much like those we have illustrated elsewhere. Mirrors had elaborately molded frames; sheet music and a metronome came with the piano. But, alas, three rooms (bedroom, dining room, and living room) cost $60, and though everyone wanted it, no one, seemingly, could afford it. The following year (1965), the makers withdrew the furniture from the stores and Mrs. Snyder was fortunate enough to purchase one of the display cases with all the furniture intact. The furniture itself seems to have all but disappeared, with the exception of a few odd pieces that turn up at sales or estate dispersals. All that remains is what was preserved in dollhouses.

The collector of miniaturia will be intrigued by mention of "pedlar dolls" in Jean Latham's book, *Dolls' Houses*, originally published in England. Mrs. Latham feels that the wares of the pedlar dolls are exactly suited to dollhouses and wonders why no one has thought of putting one outside the back door of an eighteenth- or nineteenth-century dollhouse. The collector will rarely come across the "pedlar wagons" which enjoyed such a vogue in the early nineteenth century, but the fascinating one illustrated in figure 222 was made by the Wade Sanders family of Collinsville, Illinois. Mr. Sanders built the wagon and made the harness, and Mrs. Sanders stocked it; their daughter took care of the finishing and landscaping, and their combined efforts have produced a most captivating miniature display. On the opposite side of the wagon are all of the other necessities with which the itinerant merchant supplied the pioneer homemaker—pots and pans, clothing, dishes, and dried fruits and such supplies. The detail in such a presentation is unbelievable.

IDEAL

Petite Princess

FANTASY FURNITURE

221

This original merchant's
display case for Petite
Princess furniture has now
disappeared altogether. It
included every piece of
Petite Princess that was
made. Collection of Dee
Snyder.

222

This "pedlar's wagon" is
very unusual and makes
a lively addition to a
dollhouse scene. Collection
of Wade Sanders.

Hung against a Civil War handpainted wallpaper, this handsome glass, which was a premium in a box of detergent, makes a fine impression. From the author's collection.

224

Cracker Jack prizes make interesting collections when they can be found, but establishing authenticity is difficult unless the pieces are stamped with the name of the product. All are shown full size. From the author's collection.

One of the greatest sources of material for the collector of miniatures is premiums (for prizes). Perhaps because of their universal appeal, miniatures have always been favored as premiums. Pictured in figure 223 is a handsome cheval glass that came in a box of dishwashing detergent. It is proudly hung in the dining room of the writer's Tara mansion. Many such pieces are obtainable and show up frequently at dispersal sales or in antique shops, but probably the prizes from Cracker Jack are the best known. There is a whole category of collectors across the land who prize the Cracker Jack pieces, and rivalry for the rare ones is intense. The Cracker Jack collection in the Mott Miniature Display at Knott's Berry Farm in Buena Park, California, is one of the most impressive. It is said to contain nearly every premium since the inception of the idea at Cracker Jack.

The first premiums were inserted in popcorn boxes in 1912, and from that year until 1930, metal pieces were used, some handpainted, such as the group at top left in figure 224. Here, a little lantern, alarm clock, fire engine, and doll figure are shown, as well as a metal boot. From 1940 to 1950, toys concerning World War II were featured such as the airplane at center. In this period, printed tin pieces were also inserted in the boxes, such as the miniature tin baking tray at top, the wheelbarrow beneath, the Caterpillar tractor, and the pair of tools (a whole set could be collected) to the left, the china shoe, and the tin park bench. Beginning in 1950, a variety of subjects were used: The Capricorn charm at right center was one of a series, and the little dolls at lower right all appeared, including a 1-inch Frozen Charlotte. The tiny baby buggy at top right, as well as the metal coach and dog cart,

were bought as Cracker Jack minis and are in the author's collection, but we have always questioned their authenticity; the Cracker Jack people have no record of them, and they do seem a bit elaborate to have been won in a five-cent box of popcorn.

In the 1960s interest in the premiums declined, for the quality of the prizes lessened; mini-sized storybooks were introduced and Liddle Riddles, Fun Books, Tiny Tattoos, and mini Encyclopedias moved to the fore, but not much enthusiasm is exhibited for them. In this day and age when children have some very realistic toys, a cardboard parachute jumper with a plastic film parachute is hardly something a child or a collector could become excited about.

Bull Durham charms intrigued collectors for a time, but they were so small that very few survive. This writer has found only two in years of looking. Old Monopoly pieces are favored by many collectors; others consider Avon bottles in their various forms as subjects of interest. The latest thing is a series of Chinese art objects shown in figure 225 offered by a maker of margarine and described on page 157. These are made of a special plastic that feels exactly like ivory in the hand and is of a warm ivory color. A full series, four sets containing four pieces each, makes an interesting addition to any collection.

True success with oddities usually means giving full rein to one's imagination. The one-room schoolhouse from the Snyder collection, shown in figure 226, would be just another one-room schoolhouse if Mrs. Snyder hadn't built it in an old wooden toy greenhouse from F.A.O. Schwarz. Mrs. Snyder rescued the old frame, which is 25 inches wide, 17 inches tall, and then waited for an idea; the schoolroom materialized. Notice that here, again, Mrs. Thorne's projection of space behind miniature rooms is achieved by affixing reproductions of old Currier and Ives prints behind the windows. The pupils are old

225

A series of statuary pieces offered as a premium with margarine might well become the nucleus of a collection featuring similar pieces. The columns on which they rest are the risers for wedding cake layers. From the author's collection.

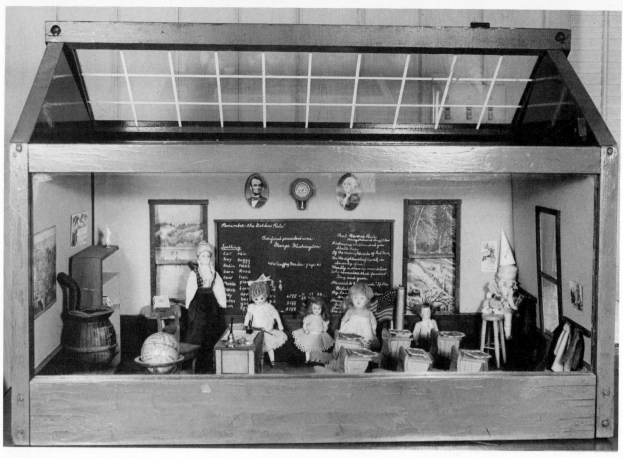

226

This charming little
schoolroom was assembled
in a discarded toy
greenhouse. Notice that
the builder has provided
scenery outside the
windows, just as in the
Updegraff castle and the
Thorne rooms. Collection of
Dee Snyder.

German and French dolls, spruced up to make them look like well-brushed youngsters who have just gotten out of the family sleigh. About the only thing Mrs. Snyder didn't make is the school desks, which were purchased from John Blauer. She did make the globe in the foreground and the slates on all of the desks. The flag is a very old metal one with only forty-eight stars and is difficult to find. The pictures around the wall are the old-fashioned cards from Sunday school; one is an award for good behavior with Mrs. Snyder's grandmother's name on it. The other reads, "Fear God."

Another oddity that may have some appeal for collectors is the author's own Ozark Log Cabin that, like the schoolroom, sprang from an idea to use up what was on the premises. We happened to have a lot of Lincoln Logs, holdovers from the days when our children built things. After three or four attempts at a log cabin built from natural logs with no success, we began to eye the Lincoln Logs. We toyed with this idea for a few weeks, trying to think of the proper substitute for the clay with which the pioneer plastered the interstices between the logs. One day I mentioned the problem to my husband. Why not use caulking compound, he suggested, since you are trying for a truly white material. Caulking compound proved the ideal plaster, and

174

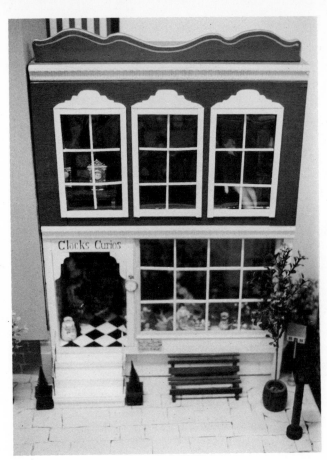

The clock and curio shop was inspired by a Victorian shop in London. A small unfinished bookcase was upended to make a shell 18 inches wide and 26 inches tall; the first floor houses the curio shop (filled with duplicates from Mrs. Snyder's collection) and the top floor is the clock shop. The mustachioed clockmaker is a copy of a Schoenhut circus man. The clocks range from fine antiques to contemporary pieces. Several old ones actually tick, and the antique silver one in the left window has a ticking device. Collection of Dee Snyder.

228

This tiny log cabin is made of Lincoln Logs and measures only 22 inches by 8 inches, but it is unbelievably complete and even boasts a "wall bed" and a pull-down stair. From the author's collection.

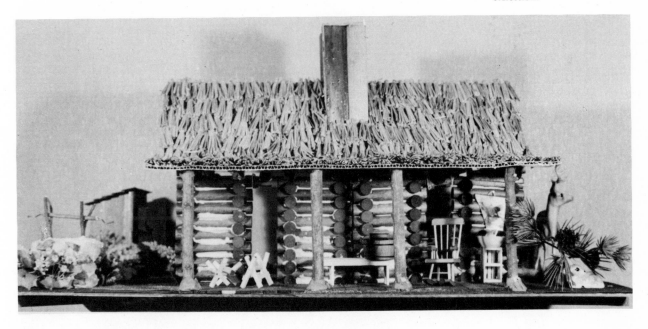

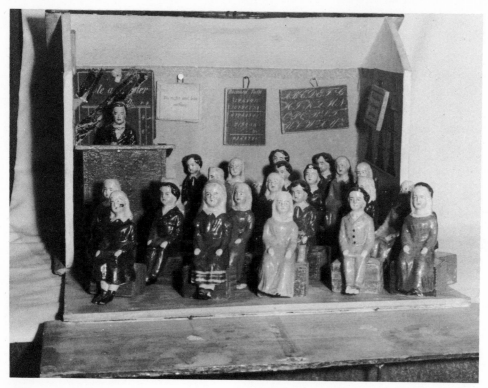

229

The schoolhouse from
Nuremberg, c. 1890, is truly
an oddity and quite rare.
Eight inches wide by
11 long, the front half of
the roof and front wall open
to disclose the students,
probably made of a
composition of sawdust and
glue pressed into molds.
When closed, it resembles a
little lunch pail. The
schoolhouse was acquired in
an obscure antique store
after the dispersal of the
Seth Thomas estate. From
the collection of Phyllis
Rembert.

230

Any collector could have
a lot of fun with the "29"
size miniatures made by the
Faurots of Willoughby's.
They are 29 percent of full
size and exactly half-way
between full size and
½12 size.

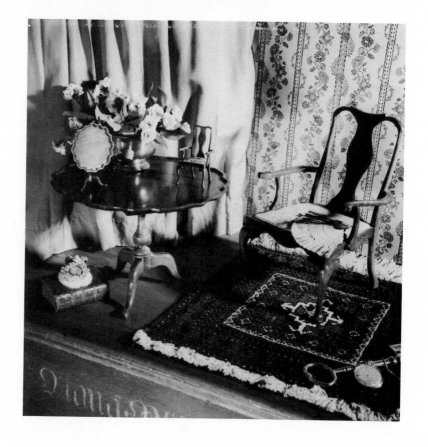

once it was in hand, our cabin rose without further delay. The furnishing of the log cabin required much searching for pioneering items that rarely are listed in catalogs or found in shops. In addition, we wanted to make a shake roof such as those found on cabins in Kentucky, and the only material available was a drying clump of prairie grass in the back meadow. This was cut into 2-inch lengths and tied in bundles exactly the size of the builder's little finger; it took 2,080 of them to finish the roof. It was a real challenge, and thus a very real pleasure for the builder.

An oddity that doesn't seem to fit elsewhere in this book, but that certainly deserves the attention of collectors, is the so-called "29" size miniature furniture the Faurots of Willoughby's 18th Century make. This idea bloomed in the course of their research for their miniature furniture; it is 29 per cent of full size and exactly half-way between full size and $\frac{1}{12}$ size. Study figure 230: The "29" size chair and table are arranged on a full-size chest; the piecrust table and Chippendale chair on the "29" size table are $\frac{1}{12}$ size, but they match the other full size pieces exactly. The tiny crown and miniature book are "29" size, as is the fan on the chair and the Oriental rug. The key is full size. It would be great fun to plan a room or house around these sizes, and see what could be found for it.

PART III

15

How to Start a Collection

Jack Norworth, one of the world's great collectors of tiny things, had a fixed rule for those who would start a collection: Start with just one item and watch it grow. It's a great thing to remember. Jules Charbneau, another great collector (with some 28,000 miniatures) suggested making up your mind what you want and then sticking to it. Charbneau, however, collected while he was making up his mind; as a seventeen-year-old apprentice seaman, he made his way to Paris to the famous exposition of 1900, and his four purchases there were a jeweled bird, a small meerschaum pipe, a miniature ruby cross, and a tiny church medal. These were the four pieces around which he built his collection and in the more than forty years that followed he devoted most of his spare time to his hobby and eventually made it his life work.

The Mott Family collection at Knott's Berry Farm in Buena Park, California, really began when Allegra Mitchell Mott began saving the prizes out of Cracker Jack boxes. Her collection eventually filled a candy box, then a dresser drawer, and now, after sixty-one years and the involvement of her entire family, numbers some 300,000 items.

John Blauer of San Francisco turned to collecting when, in early childhood, a large toy cast-iron stove collapsed on his knee. For a number of years he was unable to participate in the usual childhood

activities, and his wise mother encouraged him to develop an interest in miniatures in order to give some purpose to his life. Today his collection, upwards of 10,000 items of rarest quality, *is* his life.

Thus, we see that none of the great collections were accumulated according to any certain pattern. Rather, they came into being in a hit-or-miss fashion. These masters were collecting just because they loved collecting, and we must remember that we're collecting just because we love dollhouses and dollhouse miniatures.

Scale remains an important consideration for would-be miniaturists. Not all of the very old miniatures were made on the $\frac{1}{12}$ (1 inch to 12 inches) scale. Today, there is a strong movement to produce a great volume of miniatures on a larger scale, in order to fit the houses inhabited by the Barbie dolls and their friends, great favorites of today's little girls. Miniatures on a scale of $\frac{2}{12}$ will accommodate the 7- to 12-inch dolls that are manufactured and collected today, but in all likelihood they will be of less value to the collector. Very few items that are produced in such enormous quantities ever become collector's items. It is better to decide whether you want to collect $\frac{1}{12}$ scale things, $\frac{2}{12}$ scale things, old things, or modern things, metal or wood things, working or nonworking things, although combinations occasionally achieve unusual effects. However, you might end up with a melange of unrelated objects that not only do not bring much pleasure, but actually are bothersome because you know you wasted money acquiring them.

You can keep your dollhouse or miniature collection alive in an inexpensive, fun-filled way by following the thrift-shop circuit, the women's exchanges, the church bazaars, and the garage sales advertised in your neighborhood. Many an unknowing housewife clears her attic of things gathered by a collector of 100 years ago, never realizing what treasures she is disposing of, but if you know the signs, you can pick up these treasures for minimal amounts. Watch for signs announcing garage sales, and also for likely store-front windows that may be harboring rummage sales. Get to be a regular visitor at the thrift shops. Acquaint yourself with the volunteers who staff them and with the manager, and learn the day of the week they price the merchandise. Tell them what you're interested in, and they may set things aside for you.

This basic training will enable you to ferret out lace collars and cuffs that will make wonderful curtains for your dollhouse; small doilies and cocktail napkins for bedspreads; the new velvety finish terry towels for carpets. Look for upholstery samples and wallpaper sample books; heavy scalloped linens for window shades; wooden slat placemats for sun blinds or flooring; buttons for pictures, plates, clock

faces, or lamp bases. Bits and pieces of velveteen make fine upholstery fabrics, and even though some thrift shops have now become boutiques, you can still find some wonderful buys in the $.25 to $1.00 range.

It will be no time at all until you need a cabinet to house your treasures, and then a dollhouse, then more furniture to outfit the miniature house, and so on.

Don't overlook the possibilities of the collections within your collection. For example, I collect antique cookbooks, and in the course of the correspondence and travel incidental to this, have acquired a dozen miniature cookbooks that fit right into the dollhouses. A visit to Mexico will certainly net many baskets, carved wooden accessories, silver tableware, and so on, but that's fine—let this be the nucleus of a new Mexican collection. A visit to Spain will end with many pieces of Spanish jewelry that represent everyday things in miniature. My own collection of miniature musical instruments began with two costume pins at about $2.00 each, a banjo and a guitar. In gold (or a reasonable facsimile thereof), they are inlaid by hand on the side walls with mother-of-pearl, and are prized pieces in the music room of the author's Tara house.

Saving a prize from a box of Cracker Jacks to use as a chalk board in a miniature school room will start another collection—that of Cracker Jack prizes, or the innumerable mini-miniatures that have come as bonuses in the various packages of the last few decades. If you happen to pick up a tiny piece of petit point, you have the beginnings of a needlework collection. An old bag spotted at a rummage sale yielded a fine piece of tapestry and, in addition, had an "antique" finish that made it a "natural" for the spot in a dining room where we wanted some day to place a buffet. An old silk handkerchief in ivory colored silk with hand-hemstitched hems made lovely bathroom curtains in one of Adelaide Mannion's houses, and, of course, the uses of buttons are beyond comprehension.

16

Dealers and Craftsmen

HAVING DEALT WITH SPECIFICS, WE COME NOW TO THE NOBLE crew who are the very heart and soul of collecting—the dealers and craftsmen who make our treasures available to us. The do-it-yourselfers, no matter how talented, will always need the special pieces they cannot quite achieve on their own. The antiquarians, no matter how skilled at sniffing out the "finds" that add so much zest to their hobby, will always need contemporary gems to complete the scenes they have in mind. And we, the great middle class of collectors who love everything small no matter what its age, just so long as it is well done and beautiful, will continually be turning to contemporary craftsmen just because we are collectors and can't resist temptation.

For a number of years, collectors mourned the passing of the old artists in miniature, for they felt that there were no talents in the offing to take their places, but today this trend has reversed, and there are many, many young artists who are finding profit and satisfaction in creating imaginative, beautifully designed pieces. A list of craftsmen and dealers is in Appendix I to this book.

For years we have campaigned among miniaturists for a signing of their work, just as the old-time guildsmen signed theirs; today, those signatures are the most important details in establishing the authenticity of antique pieces. But for some reason, on the contemporary scene hallmarks have all but disappeared, with the exception of

Jack Jarque (who signs his Maritime Miniatures), Chestnut Hill Studios, Wes Faurot, Eugene Kupjack, Suzanne Ash, Ellen Blauer, and a few others. Fifty years from now the collections that have been put together today may be in the antique shops, and without hallmarks there will be no way of establishing their value. This writer hopes to continue her efforts to unite craftsmen of miniatures to uniformly mark their products.

In a like manner, this writer and Catherine Maclaren of *Nutshell News* have been agitating for some time to form a sort of loose register of all dollhouses, that is to have all dollhouse owners form a sort of group that would maintain a register and history of dollhouses in various collections, with a small plaque attached to each house giving it a number.

We hear continually from the artists and craftsmen that the demand for miniatures has grown until they can no longer keep up with it if they are to continue to turn out handmade pieces that are good enough to merit the collectors' attention. No longer can the wood carver, the maker of furniture, the glassblower, build up a stock of pieces so that an order can be filled promptly; today, four to six weeks is about average for most miniaturists or dealers, and it may even be longer.

The plea of the artists is, "Please don't ask us to hurry," and while this writer is one of the worst offenders in the matter of wanting something right now, the moment she thinks of it, she can sympathize with the plea and beg every collector to be understanding about it.

17

Forming Your Own Collector's Club

Trying to pass on instructions about forming a collector's or miniaturist's club is about like trying to tell a hungry person how to make a peanut butter sandwich; the hungry person doesn't need instructions, he needs just bread and peanut butter and the sandwich will almost form itself. It is the same with a collector's or miniaturist's club: All you need is one more congenial person who has also succumbed to miniaturia mania and you're ready to go.

Clubs almost without exception separate into two categories: those with members who just collect, and those with members who make miniatures, and so an aim, a base, will have to be decided upon before much can be done. Once this is established, there remain just a few details in order to move along. How many members will you limit yourself to? How often shall you meet?

Most clubs seem to accomplish more by working in small groups; fifteen or twenty should be the limit, and if your membership exceeds this number, it would be wise to form a splinter club. However, there are many most successful groups, for example, the Dollhouse Club of Huntington Beach, California, the Cleveland (Ohio) Miniaturia Society, and others too numerous to name, which find that operating as one single group sparks enthusiasm and inventiveness, and in addition

makes possible the planning of large, sometimes national, get-togethers such as the Tiny Treasures Society's annual exhibit in Dedham, Massachusetts, the Miniature Collector's Guild, which sponsors a fabulous meeting and fair just outside Boston, and the Cleveland Miniaturia Society, which sponsors an annual miniature fair in or near Cleveland, that attracts large numbers of both dealers and collectors.

The late Allegra Mott for many years dreamed of a national organization of all miniaturists and clubs. With a founding board of only fifteen people, she established the National Association of Miniature Enthusiasts. After only one year, the association numbered 29 clubs and 830 miniaturists among its members.

Let your friends know what you're interested in doing. Put out a few feelers at your local library or hobby shop. Our guess is that you will have a club before you can say, "Come to order." The author, who also writes a column for a St. Louis newspaper, decided to establish her own dollhouse and miniaturists' paper, and within one month after mentioning it in her column, she had over 1,000 subscriptions. It is expected that these subscribers will form into clubs that will provide an exchange of ideas in the midwest.

The "Show and Tell" idea might be borrowed from your first grader's class; miniaturists are always longing to show their progress to anyone who is in sympathy with them, and fellow miniaturists are the most likely prospects. The great thing about this, in the miniature world, is that no one ever needs worry about someone stealing their ideas, for as is the case with any artist, each creation is bound to vary with the creator's ideas; in a dollhouse and miniature club, you could offer a project such as a miniature Old Woman in a Shoe, and thirty members would bring thirty different variations on the title.

Word-of-mouth advertising will usually be all that is needed to bring additions to your you-and-one-other club; if you care to spend a few dollars, a three-line advertisement in the local neighborhood paper will bring more. You'll have enthusiasts of every age; talents that fit into every field.

Just in case you wish help in the forming of your club, or information on how to make the club a member of the national group, here are the addresses of the regional National Association of Miniature Enthusiasts groups:

Region N-1 Southern California, Arizona, Nevada, New Mexico
C. Max Boydstun, Director
P.O. Box 2621
Brookhurst Center
Anaheim, Ca. 92804

Region N-2 Northern California, Idaho, Oregon, Utah, Washington
 Mr. Bill Briner, Director
 1807 Octavia Street
 San Francisco, Ca. 94109

Region A-1 Illinois, Ohio, Indiana, Michigan, Wisconsin, Missouri,
 Iowa
 Mr. Tom Devereaux, Director
 27 J 5701 Sheridan Road
 Chicago, Ill. 60660

Region A-2 Colorado, Kansas, Minnesota, Montana, Nebraska,
 North Dakota, South Dakota, Wyoming
 Mrs. Elizabeth Edwards, Director
 2608 Cheyenne
 Wichita, Kansas 67216

Region M-1 New York, Pennsylvania, Delaware, New Jersey
 Mr. Wm. B. Wright, Director
 116 E. Forgetmenot Road
 Wildwood Crest, N.J. 08260

Region M-2 Vermont, New Hampshire, Connecticut, Maine, Mas-
 sachusetts, Rhode Island
 Mrs. Frank Gerrantana, Director
 24 Chestnut Hill Road
 Trumbull, Conn. 06611

Region E-1 Kentucky, Alabama, Georgia, Florida, North Carolina,
 Tennessee, South Carolina, Virginia, West Virginia,
 Maryland, District of Columbia
 Mrs. Gladys Walker, Director
 401 N. Boulevard, Apt. 1
 Richmond, Va. 23220

Region E-2 Oklahoma, Texas, Arkansas, Louisiana, Mississippi
 Mrs. Ray Klinge, Jr., Director
 4028 East 45th Street
 Tulsa, Ok. 74135

 For Hawaii, Alaska, Puerto Rico, Phillipines, Mexico,
 Canada, etc., address your correspondence directly to
 N.A.M.E., P.O. Box 2621, Brookhurst Center, Ana-
 heim, Ca. 92804

18

The Touring Collector

SINCE THE COLLECTOR'S HOBBY IS ALWAYS ON HIS MIND, HE IS constantly in search of examples of dollhouses and miniatures that may bring him ideas or show him in greater detail the possibilities of producing something of which he is truly proud. This is true whether he (and here we go back to our original premise as to the three classes of collectors) is a builder, a buyer, or an antiquer.

It would be impossible to offer a complete list of the collections and shops in which he would be interested, for collections change, museums are continually putting new things on exhibit and storing others, new shops open, and old ones close. The following list, however, is a guide to exhibits and shops which we have been able to inspect personally and which we feel are reasonably permanent. We'd advise the traveling collector to check first with the art museum or historical society of the city where he is visiting to make certain that the exhibits are open to visitors at the time it is convenient for him to attend.

While the museums and collections in foreign countries are numerous and fascinating, we have omitted them here; to properly classify and describe them would require another entire book—one which we may undertake some day, since the history of collecting in this country had its origins in Great Britain and on the continent, and virtually all of the dollhouses here reflect the relationship.

The following will be a guide for the traveling collector, and inquiring in the city through which he's passing, we feel sure, will produce many more possibilities.

ARIZONA

Phoenix Art Museum
Phoenix, Arizona

Permanent exhibit of sixteen Thorne rooms; other miniatures.

CALIFORNIA

Hobby City
Anaheim, California

Doll museum; a city of shops replete with items of interest to the collector.

Henderson Doll Museum
40571 Lakeview Drive
Big Bear Lake, California 92315

Fabulous array of old dolls, many miniatures, one dollhouse furnished entirely in rare Tootsietoy furniture. Call before visiting.

Mott Miniatures
Knott's Berry Farm
Buena Park, California

Largest display of miniatures in the world; not only separate pieces but rooms, shops, and dollhouses of every period from Pilgrim to mid-twentieth century.

Maynard Manor
883 39th Avenue
San Francisco, California 94121

This address also houses John Blauer's Miniature Mart and the Peddler's Shop, formerly of Independence, Missouri. Call for appointment.

COLORADO

Denver Art Museum
Denver, Colorado

Several houses here from the famous Rosenberg collection. Call to be certain they are on display.

CONNECTICUT

Barnham Museum
Bridgeport, Connecticut

Complete circus and village in miniature dollhouses and some old dolls. Open daily.

DISTRICT OF COLUMBIA

Smithsonian Institution
Washington, D.C.

The Faith Bradford dollhouse, considered one of the finest in the country. Complete furnishings of the 1905 period.

FLORIDA

Mrs. Marie McCollum
149 S.E. 18th Avenue
Deerfield Beach, Florida 33411

Private collection but open to the public by appointment. One of the best.

Cole-Olsen Museum
23955 S.W. 157th Avenue
Homestead, Florida 33030

Exceptional collection of both houses and miniatures, nicely displayed. By appointment only.

D.H. Lewis Doll Museum
off highways 98 & S490
Homosassa, Florida

A great Victorian house, many miniatures. Closed Monday and Tuesdays.

Henry M. Flagler Museum
Whitehall Way
Palm Beach, Florida

Only one dollhouse, but that one is great. Check for open hours.

Ruhmah's Doll Museum
2801 Beach Blvd. So.
St. Petersburg, Florida 33707

Primarily a doll museum but frequently shows exceptional houses. Check open hours.

Museum of Old Dolls & Toys
1530 6th Street
Winterhaven, Florida

Well worth a side trip not only for dollhouses but for antique toys and dolls as well.

ILLINOIS

Art Institute of Chicago
Decorative Arts Department
Adams at Michigan
Chicago, Illinois

Original Thorne rooms on permanent display. Exceptional miniatures for sale.

Marshall Field & Co.
Toy Department
Chicago, Illinois

Fine display of miniatures for sale; frequent dollhouse showings.

Museum of Science & Industry
57th Ave. at South Shore Drive
Chicago, Illinois

Colleen Moore Fairy Castle. One of the great dollhouse classics.

Jeanne Musselman Overbeck
130 No. Main Street
Edwardsville, Illinois

Castle displayed once yearly for benefit of a scholarship fund. End of May only.

"Time Was" Museum
Mendota, Illinois

Interesting collection of dolls, dollhouses, and toys from the good old days.

INDIANA

Ruth Hackett's Doll Museum
620 W. Jefferson
Kokomo, Indiana

Interesting collection of dolls, dollhouses, and toys. Open daily from 1 to 8 P.M.

IOWA

Amana Home Museum
Homestead, Iowa

Several handmade dollhouses of the early twentieth century; also replicas of early Amana rooms.

MAINE

The Cricket Shop
Damariscotta, Maine

Interesting miniatures both as collections and for sale. Ask whether other dollhouses in town may be visited.

MARYLAND

Baltimore Museum of Art
Baltimore, Maryland

Stirling Dutch room; a few houses but not all are on display.

Potpourri Miniatures
7811 Montrose Road
Rockville, Maryland

By appointment only but worth the effort. Many miniatures both old and new.

MASSACHUSETTS

Boston Flea Market
Faneuil Hall
Boston, Massachusetts

Sale every Sunday from 1 to 7 P.M., well worth your time. Fantastic treasures to be picked up.

Harrison Gray Otis Museum
Boston, Massachusetts

Outstanding collection of Victorian houses. Check to be sure they are on display.

South Shore Women's Exchange
60 So. Street
Hingham, Massachusetts

Not a museum but a treasure house of miniatures on display and for sale. Open Monday through Saturday, 9:30 to 6:30 P.M.

Children's Museum
60 Burroughs Street
Jamacia Plains, Massachusetts

Toys and dollhouses from various periods. Very fine.

Plymouth Antiquarian Society
Plymouth, Massachusetts

Recent innovations make definite information unavailable, but do inquire.

Essex Institute
Essex Street
Salem, Massachusetts

A must. Exhibit includes 1852 Warren house and others. Open Tuesday through Saturday, 9 to 4:30 P.M.

Peabody Maritime Museum
Essex Street
Salem, Massachusetts

Open 9 to 4 P.M.; Sundays 2 to 5 P.M. Ship models and diorama that includes miniatures.

Toy Cupboard Museum
Providence School of Design
South Lancaster, Massachusetts

A number of collections well worth the miniaturist's time. Check for open hours.

Sturbridge Village
Brimfield Turnpike
Sturbridge, Massachusetts

Exhibits and colonial rooms in miniature. Fine miniature furniture for sale.

Yesteryear's Museum
Sandwich, Massachusetts

Two floors of miniatures and dolls housed in a quaint old church. Don't miss it.

Wenham Historical Museum
Routes L-A
Wenham, Massachusetts

Model miniature farmhouses. Open Monday through Friday, 1 to 4 P.M.

MICHIGAN

Ford Museum
Dearborn, Michigan

Many exhibits of dollhouses and antique miniatures.

MISSOURI

Joplin Doll Museum
Joplin, Missouri

Fabulous Bradley collection and many others. Inquire of Chamber of Commerce; new location has not yet been selected.

Old German School Museum
Children's Room
Hermann, Missouri

Many handmade old dollhouses. Inquire as to private showings at the time of your visit.

Jefferson Memorial
Forest Park
St. Louis, Missouri

Three fine old dollhouses, plus the Country Store, with miniatures. Ask about other local dollhouses that may be seen.

NEW JERSEY

Newark Museum
Newark, New Jersey

Two fine houses, not always on display. Call to inquire.

NEW YORK

American Museum of
 Natural History
New York City, New York

Exceptional Japanese dollhouse.

Cooper Union Museum
New York City, New York

A number of antique shops and dollhouses. Very fine.

Museum of the City of
 New York
New York City, New York

Many fine dollhouses, including some antique shops.

Brooklyn Children's Museum
Brooklyn, New York

A fine display of both classic dollhouses and some miniatures. Also antique dolls.

Avis Howell's Antiques
North Salem, New York

Very fine collection. Call for appointment.

Raynham Hall
Oyster Bay, New York

Visit the old Townsend house, which includes a dollhouse.

Margaret W. Strong
Museum of Fascination
Pittsford, New York

Check for open hours. Several fine antique dollhouses.

Museum of Arts and Sciences
Rochester, New York

Part of the Strong collection now on exhibit here but not always open. Call before attending.

Phillips' Castle
Tarrytown, New York

Van Courtland dollhouse (1744). Open every day except Monday.

Hudson River Valley Museum
Trevor Park
Yonkers, New York

Susan Bliss house on display here. Check first to be sure the display is open.

NORTH CAROLINA

Nancy Tut's Christmas Shop
Dillsboro, North Carolina

Interesting shop with an occasional house of local make.

OHIO

Cleveland Museum of Arts
Cleveland, Ohio

Fascinating Japanese doll palace, not always on display. Call before attending.

Western Reserve
 Historical Society
10915 East Blvd.
Cleveland, Ohio

Ask about current exhibits. Some of the finest houses and miniatures in the country are here.

Rutherford B. Hayes Library
1337 Hayes Avenue
Fremont, Ohio

Fanny Hayes dollhouse, first made for a White House child. Call for open hours.

Warren County Museum
Lebanon, Ohio

Frequent displays of local items of note. Call before visiting.

Rena's Miniature Rooms
1315 E. High Street
New Philadelphia, Ohio

Open June through August, daily 10 to 7 P.M. Exceptionally beautiful miniature rooms.

PENNSYLVANIA

Betty Seidel Shop
Cherryville, Pennsylvania

Not actually a museum but a fine collection of miniatures. Specializes in miniature decorated eggs.

Mary Merritt Museum
Route 22
Douglassville, Pennsylvania

One of the best, including famous "Hope Villa" and many Schoenhut toys.

Memory Town
Mt. Pocono, Pennsylvania

Only miniature wax museum in this country. Shops and miniatures galore.

Chester County
 Historical Society
West Chester, Pennsylvania

Has several fine nineteenth-century dollhouses, not always on display. Check before visiting.

RHODE ISLAND

Newport Historical Society
Newport, Rhode Island

Unusual antique paper dollhouse; many other interesting miniatures.

SOUTH DAKOTA

Stuart Castle and Stuart Manor
Route 16, Rockerville Goldtown
Philip, South Dakota

Complete miniature world including train tunnel, Victorian village, many others.

Game Lodge Doll House
Custer State Park,
Custer, South Dakota

Large collection of miniature rooms depicting historical scenes.

TENNESSEE

Dublin Gallery
Knoxville, Tennessee

Many fine pieces, not always on display. Check before visiting.

VERMONT

Enchanted Doll House
Route 7
Manchester Center, Vermont

Wonderful shopping, a very fine Victorian dollhouse on display. Fine miniatures for sale.

Shelbourne Museum
Route 7, seven miles south of
 Burlington
Shelbourne, Vermont

A must. An extensive museum of various miniatures. Open daily 9 to 5 P.M., June through October.

VIRGINIA

Skyline Doll & Toy Museum
Waynesboro, Virginia

Several dollhouses with furnishings; a wealth of antique toys.

Salem House
209 No. Boundary Street
Williamsburg, Virginia

Several worthwhile dollhouses are here, not always on exhibit. Check for open hours.

WASHINGTON

Museum of History & Industry
Seattle, Washington

Exhibits the unbelievable Hammons dollhouse. Check for hours.

WISCONSIN

Milwaukee County
 Historical Museum
Milwaukee, Wisconsin

Exhibits the famed Uihlein house (1893) and other miniatures. Call to make sure it is on display.

Appendix A:

Miniature Craftsmen and Dealers

The following list for the convenience of the collector is fairly complete. We have used the initial "D" where the dealer indicated fills orders through other sources. Any name followed by "C&D" means that this artist both makes the pieces and sells them on order. SASE means send self addressed, stamped, long envelope for a brochure.

Horace A. Allen C&D
622 Evans Avenue
Missoula, Mont. 59801

SASE for list of Victorian furniture, tiles, many accessories

Hermania Anslinger C&D
320 South Ralph Street
Spokane, Wash. 99202

Mainly wood carvings, other pieces from specifications; SASE for information

Attic Miniatures C&D
2202 West Downie
Santa Ana, Calif. 92706

SASE for list; many Victorian pieces incl. curved glass china cabinet. Will copy your designs.

Peggy Barnes C&D
8122 Hardy Street
Kansas City, Mo. 64138

Simply beautiful miniature food; anythings you like; send $.50 for price list

Bazaar Cada Dia D
The Cannery
2801 Leavenworth Drive
San Francisco, Ca. 94133

Dealer in Sonia Messer Imports, other quality miniatures.

Robert Bernhard C&D
7302 Hasbrook Avenue
Philadelphia, Pa. 19111

SASE for miniature furniture; charge of $.50 for pictures; all very fine. Beautiful distinctive designs.

Emma M. Billings D
103 Mary Street
Haskins, Ohio 43525

Bisque miniatures; $.25 for price list, $.60 plus postage for photos

Milton Breeden C&D
111 North 5th Street
Millville, N.J. 08332

SASE for list of handblown glass tableware, chandeliers, many other things

Breton House D
8630 Sunset Boulevard
Los Angeles, Ca. 90069

Dealer in Sonia Messer Imports, other quality miniatures.

Brown's Miniatures C&D
P.O. Box 35
Cambridge, N.Y. 12816

Handpainted metal miniatures, copies of old pieces; send SASE

Carlson's Miniatures C&D
15671 Bender Lane
W. Chicago, Ill. 60185

Send $.50 for list; fine miniature furniture, rooms, house furnishings.

Carousel House D
1 Sherwood Square
Westport, Conn. 06880

$.50 postage for catalog showing miniatures, dolls, and toys

Carriage World D
Stage House Village
Scotch Plains, N.J. 07076

Exceptionally fine shop, home of Society for Doll House Enthusiasts

Cathy's Miniatures C&D
22 Surrey Run
Williamsville, N.Y. 14221

SASE and $.50 for list of custom-made houses, shops, accessories

Chestnut Hill Studios C&D
P.O. Box 38
Churchville, N.Y. 14428

Send $1.75 for truly beautiful catalog of handmade pieces, furniture, and accessories

Mary Christopher's Doll House D
229 Grand Street
Morgantown, W. Va. 26505

SASE for list of miniature furniture, some accessories

Terry Crocheron D
1550 East Louisa Avenue
West Covina, Calif. 91791

SASE for list of miniatures

Zelda H. Cushner D
12 Drumlin Road
Marblehead, Mass. 01945

Miniatures, dollhouses with dolls as the main attraction; send SASE for list

D & D Miniatures D
P.O. Box 122
Ho Ho Kus, N.J. 07423

Miniature furniture, accessories, contemporary and antiques; send SASE for list

D & E Miniatures D
P.O. Box 2117
Culver City, Calif. 90230

Fine pewter pieces plus many accessories; SASE brings large brochure

Davault Miniature Furniture
422 Livingston
Creston, Iowa 50801

Dollhouses to order; send $.35 for catalog of furniture patterns

Dawson's Book Shop D
535 North Larchmont Blvd.
Los Angeles, Calif. 90004

SASE for list of rare and miniature books, some old, some new

Mildred Dix D
88 Allen Street
Walpole, Mass. 02081

Fine antique miniatures at reasonable prices; SASE for brochure; stocks change rapidly

June E. Dole C&D
R.R. No. 1, Wapping Road
Rockville, Conn. 06066

Miniature samplers, in kits or handmade; send SASE for complete information

Doll Cupboard C&D
P.O. Box 458
Branson, Mo. 65616

Unbelievable list of miniature accessories and food; send SASE

Doll House Factory C&D
156 Main Street
Lebanon, N.J. 08833

Many dollhouse designs to order; cedar shakes, other accessories; send $.50 and SASE

Doll House Factory
P.O. Box 2232
Sunnyvale, Calif. 94087

Handmade doll houses using your designs or theirs, many accessories

Dollspart Supply Co., D
5-06 51st Avenue
Long Island City, N.Y. 11101

SASE for list of miniature furniture

John A. Dowling C&D
151 Raymond Street
Darien, Conn. 06820

Dollhouses made to your design or his; send SASE and specify requirements

Elsie's Doll House D
389 North Euclid Avenue
St. Louis, Mo. 63108

Old dolls, old dollhouses, miniatures, many accessories; no list at present.

Emporium Publications D
P.O. Box 539
Newton, Mass. 02158

Do-it-yourself furniture kits, $\frac{1}{12}$ scale; send SASE for brochure

Enchanted Doll House D
Route 7, Manchester Center
Vermont 05255

40-page catalog for $1.00, includes many fine miniatures and other items

Enchanted Toy Shop D
23812 Lorain Road
North Olmstead, Ohio 44070

Send $.50 for list of accessories, $1.00 for illustrated brochure; many nice pieces.

R. Ewer, Pewterer C&D
1282 Lafayette Street
Cape May, N.J. 08204

Fascinating list of pewter pieces that are exact copies of antiques; many dollhouse accessories

E. J. Faassen C&D
100 Park Lane
Lake Bluff, Ill. 60044

Custom dollhouses handmade and hand-finished; write for estimate on your requirements

Mark Farmer, Inc. C&D
38 Washington Avenue
Port Richmond, Calif. 94801

Send $.25 for lists of dollhouse furniture and accessories, also many dolls and kits. Very slow delivery

Federal Smallwares Corp. D
85 Fifth Avenue
New York, N.Y. 10003

48-page catalog includes the Shackman line and many extras—everything for the dollhouse

Lillian Gaines C&D
118 South 11th Street
Independence, Kans. 67301

Send $.50 for samples of work; makes dollhouse handwoven coverlets, many other items

Gemini Studio C&D
915 Vale View Drive
Vista, Calif. 92083

Pictures, etchings, paintings, everything in art; send $.50 for brochure

Ginger Jar, The C&D
6133 Wakefield Drive
Sylvania, Ohio 43560

Small line of very fine things, both furniture and pottery; send $.50 for list

Golden Ball, at the Sign of D
Colonial Williamsburg
Virginia 23185

Send SASE for list of silver charms that make wonderful dollhouse accessories

Hall's Lifetime Toys C&D
2305 East 28th Street
Chattanooga, Tenn. 37407

Send SASE for catalog LM 72 on doll-houses and miniatures

Hathaway, John D
410 W. 6th Street, Box 1287
San Pedro, Calif. 90731

Cardboard houses and castles; send $.25 for extensive catalog (refunded with order)

Dorothy Hesner D
5064 West 31st Street
Cicero, Ill. 60650

Send long SASE for list of miniatures and accessories

House of Miniatures
P.O. Box 1816
Santa Fe, N.M. 87501

Send $.50 plus a 10-cent stamp for an interesting catalog; lots of Mexican things

House with the Blue Door
14 Kent's Lane
Hingham, Mass. 02043

Dollhouse kits for you to make; send stamp for brochure

Ms. Evelyn Hyman D
62 Dale Road
Eastchester, N.Y. 10707

Dealer in antique miniatures and doll-house dolls; director of Miniature Collectors of America

Itty-Bitty Doll Shoppe
1238 South Beach Blvd.
Anaheim, Calif. 92804

Specializes in pewter miniatures; send SASE for list and information

Jack Jarque C&D
Maritime Miniatures
45 East 7th Street
New York, N.Y. 10003

Makes tiny ship models (2 inches long) with beautiful detail; also original, framed paintings of the ships; send for list

Anne Johnson C&D
402 East Clarion Drive
Carson, Calif. 90745

Send SASE for list of miniatures; specializes in many things; games and rosaries are wonderful

Mrs. Lewis M. Jorgensen C&D
Esther's Doll Hospital
P.O. Box 255
Viborg, S. Dak. 57070

Makes fine rugs, pillows, crocheted doilies, etc.; send SASE

Joen Ellen Kanze C&D
26 Palmer Avenue
North White Plains, N.Y. 10603

Makes great dollhouses to order; send SASE for list of fine miniatures

Kimble House C&D
8 Grove Street
Brandon, Vt. 05733

Dollhouses made to order; send SASE with requirements for complete information

Kitchen, Parlor & Doll House D
623 Toulouse Street
New Orleans, La. 70130

Small shop, lots of fine things; no list at present

Cindy Ksiazek C&D
105 Maria Lane
Zelionople, Pa. 16063

Handwoven accessories, rugs, table linen, etc.; send SASE

L. Kummerow Dollhouses C&D
16460 Wagonwheel Drive
Riverside, Calif. 92506

Send $.25 for catalog of custom-made doll-houses and furniture

Frances La Monica D
67 Pomona Avenue
Yonkers, N.Y. 10703

Send $.50 for list of accessories; has a large selection, most very fine

Jack Levien D
Enkhuizen 65
Holland

Miniature books both old and new; write for information on what is available

Lilliput Shop C&D
5955 S. W. 179th Avenue
Beaverton, Ore. 97005

Send $1.00 and SASE; dollhouses old and new, miniatures, pictures, and prints; wood supplies for builders

Dorothy Lindquist C&D
628 Tower Brook Road
Hingham, Mass. 02043

One-inch dolls, brides and bridesmaids; send SASE for information

M-A-R Kreations, C&D
115 North Pershing
Wichita, Kans. 67801

Fine dollhouses made and finished by hand, many different designs; send SASE

Merry Miniature Books C&D
Judy S. Jacobs
1375 East 5th Street
Brooklyn, N.Y. 11230

Send $.50 and large SASE for lists of miniature books, all handmade

Microbius C&D
Barbara Epstein
534 Red Haw Road
Dayton, Ohio 45405

Send $1.00 for catalog; makes her own dishes, etc.; other fine miniatures

W. R. Middleton, Jr. C&D
3809 Camaro Court
Raleigh, N.C. 27604

Handmade and finished dollhouse furniture of the 1900s; send SASE for information; specify which room

Miniature Book Studio C&D
Carol Wenk
P.O. Box 2603
Lakewood, Ohio 44107

Send $.50 and SASE for list of miniature books, stationery

Miniature Mart C&D
John Blauer
883-39th Avenue
San Francisco, Calif. 94121

Send $2.00 for catalog of fine furniture plus great accessories; all quality pieces

Miniatures by Garilyn C&D
74 Georgina Street
Chula Vista, Calif. 92010

Send $1.50 for catalog of many handcrafted miniatures and accessories

Miniatures by Marty C&D
Mrs. J. C. LaBarge
388 Wildwood Drive
Holland, Mich. 49423

Specializes in Victorian things, lists many accessories; send $.25 for brochure

Mini Things by Suzanne C&D
5600 East Oxford Avenue
Englewood, Colo. 80110

Send $1.00 for list of miniature ceramics, many kitchen pieces; new list of Chinese Export

Morley Miniatures C&D
Lucille Morley
16752 Cooper Lane
Huntington Beach, Calif. 92647

Send $1.50 for loose-leaf catalog of extrafine Victorian pieces; all handmade and handfinished

Myers Florists and Antiques D
Route No. 1
Decatur, Ind. 46733

Send $.25 for brochure of miniature furniture and accessories

Nancy Lee's D. H. Museum C&D
Mrs. George Webster
379-103rd Avenue
Plainwell, Mich. 49080

Beautifully made hard-to-find accessories; send SASE for list and prices

Paige One D
Paige Thornton
3216 Clairmont Road, N.E.
Atlanta, Ga. 30329

New and antique pieces for the discriminating collector; send SASE for pieces available; these are continually changing.

Marian Parker C&D
Old Curiosity Shop
Moberly Lake
British Columbia, Canada

Send SASE and unattached 10-cent stamp for list; makes dollhouse rugs and quilts

Patsy Models Company C&D
189 Gammons Lane
Watford WD2 5Je
England

Send International Reply Coupon for information on dollhouses and dollhouse models

The Peddler's Shop C&D
Ellen Krucker

Now operated under the same name in combination with John Blauer's Miniature Mart

Pickwick Miniatures C&D
P.O. Box 297
Glenview, Ill. 60025

Send $.50 plus large SASE for list of furniture, accessories, many hard-to-find things

The Pixie Shop C&D
1441 Jones Road
Yuba City, Calif. 95991

Send SASE for information on miniature stitchery pictures and many other accessories

Posy Patch Originals C&D
P.O. Box 38123
Atlanta, Ga. 30334

Exquisite flowers and greens send $1.00 for catalog

Mrs. Mel Prescott C&D
P.O. Box 177
Warrenville, Conn. 06278

Specializes in handmade and handfinished Victorian furniture, with Queen Anne pieces also available. Very slow delivery

Mrs. Jerold Rahrer C&D
63 Glenholme Drive
Saulte Ste. Marie
Ontario, Canada

Dollhouses and miniatures according to your specifications; send SASE for information

Roberts Toys D
35 Fashion Square
Sherman Oaks, Ca. 91403

Dealer in Sonia Messer Imports, other quality miniatures.

Robin's Roost D
P.O. Box 186
Grayslake, Ill. 60030

No catalogue; just very fine miniatures. Worth stopping to see. Call for appointment.

Ms. Betty Rockoff C&D
1031 East Magnolia Blvd.
Burbank, Calif. 91501

Send $.50 and SASE for list of foods that are simply unbelievable; now making whole dinners

Santons de Provence C&D
P.O. Box 364
Damariscotta, Maine 04543

Send $.25 for brochure on hand-kilned miniature figures, not of $\frac{1}{12}$ scale, but cute

Mrs. F. M. Seamer C&D
R.R. No. 1
Windy Hill
Moscow, Iowa 52760

Doll lists, also miniatures; send SASE and $.35

Bertha Snitzer C&D
409 Kerper Street
Philadelphia, Pa. 19111

SASE for list of dollhouse furnishings and many handmade things

Sonia Messer Imports D
Brack Shops
527 West 7th Street
Los Angeles, Ca. 90014

Sells only through dealers; check those which read "Dealer in Sonia Messer Imports".

South Shore Woman's Exchange D
60 South Street
Hingham, Mass. 02043

$1.00 brings bound catalog of many miniatures plus handblown glass items

Lois Taylor C&D
5030 Raton Circle
Long Beach, Calif. 90807

Handcrafted pewter-like pieces of authentic design; send SASE for list

Jean Townsend C&D
415 Manzano N.E.
Albuquerque, N.M. 87108

Makes ceramic blue spatter ware pieces, many other miniatures; send SASE for list

Toys by Roy D
76 Winrock Center
Albuquerque, N.M. 87110

Dealer in Sonia Messer Imports, other quality miniatures.

Toys by Roy D
1014 Valley View Center
Dallas, Tx. 75243

Dealer in Sonia Messer Imports, other quality miniatures.

Toy Shop of Happy Things D
7 Spring Street
Eureka Springs, Ark. 72632

Send $.25 for brochure of toys, miniatures

Treasures & Trinkets C&D
619 Alzazar,
Albuquerque, N.M. 87108

Send SASE for many miniatures as well as some handmade furniture pieces

United Collectors D
P.O. Box 6427
Glendale, Ca. 91205

Dealer in Sonia Messer Imports, other quality miniatures.

Betty Valentine C&D
114 E. New State Road
Manchester, Conn. 06040

Miniature furniture of the finest quality; list on receipt of SASE

Vermont Country Store D
Weston, Vt. 05161

Send $.50 for catalog; carry many tiny prints for dollhouses, also wrought iron accessories

The Village Smithy C&D
Al Atkins
73 Kensington Road
Bronxville, N.Y. 10708

Catalog costs $1.00 and is worth every penny of it; makes everything the old-time house had made of iron, many other things

M. White C&D
Doll House Miniatures
4290 N.W. 10th Street
Coconut Creek
Pompano Beach, Fla. 33063

SASE and $.50 for list of handmade minia-ture furniture of fine quality

Willoughby's 18th Century
P.O. Box 918
Los Altos, Calif. 94022

Finest Queen Anne furniture on the mar-ket, plus accessories; send $1.50 for catalog that is a joy to read

Philip Wilson
Terrapin Ridge
Elizabeth, Ill. 61028

Fine handcrafted furniture; send SASE for information and prices

Winbon Creations C&D
1900 Paradise Drive
Tiburon, Calif. 94920

Fine box rooms, fireplaces, miniatures, supplies: send $.50 and SASE

Windfall D
Main Street,
Sharon Springs, N.Y. 13459

Fine catalog includes much of furniture and accessories plus new French furniture not offered elsewhere

Woody's Miniatures C&D
P.O. Box 3211
Green Bay, Wis. 54303

Send $1.00 for list of furniture made by hand; specializes in circus wagons

Yankee Heirlooms D
Kaye H. MacLeod
9942 Continental Drive
Huntington Beach, Calif. 92646

Handblown glassware and graniteware dishes and pans in $\frac{1}{12}$ and $\frac{2}{12}$ scale

Yield House D
North Conway
New Hampshire 03860

Send $.25 for catalog; includes miniature furniture and dollhouse

Mrs. Pearl Zak C&D
11662 Second Street
Yucaipa, Calif. 92399

Handmade and handfinished miniature furniture; send $.75 for catalog

Appendix B:

Publications of Interest to the Collector

The Antique Trader
P.O. Box 1050
Dubuque, Ia. 52001

Weekly paper on antiques carrying frequent news on miniatures. $9.50 per year

Art Institute of Chicago
Decorative Arts Department
Adams and Michigan
Chicago, Illinois 60603

Have two books on the Thorne Rooms, one on American, and one on European— $2.00 each; slides and postcards also

Creative Crafts Magazine
Model Craftsman Publ. Co.
31 Arch Street
Ramsey, N.J. 07446

Publishes many articles on dolls and dollhouse miniatures; June 1973 issue was exclusively miniatures

Doll Castle News
Mrs. Edwina L. Mueller, Editor
Brass Castle
Washington, N.J. 07882

Magazine primarily devoted to dolls but uses many articles on miniatures; $3.50 per year for six issues

Doll House (and Miniature) News
Marian O'Brien, Editor
No. 3 Orchard Lane
Kirkwood, Mo. 63122

Monthly issue contains news and ideas for do-it-yourselfers, many hints on new craftsmen; $6.50 for ten monthly issues

The Doll's House
(Faith Bradford's House)
Smithsonian Publications (No. 4641)
Washington, D.C. 20044

Booklet containing the enchanting story of Faith Bradford's dollhouse in the Smithsonian

Hobbies Magazine
1006 South Michigan Avenue
Chicago, Ill. 60605

Published monthly at $6.00 per year, has a special department on miniatures

Hopkinson's Antiques
RFD No. 1
Tilton, N.H. 03276

Published a book entitled *Dolls and Miniatures with Their Prices at Auction*, $4.95

International Doll House House News
41 Manor Street
Braintree, Essex, England

One of the best, published four times a year, $1.00 single copy, $5.00 for six issues surface mail, $9.20 air mail

Mott's Miniatures Workshop News
P.O. Box 5514
Sunny Station Hills
Fullerton, Calif. 92633

Quarterly covering shared stories on projects, diagrams, ideas; costs $7.00 per year, each subscription begins with No. 1

Miniature Gazette
Box 2621, Brookhurst Center,
Anaheim, Calif. 92804

Published quarterly, official publication of National Ass'n. of Miniature Enthusiasts; $3.00 per copy or free with registration in the association

Nutshell News
Catherine B. MacLaren, Editor
1035 Newkirk Drive,
LaJolla, Calif. 92037

Published quarterly, oldest of the miniaturist's magazines; costs $5.00 per year, $7.50 overseas

Poppenhuizen ("Dollhouses")
Decorative Arts Department
Rijksmuseum, Amsterdam, Holland

Little book printed in English and Dutch, describing some of the dollhouses in the museum

Paul A. Ruddell
4701 Queensbury Road
Riverdale, Md. 20840

Deals exclusively in doll or dollhouse books; send for latest list, which is free

Index

Mary Merritt Museum, 195
Maryland, 188, 192
Mason, Edith, 44–45
Massachusetts, 50, 188, 192–193
Master bedroom (Maynard manor), 84
Masterpieces, copies, 98
Mastrovito, Charlotte, 32–34
Mastrovito Collection, 32–34, 133
Mats, table, 144
Maynard Manor, 82–85, 122, 155, 190
Maynard Manor: The Miniature World of a Modern Gulliver (Blauer), 83–84
Medallion, plasterwork, 79
Mediterranean villa, 5, 6
Meerschaum pipe, 181
Memory Town, 195
Merry Miniature Books, 166, 201
Metal: boots, 172; chairs, 139; coaches, 172; furniture, 40, 41
Metallics, 131–142
Metalwork, 12
Metronome, 170, 171
Metropolitan Museum of Art, 139
Mexican miniatures, 200
Mexico, 137, 183
Mezuzah, 166
Michigan, 188, 193
Microbius, 147, 201
Middleton, W. R., Jr., 201
Milk glass chairs, 150
Mille fleur paper weight, 148
Milliner's shop, eighteenth century, 110
Milwaukee County Historical Museum, 196
Mini Contracting Company, 7
Mini Things by Suzanne, 108, 134, 145, 146, 160, 161, 201
Miniature Book Studio, 166, 201
Miniature Collector's Guild, 187
Miniature Mart, 190, 201, 202
Miniatures. *See* specific types of miniatures
Miniatures by Marilyn, 201
Minnesota, 188
Mirrors, 12, 14, 78, 81, 86, 89, 154, 170, 171; antiqued, 138, 139; Chippendale, 154; full-length, 91; handbag, 90; pier glass, 75; what-not shelf, 32
"Miss Willoughby" (Romney), 13, 14
Mississippi, 188
Missouri, 43, 188, 193
Missouri Botanical Garden, 44
Missouri farmhouse, 64–68
Modern range, 72
Momoyama screens, 157
Monk, 42
Monopoly pieces, 173
Montana, 188
Montgomery Ward catalog (1932), 41
Morley, Lucille, 201
Morley Collection, 121, 123
Morley Miniatures, 121, 123, 201
Mosque, 28
Mother Larke Collection, 84
Mother-in-law house, 51
Mott, Allegra, 24, 25, 26, 181, 187
Mott Collection, 23–26, 181

Mott Miniatures, 26, 172, 190
Mott's Miniatures Workshop News, 206
Mouse, Mr. and Mrs., 32
Mueller, Edwina L., 205
Muffin stand, 111
Murano, Italy, 148
Museum of Arts and Sciences, 194
Museum of the City of New York, 6, 151, 194
Museum of Fascination, 194
Museum of History & Industry, 196
Museum of Old Dolls & Toys, 191
Museum of Science & Industry, 191
Museum of Spanish Armor, 42
Music room, 5, 15
Music room: corrugated carton, 46, 163; Tara, 163; Updegraff castle, 85
Musical instruments, 161, 183
Mustard pot, pewter, 135, 136
Myers Florists and Antiques, 202

N.A.M.E., 206
Nancy Lee's Dollhouse Museum, 202
Nancy Tut's Christmas Shop, 194
Napkin rings, 5, 144
Napkins: cocktail, 182; linen, 5
National Association of Miniature Enthusiasts, 187, 206; regional groups, 187–188
Nebraska, 188
Needlepoint: carpets, 62; seats, 77, 80
Needles, 75
Netherlands, 89
Nevada, 187
New England, 36
New England house, 7
New Hampshire, 188
New Jersey, 188, 193
New Mexico, 187
New Orleans, 95, 109
New York, 36, 43, 134, 157, 188, 193–194
Newark Museum, 193
Newbridge dollhouse, 48, 49
Newel post, 4
Newport Historical Society, 195
News Letter of the XLIVmos Club, 165–166
1902 house, 102
Noble, John, 6
North Carolina, 188, 194
North Dakota, 188
North Palm Beach, 41
North White Plains, 7
Norton, Edward G., 129, 130
Norworth, Jack, 181
"Nude Descending a Stair" (Duchamp), 151
Nude model, 74, 75
Nuremberg, 24, 67, 176
Nursery (Updegraff castle), 85
Nutmeg, 167
Nutshell News, 6, 43, 125, 185, 206

Oberammergau Passion Play, 64
Oddities, 169–177
Ogden house, 68–71

Ohio, 188, 194–195
Oil paintings, 153, 157, 158
Oils painted on linen, 151
Oklahoma, 188
Old Curiosity Shop, 202
Old German School Museum, 193
101 Productions of San Francisco, 36, 38
One-post bed, 71
One-room schoolhouse, 173–174
Oregon, 188
Oriental shop box room, 28–29
Ormolu, 9, 75, 135, 136
Otto M. Wasserman Collection, 143
Overalls, 24
Overbeck, Jeanne Musselman, 90, 92–96, 191
Overbeck "Fantasy Castle," 90, 92–96, 128, 191
Oxen yoke, 66
Ozark log cabin, 174–177

Pad feet, 124, 129
Pagodalike display cases, 28
Paige I, 202
Paintings, 62, 63, 199, 200; gilt-framed, 170, 171
Paneling, black walnut, 31
Panels, recessed, 26
Pans, 23, 108, 109, 170, 171
Pantry, sepia tone, 35, 37
Paper, wall panel, 16
Paper houses, 35–41
Parasols, 156
Parian dolls, 75
Paris, 11, 12, 164, 181
Paris Exposition, 165
Paris Flea Market, 94
Park, Irma, 202
Parker, Marian, 202
Parlor, American Gothic, 15
Parlor (Campbell house), 96
Parvin, Stuart A., 96–99
Patsy Models Company, 202
Peabody Maritime Museum, 193
Pearson, Eric, 85
Peasant Bazaar, 17
Peddler's Shop, 12, 82, 83, 134, 152, 155, 162, 163, 190, 202
Peddler's wagon, 170, 171
Pediment, broken-arch, 124
Pedlar dolls, 170
Pendulum, 22
Peniston Miniatures, 202
Pennsylvania, 188, 195
Pennsylvania Germanware, 146
Penz house, 53–55
Perfume bottles: French, 10; handmade china, 147
Petit point, 183; couch cover, 79
Petite Princess, 20, 170, 171
Pewter, 134–137, 198, 199, 200, 203; accessories, 70; ashtray, 136; baby buggies, 135; candelabras, 40; candlestick, 136; chandelier, 34; dishes, 131; fork, 137; mustard pot, 135, 136; Swedish, 137; tea set, 136; tray, 136
Phillips' castle, 194
Phoenix Art Museum, 190
Photographs, 164
Phyfe, Duncan, 113–114
Piano, 5, 23, 28, 65, 112; baby

grand, 40, 62, 161; hand-carved French, 128; metal, 139; petit point, 95; Petite Princess, 62, 128, 161; rosewood, 21; Royal Grand, 170, 171; Spielwaren, 128; square, 123, 161; upright, 161; Victorian square, 161
Piano bench, 139
Piano stool, 65, 128, 161
Pickwick Miniatures, 13, 152, 156, 163, 202
Picture-frame cases, 24; silver, 139, 140
Pictures, 110, 199, 201; from Sunday School cards, 174
Pie safe, 108, 121
Piecrust table, 177
"Pieta, The," statuary replica of, 89, 91
Pilgrims, 16, 134
Pillars, 98
Pillows, 200; sachet bag, 33
Pine chairs, 120
Pine cupboards, 120, 122
Pine pieces, American primitive, 119–120
Pirie, H. W., 17, 30, 43–44
Pirie, Mrs. H. W., 44
Pirie Collection, 17
Pistol-handled urns, 146
Pitchers, 139–140
Pixie Shop, The, 202
Plane, 41
Plaques, handpainted, 152
Plasterwork, 79
Plastic Chinese figures, 155–157, 173
Plastic furniture, 113
Plates, 144, 145
Platform rocker, 79, 80
Playroom (Updegraff castle), 85
Plexiglas, 21, 92
Plum pudding, 13
Plymouth Antiquarian Society, 192
Poland, 15
Pole screen, 114
Pompeii, 89
Pond, 106
Pooh house, 71
Poppy shows, 18–19
Porch supports, turned-wood, 56
Porches, 7, 56, 102
Portrait in oil, 75
Portugal, 88
Potato chips, 167
Potpourri Miniatures, 192
Pots, 67, 108, 133, 134, 170, 171
Pottery, 199
Prayer altar, 96
Prelude to Serenity shadow box, 21
Prescott, Mel, 13, 109, 145, 147
Prescott, Mrs. Mel, 124, 161, 202
Pretend rooms, 80
Prie-dieu (Kennedy house), 62, 159, 160
Princess' bedroom (Stuart castle), 99
Print, J. Chamberlain, 95
Prints, 52, 53, 201
Prophet, The (Gibran), 166
Prunes, 167
Publications, 205–206
Pump, 22; with basin, 132